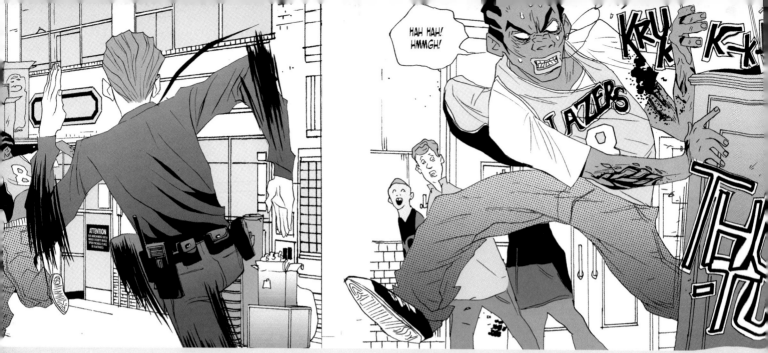

MANGAKA AMERICA: MANGA BY AMERICA'S HOTTEST ARTISTS
Copyright © 2006 by STEELRIVER STUDIO LLC

HarperCollins books may be purchased for educational, business, or sales promotional use. For information, please write: Special Markets Department, HarperCollins Publishers, 10 East 53rd Street, New York, NY 10022.

First Edition

First published in 2006 by:
Collins Design
An Imprint of HarperCollinsPublishers
10 East 53rd Street
New York, NY 10022
Tel: (212) 207-7000
Fax: (212) 207-7654
collinsdesign@harpercollins.com
www.harpercollins.com

Distributed throughout the world by:
HarperCollinsPublishers
10 East 53rd Street
New York, NY 10022
Fax: (212) 207-7654

Interior design by:
Lonewolfblacksheep design
www.lonewolfblacksheep.com

Library of Congress Control Number: 2006928288

ISBN-10: 0-06-1137693- 3
ISBN-13: 978-0-06-113769-3

Printed in China
First printing, 2006

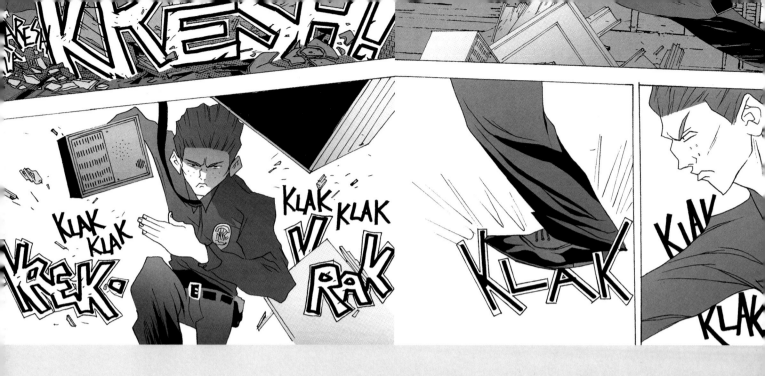

MANGAKA AMERICA

STEELRIVERSTUDIO

WWW.STEELRIVERSTUDIO.COM

COLLINS|DESIGN

An Imprint of HarperCollinsPublishers

CONTENTS

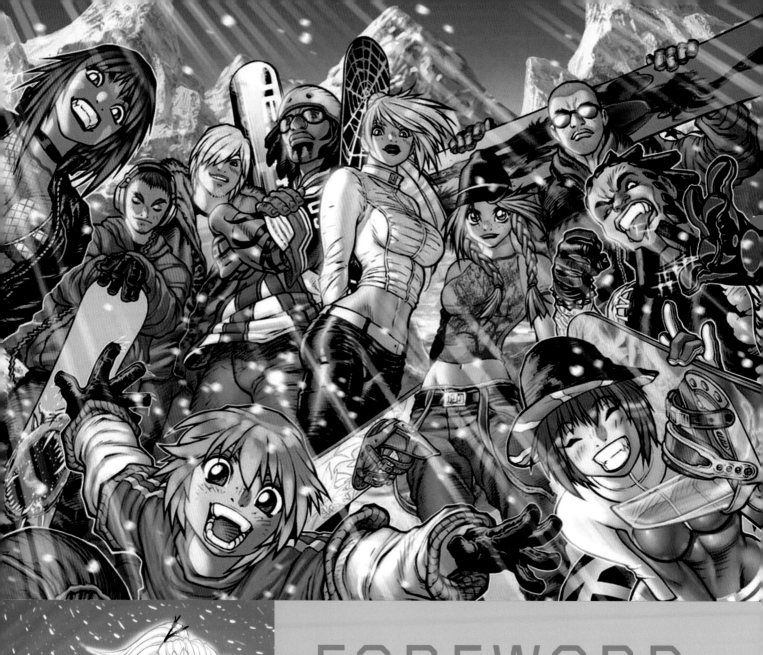

FOREWORD BY

ADAM WARREN, one of the first American comics artists to work in a heavily manga-influenced style, has written and drawn an original English-language comic based on the Japanese science fiction characters The Dirty Pair since 1988 (as well as a miniseries adapted from the anime *Bubblegum Crisis*). In mainstream comics, he's worked extensively on Wildstorm's teen-superhero series *GEN13*, written and drawn a DC Comics one-shot derived from the popular Teen Titans characters (*Titans: Scissors, Paper, Stone*), and more recently created the Marvel Comics "mecha" title *Livewires*. Currently, he's writing an *Iron Man* miniseries for Marvel, producing a monthly humor feature for the video-game magazine *PSM*, and finishing up the first two volumes of his upcoming "sexy superhero comedy" comic, *Empowered*.

ADAM
WARREN

HELLO, THERE! My name is Adam Warren and, at least in theory, I'm an "American mangaka"! Well, maybe.

The truth is, I don't personally use the term "manga" (meaning Japanese comics) to describe the artwork that I create, nor do I use the term "mangaka" (meaning a practitioner of Japanese comics art) to describe myself. . . and neither do many of the artists you're about to meet. As Tania del Rio will address shortly, much controversy swirls around the issue of whether the term manga can apply to Japanese-influenced Western comics work, or should it be reserved strictly for comics produced by Japanese creators? Countless horrendously tiresome "flame wars" have raged online over this matter, hinging on hot-button issues of etymological hairsplitting, "tomato/tomahto" dichotomies, cultural appropriation, and worse.

Unlike some, I'm not a die-hard partisan on the issue of how the term manga should or should not be used. I tend to use the word as just shorthand for "Japanese comics by Japanese people," despite being aware that such a strict usage tends

CONTINUED >>

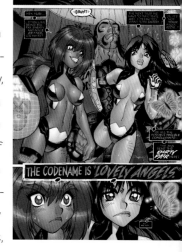

to break down upon closer and closer review. Example: By that definition, a former (Japanese) roommate of mine definitely produced manga, but would a Japanese-American child of hers still be able to say the same? Is this definition a matter of citizenship, culture, or (look out!) race? That sound you hear is the sound of me shrugging, gesturing dismissively, and saying, "Fehh!" as I shuffle away from the ideological fray.

To be honest, I've never heard a wholly apt term for what I (and, more important, the subjects of this book) do: that is, write and draw comics and illustrations strongly influenced by the artwork and storytelling of Japanese manga. At least today's phrases used to define this activity, whether the rather vague and all-encompassing "manga-influenced comics" or the technically oxymoronic "original English language manga" is more pleasant than the clumsy neologisms that were first coined back in the 1980s and 1990s, such as the contemptuous "faux manga" or the truly horrific "Amerimanga." (On a more positive tip, I should note that I don't refer to myself as an *otaku* either, despite the fact that I more than fulfill that Japanese slang term's rather pejorative definition of "narrowly focused obsessive." I prefer the considerably more romantic and evocative "doomed, pathetic loser" as a self-definition, personally.)

In all honesty, you're probably NOT asking yourself, "Say, how did Mr. Arguably Not an American Mangaka get into this line of work?" Regardless, I'll go ahead and tell you, Hypothetical Reader Who Didn't Actually Ask This Question! After a 1970s childhood of devouring Marvel superheroics rendered by greats such as John Buscema and Jack Kirby (the latter via reprints), then following a 1980s adolescence brightened by the alternative comics scene of talents like Howard Chaykin, Alan Moore, and Los Bros Hernandez, I decided to "like, follow my bliss, man" right into the comics field . . . and thus wound up attending the Joe Kubert School of Cartoon and Graphic Art in scenic Dover, New Jersey. Before too long, though, I became thoroughly disenchanted with both the comics-training experience and the comics field itself, as the first, infernal superhero crossovers at industry titans Marvel and DC rampaged unchecked

through American mainstream comics. I contemplated ditching the Kubert School entirely, with my attitudinal nadir taking place as I labored through a particularly inept illustration of comic-strip hero The Phantom riding a spectacularly deformed-looking elephant (not sure why I felt obliged to mention that, but there you go) . . . I couldn't conceivably imagine doing this loathsome stuff for the rest of my life.

Then, for the first time, I encountered anime and, much more important, manga. Certain knowledgeable Kubert School classmates loaned me videotapes and *tankoubon* (Japanese paperback collections of manga) aplenty. . . And lo, the scales did fall from my eyes, as the work of Rumiko Takahashi, Hayao Miyazaki, Yoshikazu Yasuhiko, and others did proceed to warp my mind most grievously . . . and change my life in the process.

What is the sheer, visceral appeal of Japanese character design and manga storytelling? Why would an Asian country's indigenous, hyper-stylized pop culture strike such a resonating chord in a white boy from the New England boonies? Why should work like Takahashi's manga *Urusei Yatsura*, heavily rooted as it was in Japanese folklore, mythology, and cultural references of which I was wholly ignorant, nonetheless seem so utterly appealing and hilarious? Why, after years of reading manga set in high schools, would the cultural tropes of Japanese school uniforms now seem more familiar and agreeable to me than the 1980s-era Chess King and Ocean Pacific sartorial atrocities of my own, real-life high school experience? (Pardon me as I twitch with long-repressed memories of parachute-pants trauma.) I've no real explanation for this puzzling cross-cultural phenomenon, alas; if I did, I'd no doubt be writing a book, instead of writing only the foreword to a book.

> "WHY WOULD AN ASIAN COUNTRY'S INDIGENOUS, HYPER-STYLIZED POP CULTURE STRIKE SUCH A RESONATING CHORD IN A WHITE BOY FROM THE NEW ENGLAND BOONIES?"

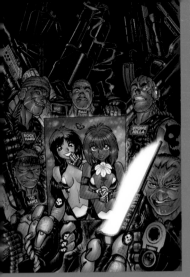

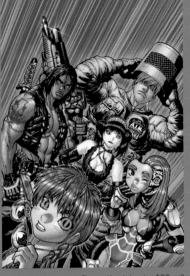

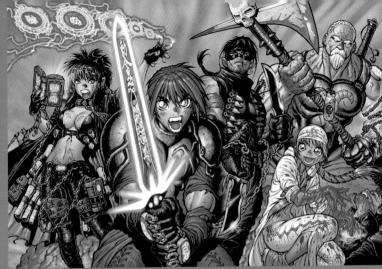

Cover from *The Dirty Pair: Run from the Future*
The Dirty Pair © 2002, 2006 Haruka Takachiho.

Livewires: Clockwork Thugs, Yo miniseries TPB collection #1
LIVEWIRES™ & © 2006 Marvel Characters, Inc. All Rights Reserved

Fantasy Illustration ©2006 Adam Warren

Regardless of the ineffability of manga's attraction, I was galvanized into producing my own attempts at Japanese-flavored comics work, trying to capture some of the energy and humor and kinetics and originality of my favorite manga into an American comics idiom. I could, in fact, conceivably imagine doing this stuff for the rest of my life . . . which, so far, is pretty much what happened. Now, 20 years later (and please pardon me while I flinch at that painful number), a new generation of manga-savvy North American artists is incorporating Japanese-influenced character designs, art techniques, and story-telling approaches into their work. *Mangaka America* is about to give you a front-row seat as the curtains open on this promising new generation.

The artists you'll meet in these pages produce an impressively diverse and wide-ranging body of work, one that strays well beyond the stereotypical perceptions of manga-influenced comics as merely imitative pastiches of "big eyes and speed lines." From M. Alice LeGrow's Gothic Lolita delicacies and the graphic design dynamism of Jesse Philips to Rivkah's impeccably *shoujo* stylings and the wild, gaming-informed "meta" riffs of Corey "Rey" Lewis, you'll experience a sweeping variety of artistic styles. Most of the manga-emulating artists of my generation (including myself) were narrowly fixated on *shonen* manga (boys' comics) action tropes, mechanized mayhem, and titillating "fan service". . . but, as you'll see, this new cohort of artists represents a considerably broader range of Japanese influences, to their credit.

NOTE: ALL ARTWORK COLORED BY RYAN KINNAIRD

An interesting fact about *Mangaka America*'s featured artists is that most of them both write and draw their own comics work. While this is common practice (if not the norm) in Japanese comics, it's still a highly infrequent occurrence in the American comics field, where the overwhelming majority of artists work from a separate writer's story and script. Moreover, a fair number of this book's subjects go even further and do all the labor on their comics pages, even down to producing the lettering and screen tones. This is seriously out of the ordinary for American comics, where usually an assembly line of different artists handle the tasks of penciling, inking, and coloring separately; it's even a bit atypical for the Japanese market, where most successful mangaka use assistants for the rendering of backgrounds and crowd scenes, inking, toning, and the like.

Now, there really is a lot to be said for the oft-cited synergy between writers and artists inherent to most American comics' separated division of labor. . . and I've definitely benefited from that synergy in my nominal "second career," during which I've written many stories for other artists to draw. However, perhaps because I started out in comics as a writer/artist (and still work that way, more often than not), I'm especially fond of comics creators who both write and draw (and ink and letter and tone!) their own work. At their best, such folk can produce a purer, more intense, and more passionate evocation of individual creative vision than would be possible with multiple-artist synergies, however talent-laden the latter might be. I think you'll eventually see what I'm babbling about, here, when you read through the rest of this book and encounter

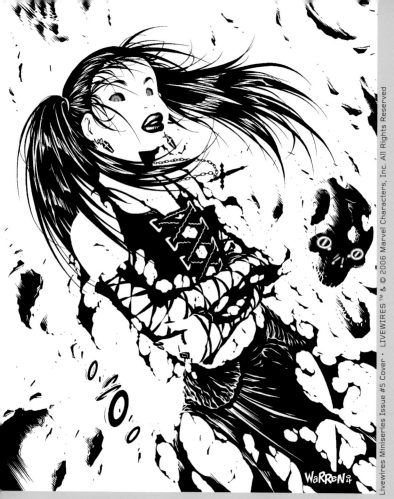

"overnight" meaning "over several years," admittedly, but that's still a short time in the average artist's decades-long career). So definitely keep your eye on this book's young artists in the near future; believe me, the work you'll see here will be only an early snapshot of abilities that are bound to increase dramatically over the years of experience that will follow.

I should note that one particular issue has swirled around would-be American mangaka ever since the beginning: is direct emulation and/or imitation of manga necessarily a desirable goal? I've known manga-influenced artists whose fondest desire was to create artwork that would be indistinguishable from that of an actual Japanese artist. I have to admit, the idea of attempting to "pass" as an authentic mangaka by rote imitation has always struck me as a sterile and ultimately pointless endeavor, the underlying sentiment of which smacks of the infamous, self-loathing cry of "Would that I had been born in this golden land!" uttered by the expatriate Japanophile American from Gainax's anime/docucomedy *Otaku No Video*. Why bother reading a slavishly derivative, but nonetheless ersatz, American re-creation of a Japanese comic when so much of the genuine article is available?

strong writer/artist work like that of Felipe Smith, Svetlana Chmakova, Christy Lijewski, Amy Kim Ganter, and their peers.

May I spare a paragraph to list the ways in which I envy this book's authors and artists? Envy's always fun, isn't it? I envy them the joy of having grown up with manga (translated manga, even!), as I did not, given that I encountered Japanese pop culture at the relatively doddering and long-in-the-tooth age of 18. I envy them the fact that they're part of a wide community of manga-inspired artists, a community enabled to a terrifying degree by the Internet; there weren't very many of us would-be American mangaka "back in the day," and lemme tell you, there sure weren't no fancy Interweb thingamajig for us'n to be pala-verin' on, consarnit! Finally, as almost all of these creators are twentysomethings, I envy them their youth, but for a safe, art-related reason: namely, young artists are capable of dramatic, even amazing spikes of skill development in very short periods of time. During their early twenties, most of my mangaka idols (Shirow Masamune, Kenichi Sonoda, Tatsuya Egawa, Fujihiko Hosono, et al) were able to achieve drastic improvements in their work almost overnight, as was I, to a lesser degree (with

What interests me most about the artists featured in this book isn't the degree to which their artwork might or might not be mistaken for REAL manga, but rather how they integrate diverse, often non-Japanese artistic and cultural influences into a manga-flavored storytelling idiom. The best of these creators bring much more to the table than mere emulation of familiar manga tropes; they infuse their art with fresh elements ranging from pop culture flourishes and graphic design riffs to unique narrative takes and disparate points of view that make their work more fascinating and innovative than its superficial resemblance to manga might indicate. This, to me, is far and away the most exciting promise of so-called American manga: rather than producing hackneyed imitations of "real" Japanese comics, such a movement might instead integrate unique and localized Western cultural takes and influences with Eastern storytelling and artistic inspirations. Sounds a tad pretentious, I know, but I still think that's a valid aspirational goal.

In terms of pretentiousness (if not portentousness), try this sentence on for size: Artists like those you'll encounter in *Mangaka America* may well represent the only hope for long-term survival of the American comics idiom. Some clarification: After graduating from the Kubert School, I found work writing and drawing in the American direct market served by retail comics stores, an often insular, conservative, and narrowly focused industry that remains to this day wholly dominated by Marvel and DC superhero titles. Alas, even though the quality of such American comics is arguably at a higher level than at any time before (due to a much stronger selection of writing talent), only a tiny and ever-shrinking fraction of the American population is reading them. . . Even worse, that dwindling demographic is an aging one, skewing heavily towards males in their late twenties and thirties and (gasp!) beyond. Think: The Simpsons' iconic Comic Book Guy writ large. And, increasingly, writ gray. To wildly understate the situation, children and teens aren't flooding into comics stores to read the individual-issue, monthly "pamphlets" of American comics; what they are read-

> "...WE'RE CERTAIN TO SEE AN EVER-WIDENING AND HENCE EVER-IMPROVING ARRAY OF COMICS TALENT JOINING THE FIELD."

ing is manga, on a scale that would've seemed outlandish only five or 10 years ago.

Thus, as the direct market embodied by old-school Comic Book Guys (like myself, I'm saddened to admit) ages and withers away into demographic collapse, in the future the only viable readership for American comics creators to address may well be those very manga readers . . . and I find it extremely likely that Japanese-influenced artists like those featured here will have the best hopes of appealing to them. One problematic issue, though, is whether or not the new manga readership will come to accept, let alone embrace, manga by Americans in the long term. I'm all too aware that a certain proportion of manga readers will automatically and unthinkingly reject any work by Americans as being intrinsically inferior to pure-strain Japanese manga; the question is, how widespread will this attitude

turn out to be? I've no real idea, but remain perhaps uncharacteristically optimistic about the future of manga by Americans primarily because of two words: talent and pool.

A word of explanation: One of the more promising aspects of today's vastly larger manga readership in North America is that it provides a correspondingly expanded "talent pool" from which potential comic artists might spring. The mere handful of Japanese-inspired American artists of my generation were a subset of a far, far smaller manga-reading base population, back in the dark, primordial 1980s when translated manga were few and far between. Still, our relatively shallow talent pool managed to yield some impressive artists (with the most talented artist of that era probably being cartoony wunderkind Robert DeJesus). In the near future, as more and more creators like those of *Mangaka America* emerge from today's much deeper talent pool, we're certain to see an ever-widening and hence ever-improving array of comics talent joining the field. After all, the Japanese mangaka whose work is now translated and published worldwide represent the cream of an artistic crop that derives from the jawdroppingly huge proportion of the Japanese population that reads manga; while the equivalent American readership base remains considerably smaller, that might well change within five or 10 or 20 years. In that time, we're certain to see some world-class (North) American talents emerging into the manga idiom, not to mention improvement of existing American mangaka as they gain experience over the years.

Who knows? In twenty years, Tania del Rio and Will Staehle might well be writing the foreword to a book (insert futuristic, two-decades-hence vocabulary equivalents of "writing," "foreword," and "book" here!) featuring the comics work of an even more impressive generation of artists . . . Have to say, I'm looking forward to it.

BACK TO THE DRAWING BOARD,

Adam Warren

ADAM WARREN

BY **TANIA DEL RIO**

Originally seen on **popcultureshock.com** in Tania's column *Read This Way.*

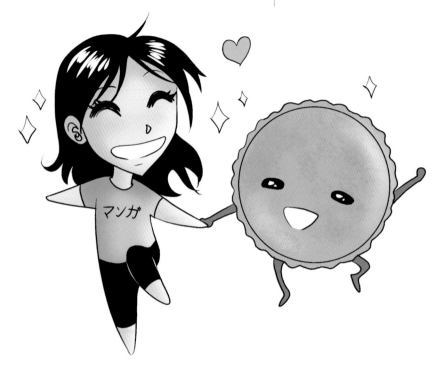

YOU SAY POTATO, I SAY MANGA

WILL SOMEONE HELP ME NAME MY BABY? Look at him, cute and pudgy in his screen-tone romper as he blinks at you with his enormous liquid eyes. He's pretty young, you know. Sometimes he's a little shaky on his feet, but I'm sure he'll grow into something good.

I wanted to call him Manga, but some people had an issue with this. They said that he can't be called that unless he was born in Japan! Can you believe it?

So I'm going to come right out and say it. The whole argument over whether American manga is actually manga is a petty one. I often wonder why some people take the issue so personally. Even more bewildering is the fact that some of the most hard-core manga purists and defenders of the art form are not Japanese, but young Americans.

It's true that some Japanese do not seem to look at American manga in a favorable light. Some have begun calling it *nissei comi* which could either mean "second-generation comics" or "fake comics." I actually find the double entendre pretty amusing. (Oh wait . . . entendre is a French word. I guess I shouldn't use it.)

That said, I actually wouldn't mind if we started using *nissei comi* to describe American comics, the same way hardcore anime and manga fans have started calling themselves *otaku.*

For those who don't know, the word *otaku* in Japan is not exactly a positive term. It's an insulting word that describes anyone obsessed over a particular thing. It doesn't have to be comics and anime. It can be guns, bottle caps, vintage posters, whatever.

Yet, in America, many of these hard-core fans proudly proclaim to be *otaku.* They

are hardly insulting themselves. Rather, the meaning of *otaku* has changed during its trip overseas. Now, on our shores, it means "hard-core anime and manga fan." These American *otaku* are also quite keen on sprinkling Japanese words into their vernacular. They'll exclaim *kawaii!* when they see something cute. Or say *ja mata* as they leave the room. In some ways, these words are also being absorbed into our culture and being used in the same way that words like karaoke, honcho, ninja, and futon have become common English words.

For me, it all comes down to labels. And I've always felt that labels are temporary, everchanging, and, at the end of the day, really only serve for the sake of convenience.

I love manga as much as the next person, and I'll admit there is a bit of an *otaku* inside me, but I just don't understand why some feel threatened by the advance of American manga. I think that this globalization of the art form is an extremely positive thing. Imagine what the world would be like if we weren't allowed to borrow or adapt things from other cultures!

It's ludicrous to insist that Americans have no right to take Japanese manga and create art in a similar style. We're adapting something from another culture for our own culture. We're not trying to eradicate Japanese manga; we're not trying to replace it. We're not even trying to sell it to the Japanese. There's plenty of room for American manga, European manga, and manga from any other place in the world.

Some argue that manga just means "comics" and that Americans don't have a right to use the Japanese word for comics unless they were made in Japan. So I guess we should tell Japan to stop using all the American words that they have borrowed? Should we tell them they can no longer call blues music *buruusu*, or even perform it, because they're not American? Yeah, it sounds pretty silly, doesn't it?

I took a Japanese class a couple of years ago and the teacher went around the room asking what each of us did for a living. I told her I wrote and drew comics. She said, "Ah! You are a mangaka." This was before she even knew that I drew comics in a Japanese style. She was simply telling me, in Japanese, that I was a comic creator. She could care less what kind of comics I drew, whether it was superhero, indie, or otherwise. As long as I drew comics, I was a mangaka as far as she was concerned.

Some people say we should simply call American manga "comics" since that's what they are. True, but I see the word comics as being an umbrella term. Beneath it are Superhero comics, Indie comics, Web comics, 24-hour comics, comic strips, and, yes, manga comics. While manga comics is literally redundant (comics comics?), I think the word manga has already been assimilated into our language to describe a particular style. Its meaning has changed for us in the West; it doesn't simply mean "comics" in the way that *otaku* simply means "obsessed fan." It means "Japanese-style comics" in the way that *otaku* now means "Japan-obsessed fan."

> "...AT THE END OF THE DAY MANGA
> IS JUST A WORD."

And, people, at the end of the day manga is just a word. It's two syllables that only have meaning because we give it meaning. We could call American manga "pumpkin pie" and that wouldn't change what they are.

We should stop trying to hold back this tidal wave of artistic influence and accept that, as we progress into the future, boundaries between continents will become less distant and impregnable; we'll continue to share ideas and borrow others. This isn't a war, and it isn't a competition—especially where art is concerned. Art is meant to be shared and changed, and shared again.

I'm sure that one day Americans will find a new word for American manga, whether it's OEL, Amerimanga, *Nissei comi*, or pumpkin pie, much in the same way that Korean manga is now *manhwa* and Chinese manga is *manhua*. But at the end of the day, it's just a label.

And dammit, I'll name my kid whatever I want!
Mmm . . . pumpkin pie . . .

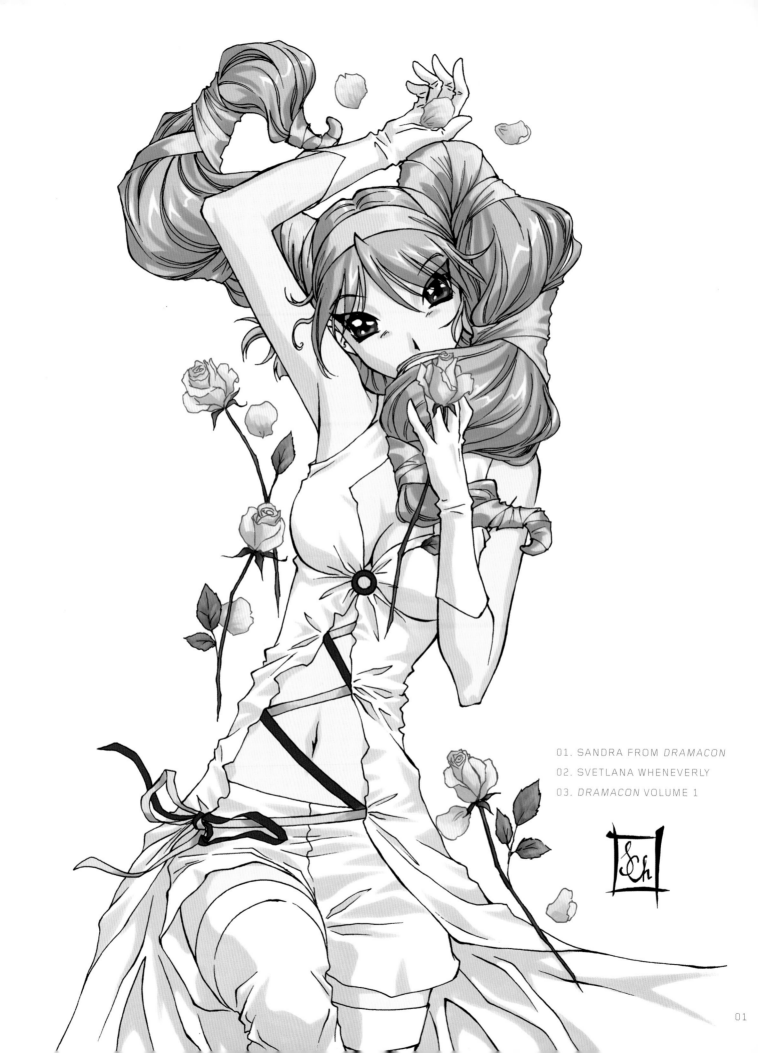

CREATOR OF TOKYOPOP'S Z Z z z z 02 DRAMACON

svetlana
CHMAKOVA

SVETLANA CHMAKOVA was born in Russia in 1979 and lived there until she was 16. Currently she resides in Ontario, Canada, and is in what she describes as a serious relationship with her work. ("We eloped and no one has seen me since!") Svetlana received a three-year classical animation diploma from Sheridan College and went on to become a frequent contributor to the *How-to-Draw* book series by Christopher Hart. Svetlana is perhaps best known for her critically acclaimed work on *Dramacon*, a graphic novel series published by TOKYOPOP. In addition to this, Svetlana also writes and draws a monthly manga-style strip for *CosmoGirl!* magazine, called *The Adventures of CG!* She is also the creator of the Web comics *Chasing Rainbows* for www.girlamatic.com and *Night Silver* for www.wirepop.com. More of her work can be viewed at her Web site, www.svetlania.com.

Q + A WITH SVETLANA

YOUR ART STYLE:

I draw in several styles, actually—realistic, stylized, cartoony (Disney, other North American cartoons), and manga influenced. My manga-influenced style looks very authentically manga, or so I've been told. Of course, I've also been told that I suck, so I don't quite know whom to believe. Judge for yourselves!

INFLUENCES:

Star Trek TNG and *Star Trek Voyager* for storytelling, *Sailor Moon* and *Ranma 1/2* as anime/manga influence (with some *Slayers* mixed in), *Buffy the Vampire Slayer*, and the work of Warren Ellis for dialogue pacing.

YOUR WORK PROCESS:

The first part of my process (coming up with ideas, doing research, and developing the characters and worlds) is my favorite. But making it work as a script is usually accompanied by a lot of crying and the sounds of my forehead hitting my desk, repeatedly. Once the script is done, I draw the thumbnails for it on paper. I then scan the thumbnails and do tight pencils over them on the computer in Photoshop, print them out in blue for inking by hand, then scan the inks to do the tones digitally. For toning I use mainly Deleter Comicworks, sometimes Adobe Photoshop, and E-Frontier Manga Studio.

YOUR WORK SCHEDULE:

Crawl out of bed, have tea to wake up, loiter around blogs and message boards until guilt sets in, get to work. If there is a deadline looming—skip bed, tea, blogs, and get to work.

FIRST EXPERIENCE WITH MANGA/ANIME:

Candy Candy and the *Robotech* anime series in Russia, when I was 13 or 14, I think.

YOUR THOUGHTS OF IT AT THE TIME:

I was floored, sold, addicted—I couldn't get enough. The style was so pretty-looking and cool, the stories so different from what I was used to.

THE FUTURE OF WESTERN MANGA:

I think it will take deep root and grow very strong. Manga's following has exploded in recent years, and it will continue growing, along with the creator scene. It's like eating a very yummy cake at a café—you finish it, lick the spoon, and start wondering (well, some of us, anyway) if you could figure out the recipe and make one yourself. Possibly with less cinnamon and more chocolate. And maybe some strawberries on the side. Mmmm.

FOR THOSE WHO OPPOSE WESTERN MANGA:

Please, go protest something that's actually important.

YOUR MESSAGE TO ASPIRING ARTISTS:

Always strive to improve and study, study, study! Anatomy, perspective, composition, color theory, etc. No art knowledge is useless knowledge.

SUGGEST MANGA TO A NEWCOMER:

MARS to a romance lover, *Planetes* for someone with a more serious taste, *Ranma 1/2* to everyone else.

YOUR HOBBIES:

Sleeping and eating.

GUNDAMS OR EVAS?

Evangelions. I love how organic and predatory they look.

FAVORITE NON-JAPANESE COMICS:

I read anything by Warren Ellis and Alan Moore. I also like *Preacher* by Garth Ennis, *Strangers in Paradise* by Terry Moore, *Courtney Crumrin* by Ted Naifeh, *Thieves and Kings* by Mark Oakley, *A Distant Soil* by Colleen Doran, *Bone* by Jeff Smith, and *Runaways* by Brian K. Vaughan and Adrian Alphona. I also enjoy many of the titles published by *Oni Press*; they've got a great lineup.

FAVORITE MANGA:

Planetes by Makoto Yukimura.

FAVORITE MOVIE:

Kiki's Delivery Service—I love the parts about a witch's *"artist block"* in it. It's my comfort movie.

YOUR FUEL:

Strong tea with lots of sugar, bouncy music, and DDR.

EARLY BIRD OR NOCTURNAL?

Very nocturnal, but I try to be an early bird, because the whole world conspires against my sleep during the day! Darn telemarketers . . .

KILLER MECHS OR CHIBIS?

Chibi characters!

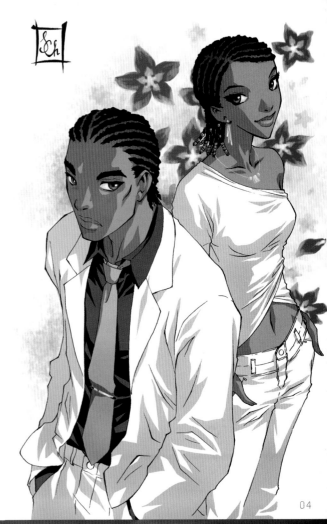

04. FAMILY • 05. LIGHTING THE MORNING SUN

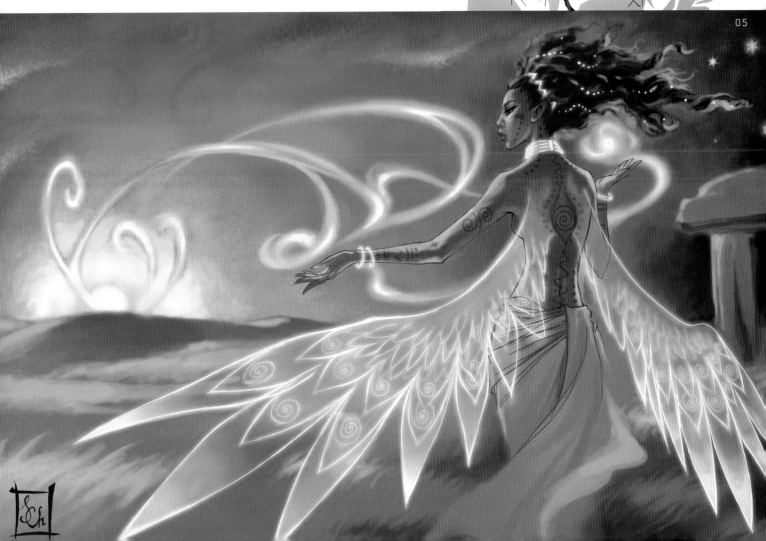

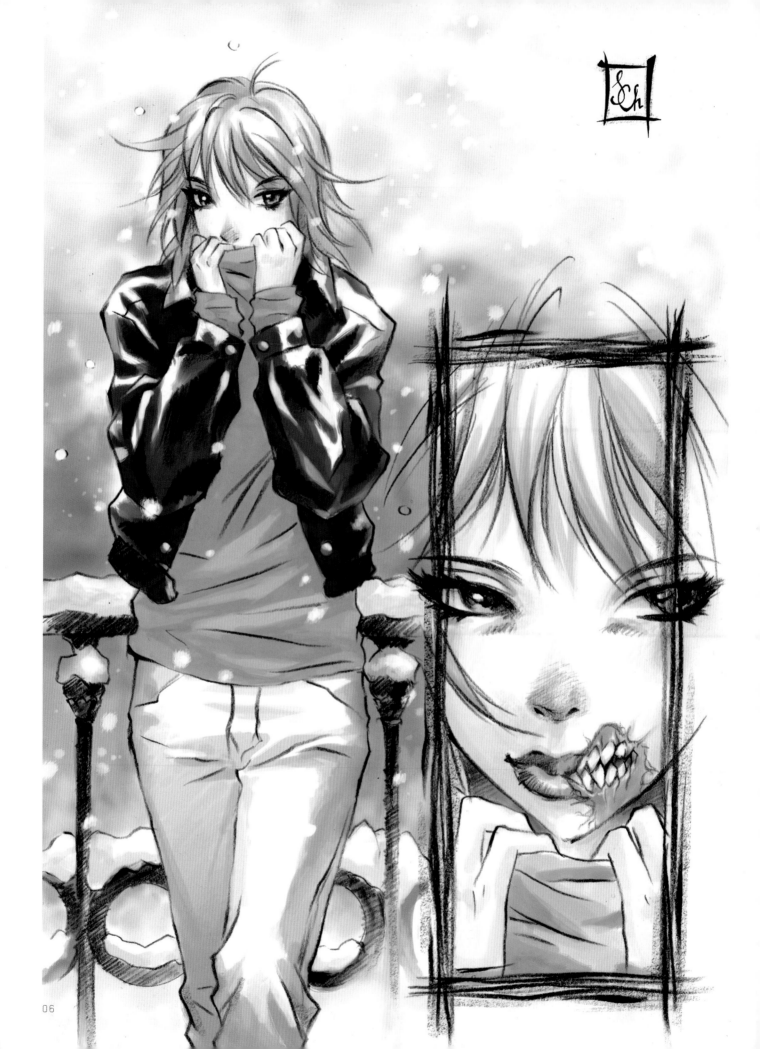

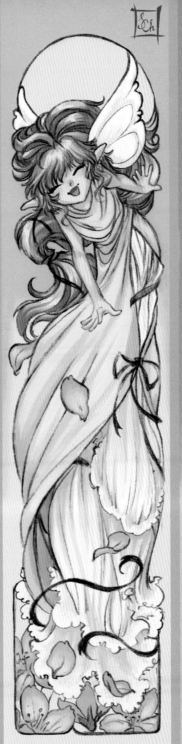
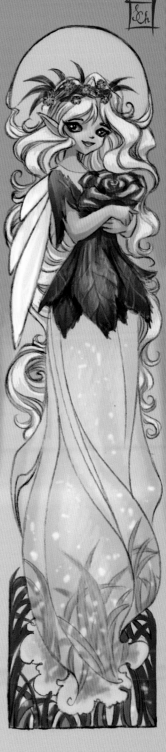

07

DESCRIBE A CON EXPERIENCE:

I once saw a life-size Nazgul statue at a con. At least I thought it was a statue, until it moved and stretched its hand toward me. I shrieked like a girl!

YOUR CATCHPHRASE:

I know this thing is really late, but you see, there was this Deathstar and I had to go fight it to save the world and . . .

YOUR HAIKU:

Svet can't write haiku
Because she's not Japanese
. . . Hey wait a second.

GOAL FOR THE FUTURE:

Write all my stories before I die, influence the world while doing so, and help it be a better place.
(Sounds cheesy, I know. But it's true!)

SVETLANA CHMAKOVA

20

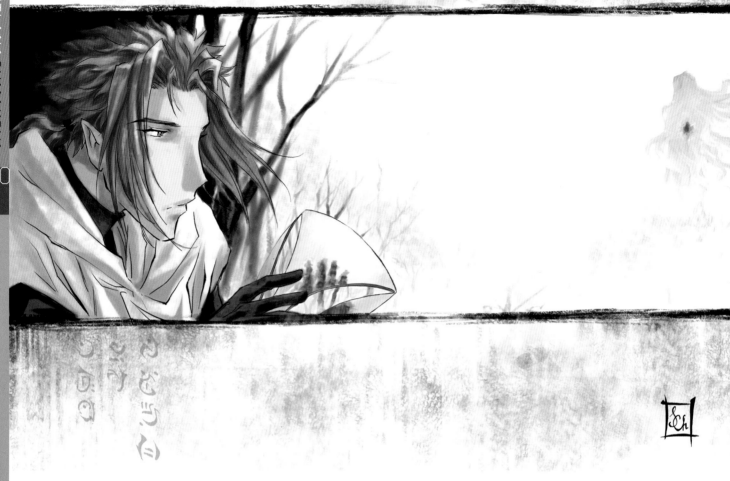

09

10

11

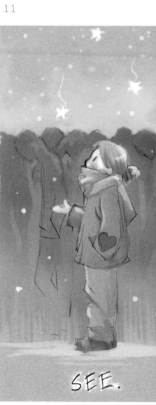

SEE.

08. WOUNDS THAT BIND · 09. CHRISTY + MATT · 10. SUMMER RAIN · 11. SEE · 12. FALLING

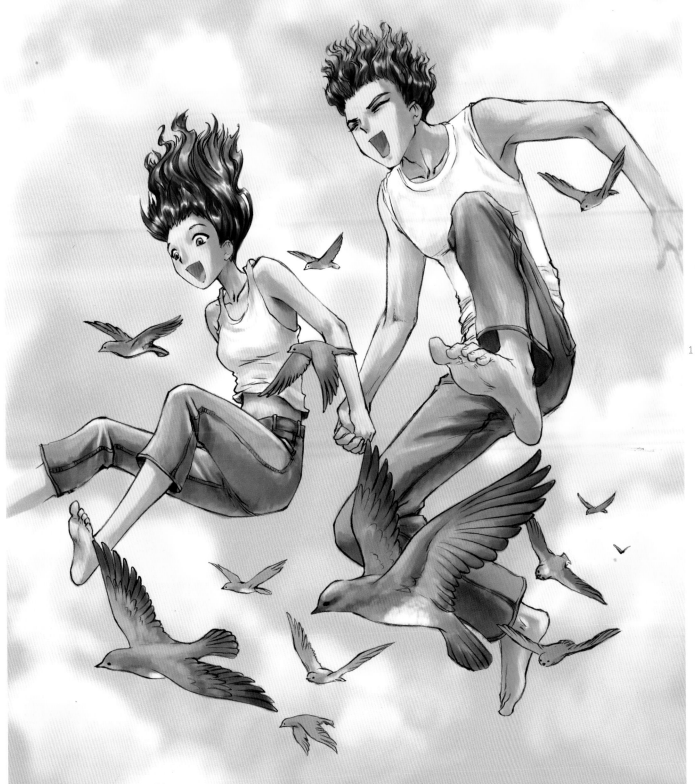

12

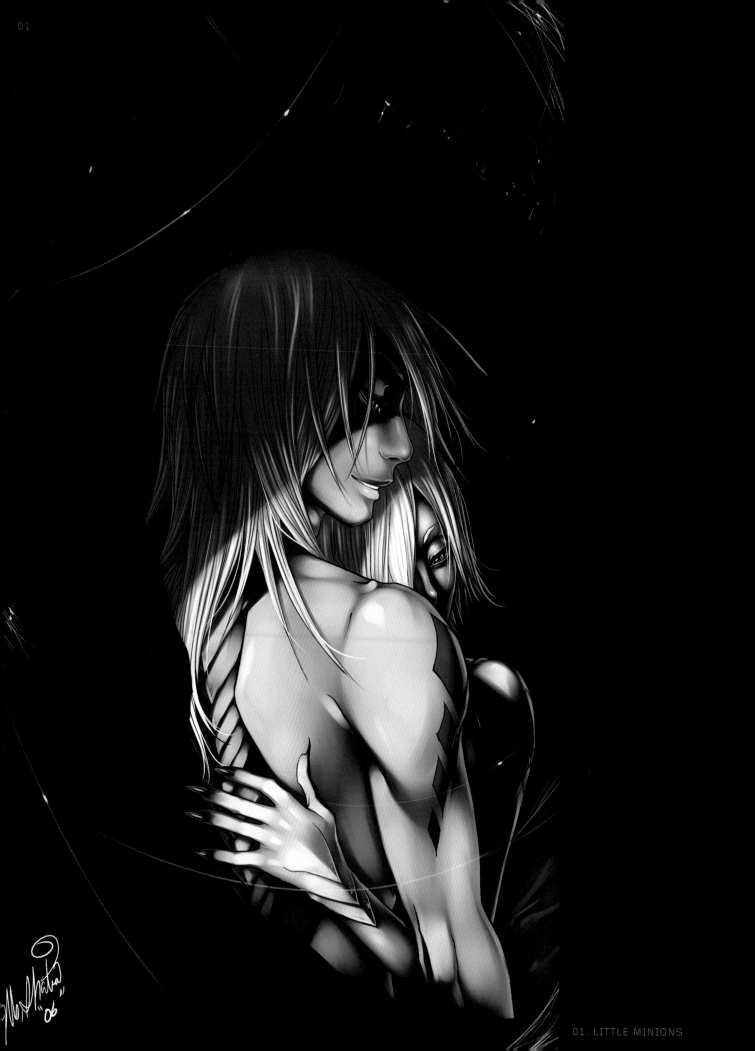

Ms,Shatia
CREATOR OF
Hamilton
Fungus Grotto

Ms,Shatia PaviElle Hamilton was born on June 18, 1984. Right now she lives in Minneapolis, MN, with an army of four kittens, six cats, and one dog. She spent two years at the Art Institute of Minnesota and her past projects include an online comic about vampires, and a winning entry in TOKYOPOP's *Rising Stars of Manga™* volume two, *Whisper*. Currently, Ms,Shatia is working on a full-color comic, *Fungus Grotto* and is preparing a pitch for TOKYOPOP. You can see more of her work at

http://nashya.deviantart.com.

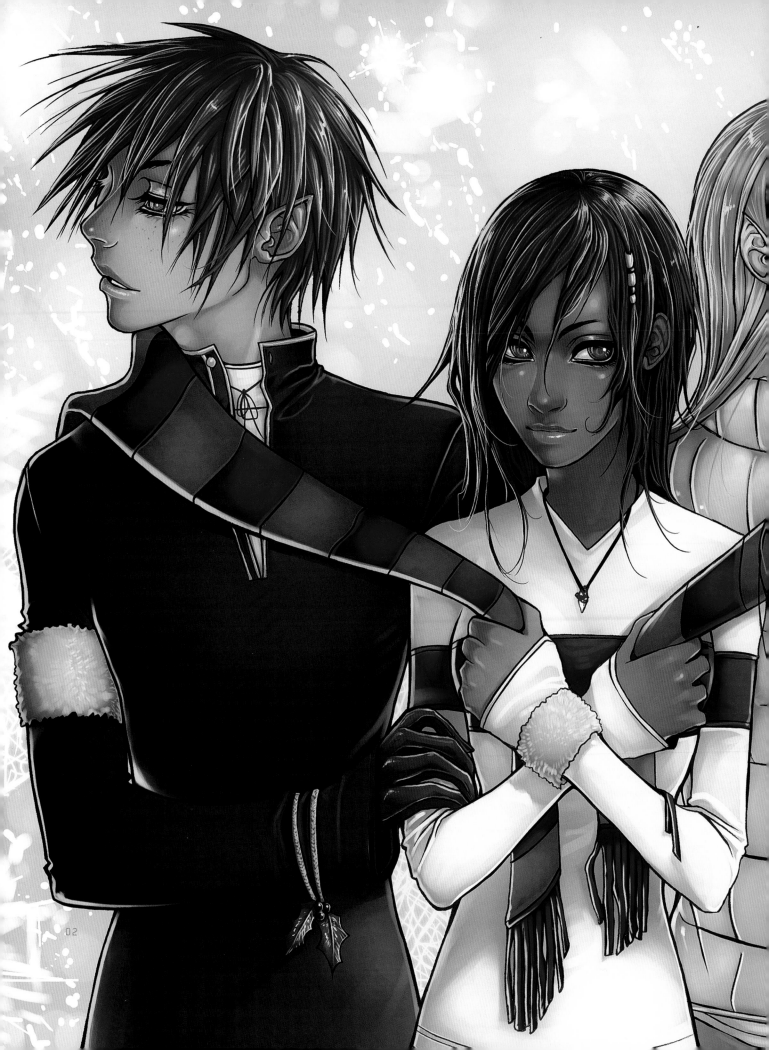

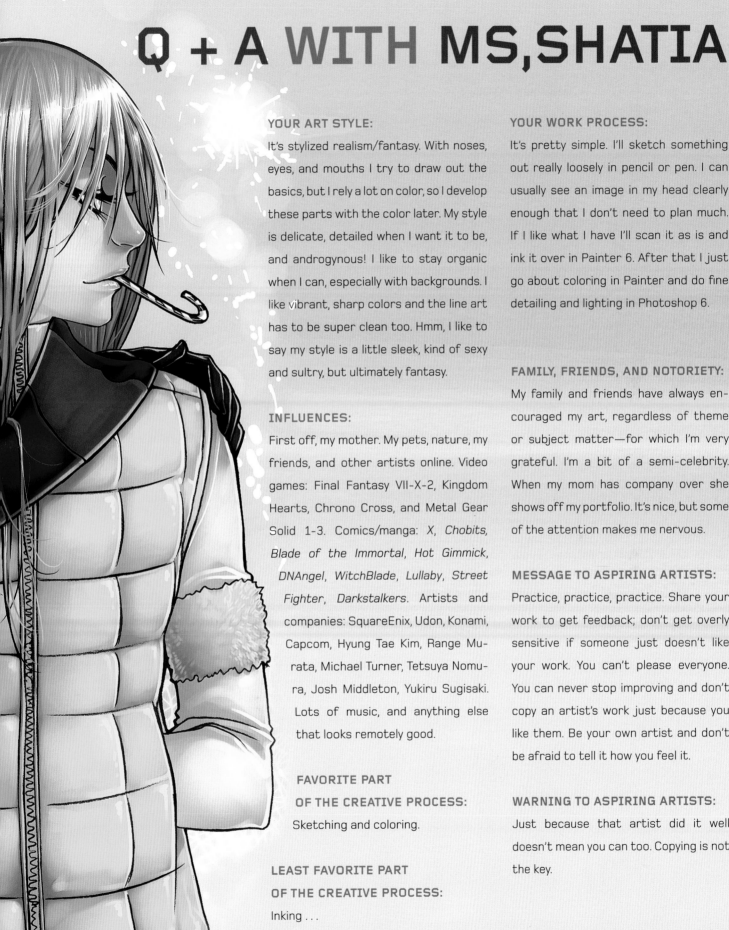

Q + A WITH MS, SHATIA

YOUR ART STYLE:

It's stylized realism/fantasy. With noses, eyes, and mouths I try to draw out the basics, but I rely a lot on color, so I develop these parts with the color later. My style is delicate, detailed when I want it to be, and androgynous! I like to stay organic when I can, especially with backgrounds. I like vibrant, sharp colors and the line art has to be super clean too. Hmm, I like to say my style is a little sleek, kind of sexy and sultry, but ultimately fantasy.

INFLUENCES:

First off, my mother. My pets, nature, my friends, and other artists online. Video games: Final Fantasy VII-X-2, Kingdom Hearts, Chrono Cross, and Metal Gear Solid 1-3. Comics/manga: *X*, *Chobits*, *Blade of the Immortal*, *Hot Gimmick*, *DNAngel*, *WitchBlade*, *Lullaby*, *Street Fighter*, *Darkstalkers*. Artists and companies: SquareEnix, Udon, Konami, Capcom, Hyung Tae Kim, Range Murata, Michael Turner, Tetsuya Nomura, Josh Middleton, Yukiru Sugisaki. Lots of music, and anything else that looks remotely good.

FAVORITE PART
OF THE CREATIVE PROCESS:

Sketching and coloring.

LEAST FAVORITE PART
OF THE CREATIVE PROCESS:

Inking . . .

YOUR WORK PROCESS:

It's pretty simple. I'll sketch something out really loosely in pencil or pen. I can usually see an image in my head clearly enough that I don't need to plan much. If I like what I have I'll scan it as is and ink it over in Painter 6. After that I just go about coloring in Painter and do fine detailing and lighting in Photoshop 6.

FAMILY, FRIENDS, AND NOTORIETY:

My family and friends have always encouraged my art, regardless of theme or subject matter—for which I'm very grateful. I'm a bit of a semi-celebrity. When my mom has company over she shows off my portfolio. It's nice, but some of the attention makes me nervous.

MESSAGE TO ASPIRING ARTISTS:

Practice, practice, practice. Share your work to get feedback; don't get overly sensitive if someone just doesn't like your work. You can't please everyone. You can never stop improving and don't copy an artist's work just because you like them. Be your own artist and don't be afraid to tell it how you feel it.

WARNING TO ASPIRING ARTISTS:

Just because that artist did it well doesn't mean you can too. Copying is not the key.

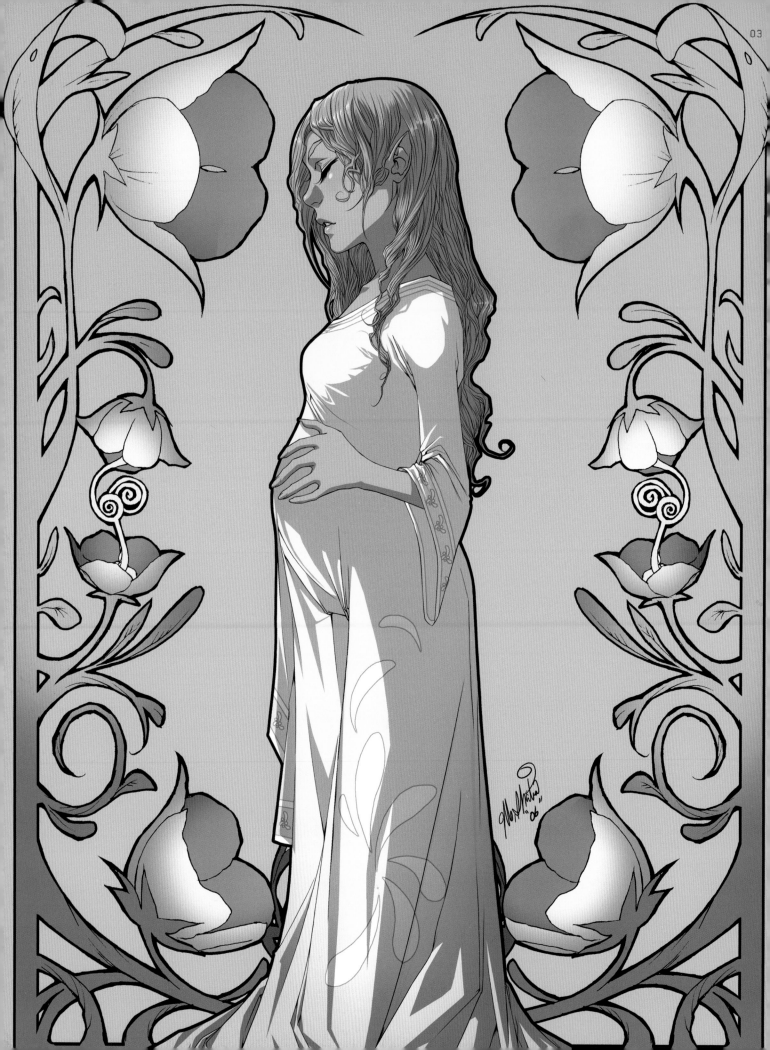

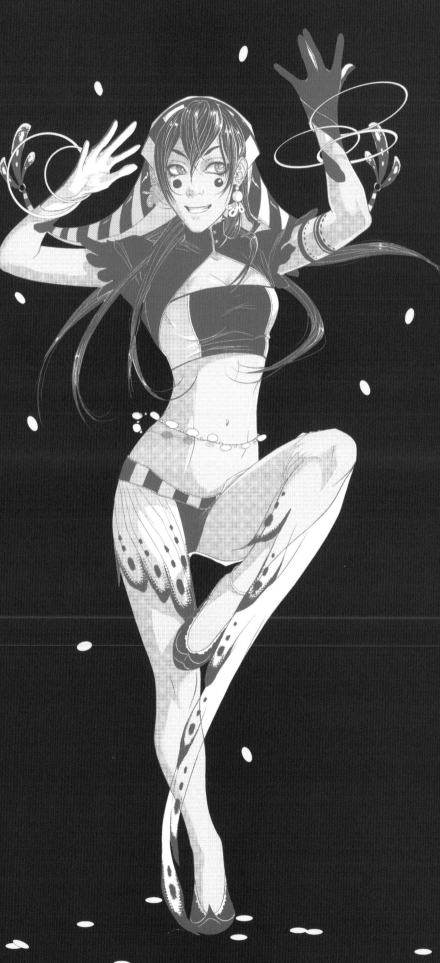

Q + A CONTINUED

SUGGEST MANGA TO A NEWCOMER:
DNAngel. Really sweet story.

GUNDAMS OR EVAS?
Both! But Evas are sexier.

YOUR COMIC SHOP:
Borders or the comic shops Big Brain
and Shinders in downtown Minneapolis.

FAVORITE MANGA:
DNAngel. I read this on a daily basis dur-
ing breaks.

NOCTURNAL OR EARLY BIRD?
Absolute vampire. I'm amazed I made it
through school with the way I function.

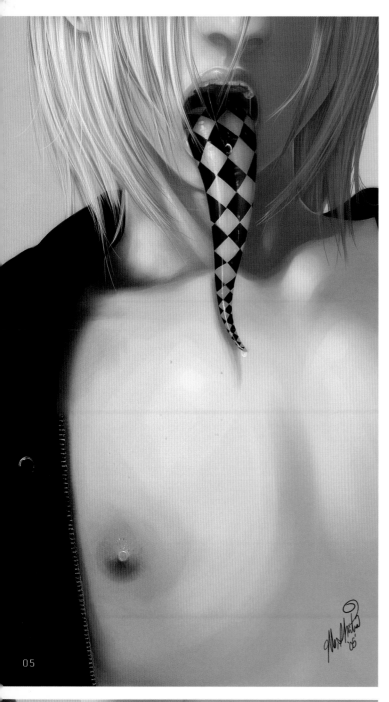

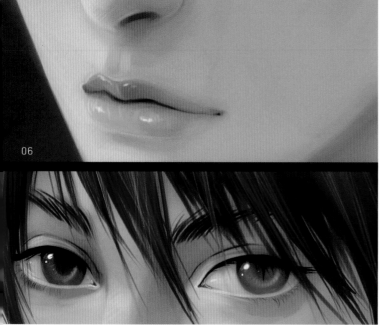

Q + A CONTINUED

KILLER MECHS OR CHIBIS?

Kawaii chibi characters piloting the killer mechs! No, seriously, killer mechs.

DESCRIBE A CON EXPERIENCE:

Hmm, well there was this one time . . . Oh wait . . . that was a manga I read. Something about Drama and Yatta Con. I wish that had been me. I've sadly never been to a con.

ARE YOU AN OTAKU?

When it comes to Final Fantasy, yes. I wear my *otaku*-ness proudly thank you.

YOUR CATCHPHRASE:

Don't talk about it, be about it.

YOUR HAIKU:

A story weaver,
a day dreamer's open-eyed
imagination.

GOAL FOR THE FUTURE:

For my comic *Fungus Grotto* to still be running strong and have at least three other titles under my belt.

EXTRA:

It's hard to use my tablet with my cat sitting in my lap . . . Having a Web site and maintaining one are two entirely different things. I need to update badly.

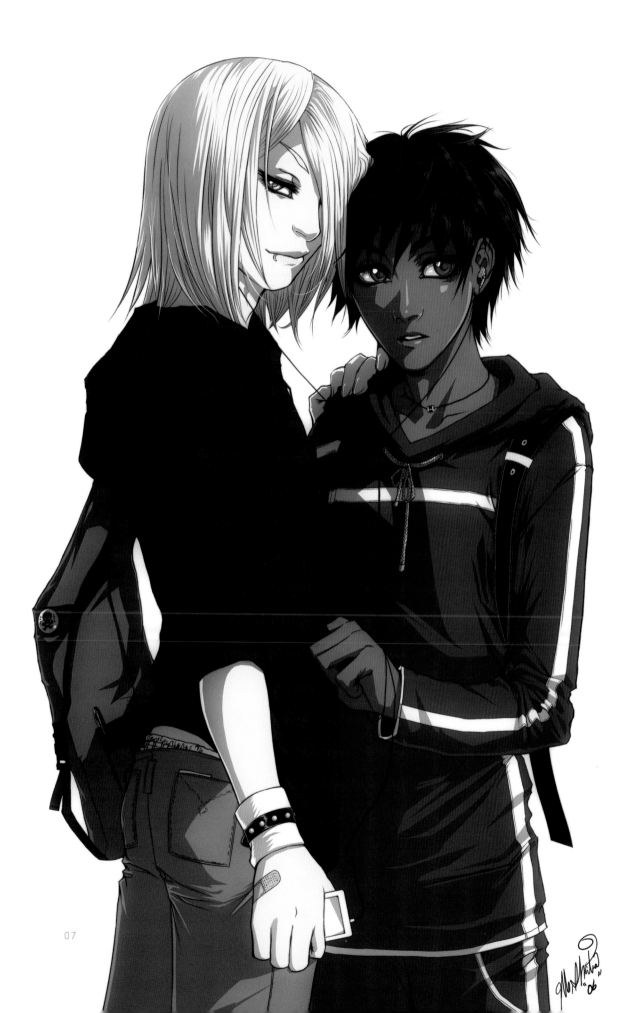

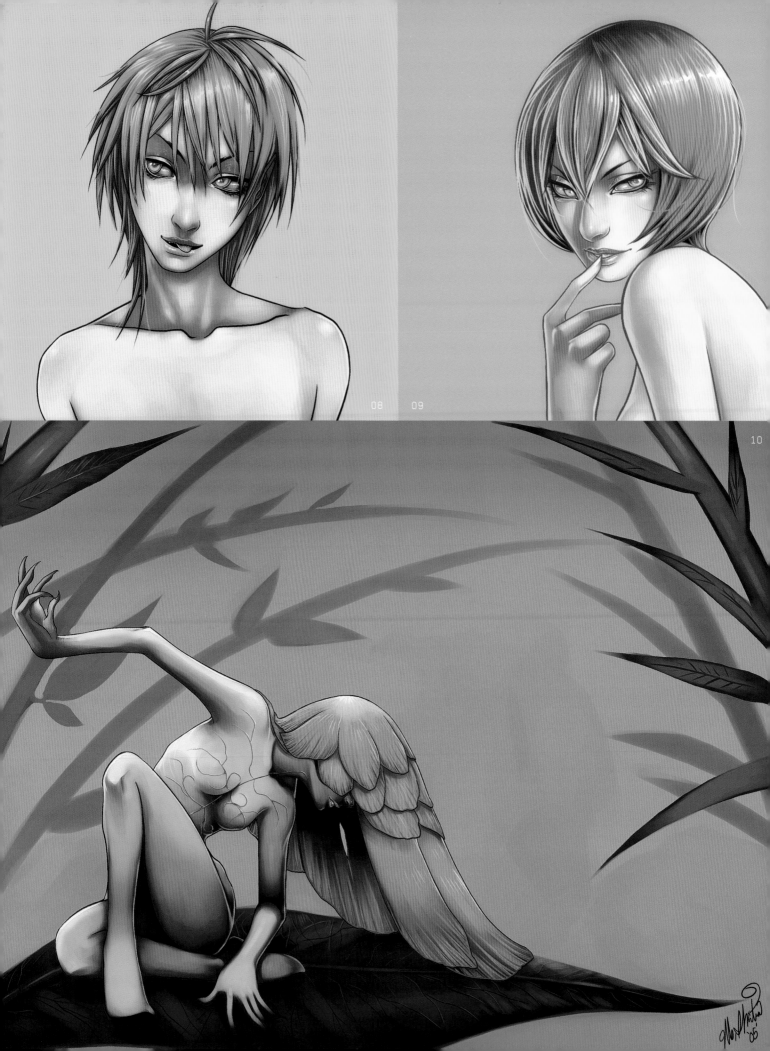

PAINTING DIGITALLY
TUTORIAL

BY MS,SHATIA HAMILTON

DIGITAL PAINTING has become the new paintbrush and acrylics of the advancing digital era, and is slowly building a reputation as its own art form. It saves artists the mess associated with traditional painting, but can be costly. Painter and a tablet are a big investment. Digital painting is also time consuming and tedious, and requires patience or you won't improve.

The nice thing about it is that you can do thousands of things—at the click or stroke of your stylus—that would probably take days, or be impossible altogether, with real paint. It's also possible to take your traditionally painted work into Painter and enhance it! The best of both worlds.

I'm not a computer graphics expert, but here are a few steps I take and methods I use when working in Painter. Oh, as a starting note, save often as you work. Spare yourself lots of stress and tears.

INTRODUCTIONS: GETTING STARTED IN PAINTER

 I scanned in some line art I drew in pencil at 600 dpi and cleaned it up in Painter using the Scratch Board tool. I can do lots of really small details at this resolution and fix errors in the lines. I also added color to the lines.

In Painter the bottom default layer is called the Canvas. It works like a wet layer and it's the only layer you can use the Simple Water brush on when the Method is set to wet. I only paint on this layer and use the Simple Water brush.

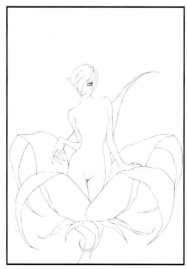

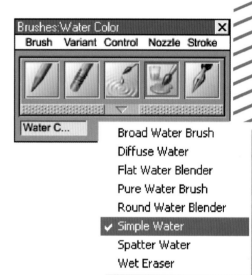

To use wet paint, go to the Brush Controls menu, under General, and change the Method to wet. To paint on any layer, go to Method and pick Cover.

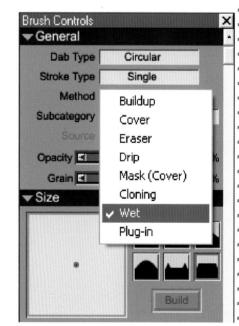

PREVIOUS PAGE: 08. MMM, TROPICAL · 09. PINK N SASSY · 10. DAHLZ DANCE

What affects the way colors blend, besides the pressure you paint with, is Bleed, Resat, and Dryout in the Well menu and Opacity on the General menu. These settings vary for me and can be used with Method set to Cover as well. Play around with them.

SETTING THE STAGE: COLORS, LIGHTS, AND SHADOWS

This creature is one I created. They're called Dahlz (pronounced like dolls) and they're basically flowers with human physiques. So she'll be green with another color for her hair.

To help pick a color palette, think of a mood/setting early on. Mine was outside in the grass: it's semidark, it has rained, and the sun is coming back out from behind the clouds. With that in mind I picked the base colors and tried mixing light or dark shades of the base color, or its complementary color, to get highlights and shading colors. This isn't something I have to decide on now though.

Finding good colors is a gradual process as I paint and I play around with various shades until I like what I see.

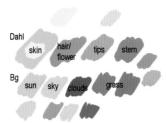

Here, I've laid down a rough background. I used the sky, sun, clouds, and grass colors. I used loose quick circular and straight strokes with a big hard-edged brush and the Opacity was set to 100 percent. I'm using the Simple Water brush and I'm not trying to define anything yet.

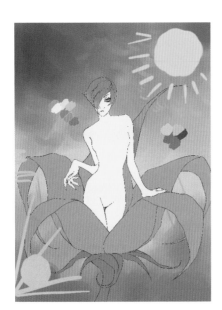

Now I have an idea of where the light source will come from. I always pick a light source before I start doing any real coloring. I chose the top left, our right, for the main light source, and the bottom right, our left, as the secondary backlight source.

I can start coloring the figure now. I'm going to take you through the process of coloring her face.

01

I took a purple/blue-gray color and loosely laid down a dark area with a big brush. I tried to paint with a circular motion and I work from dark to light because it's easier to pull light areas out that way. No defining, just loose painting. I'm not completely certain how soft plant skin is. So I tried to think of soft plastic and I decided to keep the shadows fairly hard edged. The Opacity is at 80 percent.

02

This is all rough and the shading is flat. I'm undecided on where the shadows will fall right now.

03

I always paint a circle to find the tip of her nose. This will help me define it later. For her lips I'm going to try and make them look like they're puckered. A lot of these first steps act like placements for things I'll define later.

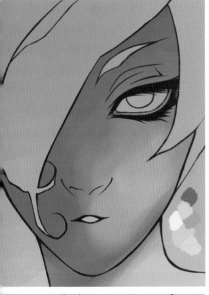

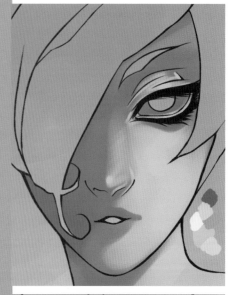

04 I spend a lot of time on the nose. I paint it out by crosshatching the colors. This again is a gradual process and I had to redo the shading a few times before I liked it. I'm still only using two colors. I try to rely on using different levels of pressure as I paint to determine how dark or light the color will be so I can avoid having to pick new shades of green.

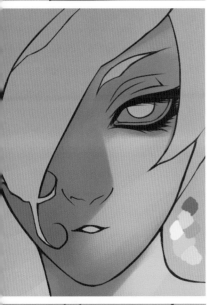

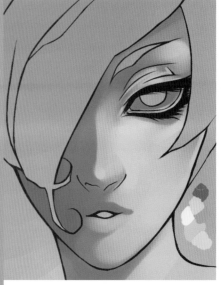

05 I tried to bring out her eyelid, that crease and fold of skin where her eye curves into her nose, the bridge of her nose, and her chin, since these are her most striking features. This was all done using a large brush for the big areas and a medium brush for the tighter areas. I avoid using small fine brushes until the end and instead zoom in really close to paint small areas. This keeps the color even and I don't have to focus so much on keeping light pressure on my tablet pen.

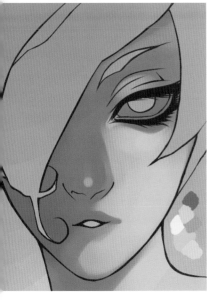

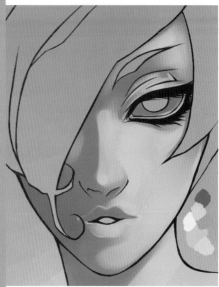

06 I got those puckered lips I wanted. I just painted simple lines to define her upper lip and lower lip with a small flat brush. I felt my own lips to figure out how to get this look.

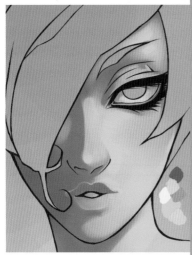

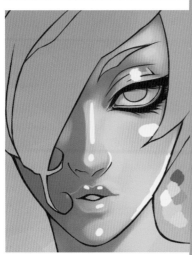

07 I painted in the white of her eye. This area will reflect whatever color is closest to it. I took the base skin color and mixed it with a pale yellow, then dabbed the same purple/blue-gray I used for shading her skin across the top for the shadow. I'm assuming she's got blood in her veins, as well, and added some pink to her cheek, lips, nose, and upper eyelid. It's not makeup, so I was really light with it and used a big brush with the Opacity set to 45 percent.

08 I've kept the light source in mind while shading. Shadows fall opposite the light, so highlights cast in areas closest to it. Rounded areas are affected by this the most. Her cheek, eye, nose, lips, chin, eyelid, and the side of her face will catch the most light. She's still got a plastic-like skin texture, so the lights will be fairly hard on her skin. I used a pale yellow color for the highlights.

09 Considering the background will be green and that she's in the grass, I need a way to make her stand out from this setting, but not clash with it. I chose hot pink for the backlight, which is to her right. Secondary lighting shouldn't overpower the main light. Here's a rough idea of where that light will fall.

10 Here's what she looks like with the highlights and backlight refined. Everything came together very nicely.

11 I went back and painted all of the other parts of the picture and added sunlight and water droplets to her face. I do all of this stuff on a new layer just in case I mess up. Things like color adjustments and other small details come last, and can be almost as time consuming as coloring the picture to begin with. It's these little details that can make or break a piece though.

There you have it. One of the biggest things you need to keep in mind when using computer graphics is that it's OK to play around. Things don't have to make sense; colors don't have to coordinate or blend. It's all up to you, so have fun with it.

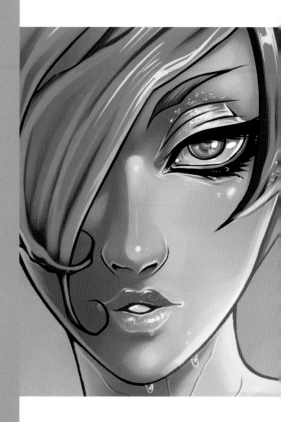

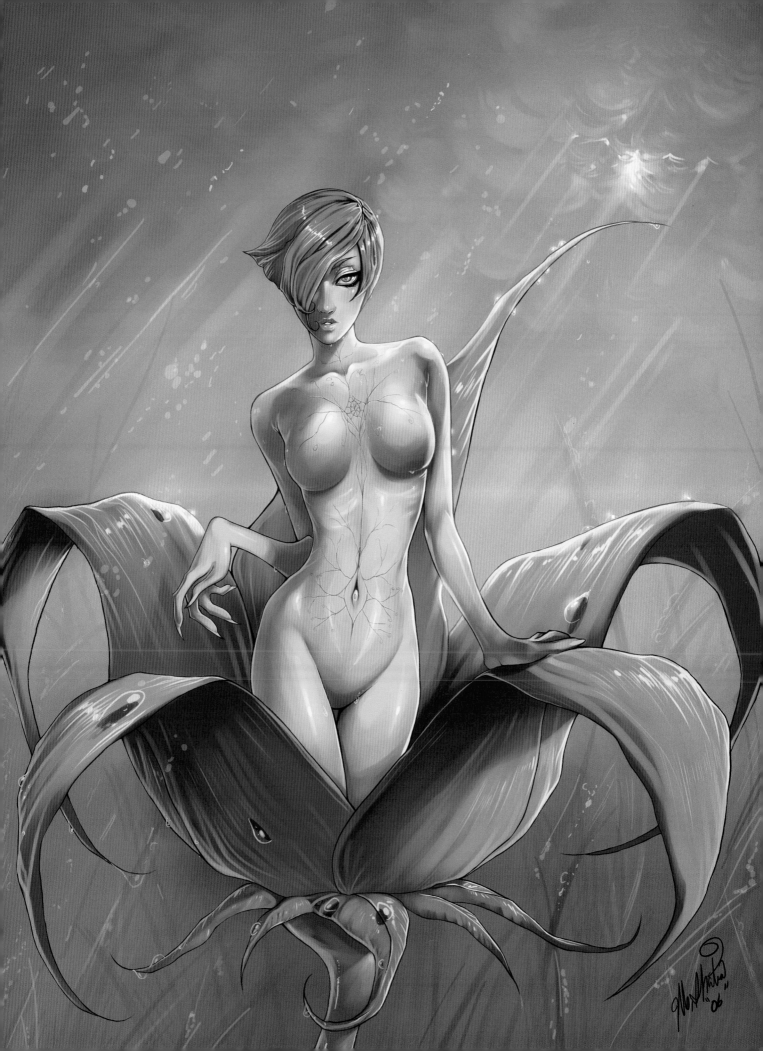

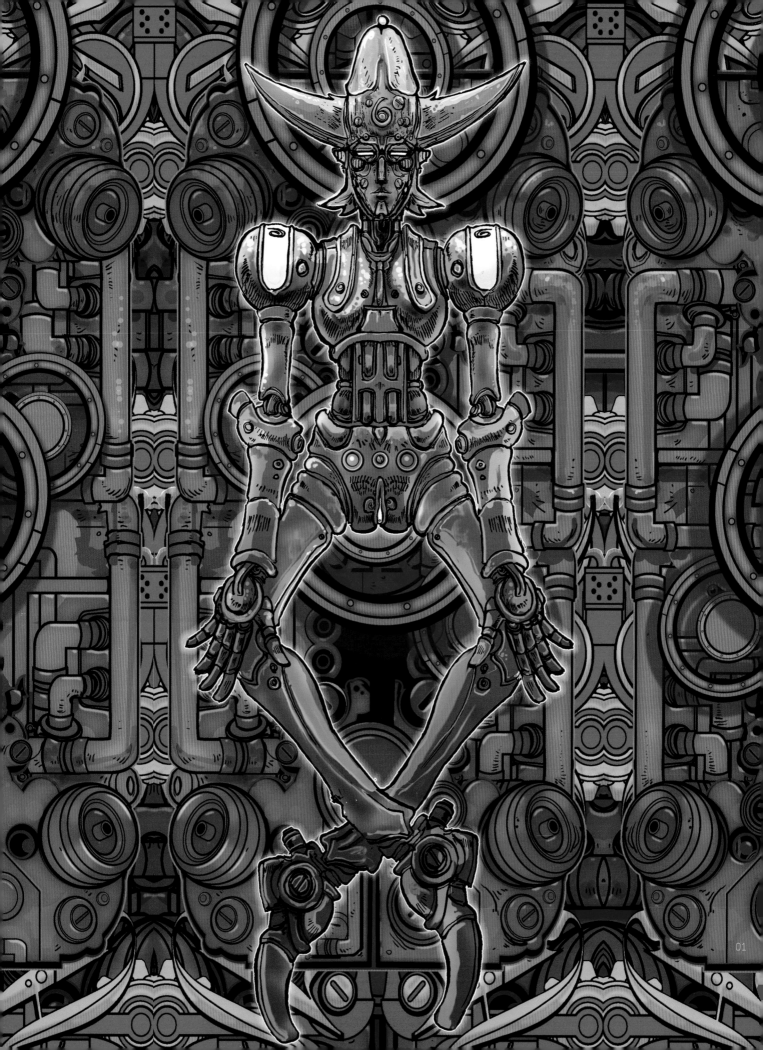

02

JESSE PHILIPS

03

JESSE HENDRICKSON PHILIPS

was born on June 27, 1979, and currently resides in Albuquerque, NM. During his junior year of high school, he went on a summer exchange to Osaka, Japan. Years later, he returned to Osaka for his junior year of college and attended the Sozosha College of Art and Design. In 2002, he graduated from the Minneapolis College of Art and Design with a degree in comics/illustration. His previous and current work has largely consisted of projects relating to the music industry. The music projects, posters, shirts, etc. have allowed Jesse to combine his graphic design and illustration skills with his love for manga and Japanese art. More of his work can be seen at

www.jessephilips.com

www.gigposters.com/designers.php?designer=44950.

01. UNTITLED · 02. ZANI · 03. UISUKI

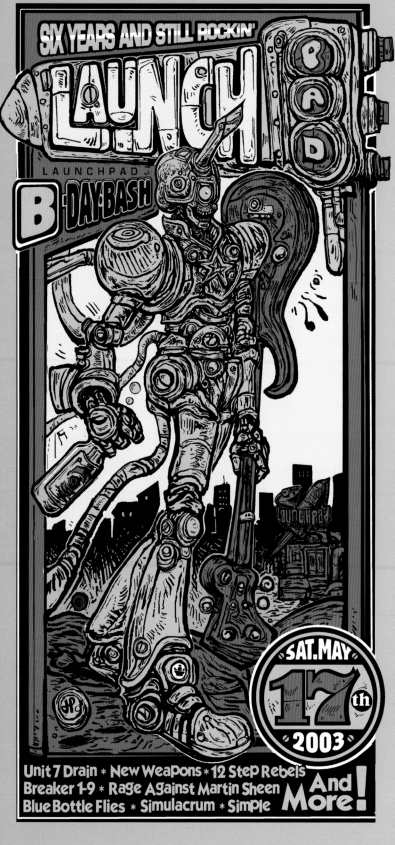

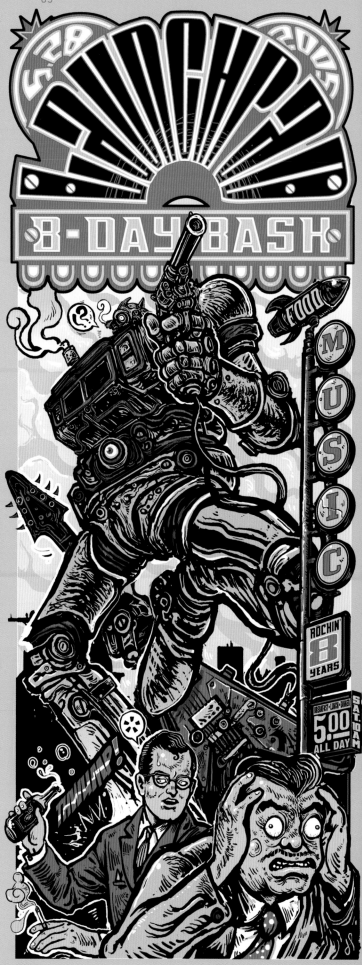

Q + A WITH JESSE

YOUR ART STYLE:

Organic/industrial/electric.

YOUR INFLUENCES:

1970s and early 1980s giant robots, Hirohiko Araki, Moebius, Go Nagai, Katsuya Terada, Bill Sienkiewicz, Tetsuo Hara, Simon Bisley, Yasushi Nirasawa, graffiti, old sign painting, *pachinko* graphics, and video game concept art and design.

SELF-TAUGHT?

While I did graduate from art school most of my specific skills and techniques were developed on my own. School taught me how I could learn programs, methods, and techniques, and apply them to my work.

YOUR WORK PROCESS:

I have found that creating my art digitally gives me the most freedom and versatility. It allows me to keep my work fresh, as I can avoid the redundancy of tracing over pencil marks. I often don't even do a preliminary sketch on paper; I prefer to have a loose idea in my mind, and then jump right into the final piece, tweaking and composing as I go in Photoshop. That being said, I still doodle and sketch on paper quite often.

PREFERRED PENCIL:

I rarely pencil; even when I sketch, I prefer a ballpoint pen over pencil. But when I do pencil I like the ol' #2 pencil because my heavy hand tends to snap the lead in the mechanical variety.

PREFERRED INK:

While tricky to use, I used to love inking with my G-pen nib and a brush. However I have found that my Wacom tablet can produce comparable line variation and is much less of a hassle for this sloppy fellow to operate.

SOFTWARE YOU USE:

Adobe Photoshop and Adobe Illustrator are my primary tools.

FAMILY, FRIENDS, AND NOTORIETY:

I am lucky. My family has always been very supportive of my art even though they often don't understand or even like it. My personal work is definitely not their thing but they often like the work I do for other clients. Most of my friends like my art quite a bit and offer plenty of encouragement. Not much of a surprise I suppose, as almost all of my close friends are creative artists or musicians of some sort. Of course it would be nice if more of them wanted to plunk down some cash on my posters. ;)

FIRST MANGA/ANIME:

My first real encounter with manga can be traced back to a trip with my parents to Japan when I was around eight years old. While traversing the streets of Tokyo I happened upon a discarded comic book lying on the ground. It was just about the most magnificent thing I had ever seen. I grew up reading standard superhero comics so the contrast of the giant black-and-white tome filled with superbly illustrated scenes of violent action and eroticism overwhelmed my impressionable senses. I was instantly hooked and proceeded to grab up all the discarded manga I could find throughout the course of the weeklong trip. By the end of the journey my mother made me painfully select only a couple of books from the volumes of comics I had gathered along the way. While that initial exposure certainly left an impression on me, after a couple of years had passed with no new manga to keep my interest piqued I gravitated back toward comics and cartoons of the domestic variety. That is, until one night when my mother saw a film blurb in the local paper about a movie based on a Japanese comic book. I immediately talked my father into taking me to the movie. The movie was called *Akira* and, needless to say, from that point on I was entirely infatuated with any and all Japanese pop culture I could get my hands on.

> "I CAN'T EVEN BEGIN TO COUNT MY MANGA COLLECTION, THE BULK OF WHICH I PICKED UP ON TRIPS TO JAPAN. I ENDED UP HAVING TO SHIP LARGE BOXES HOME VIA CARGO SHIP. "

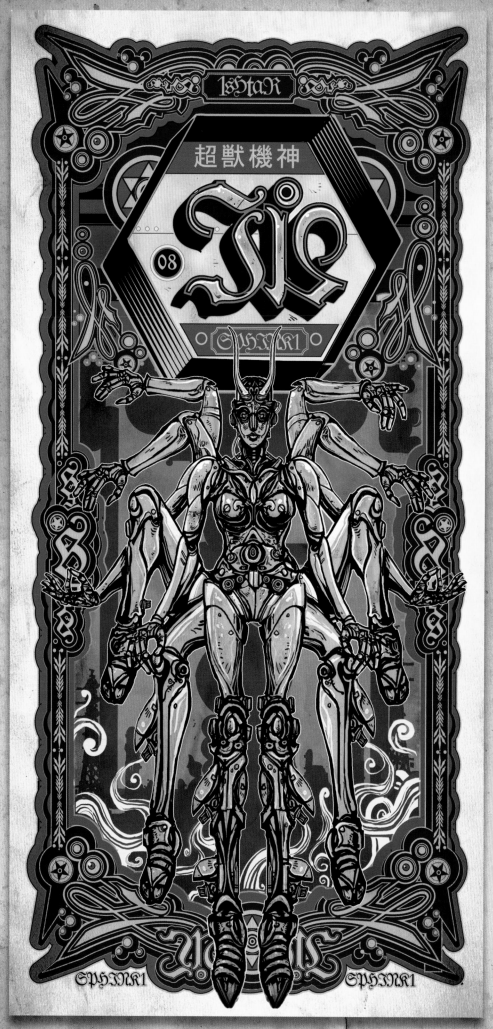

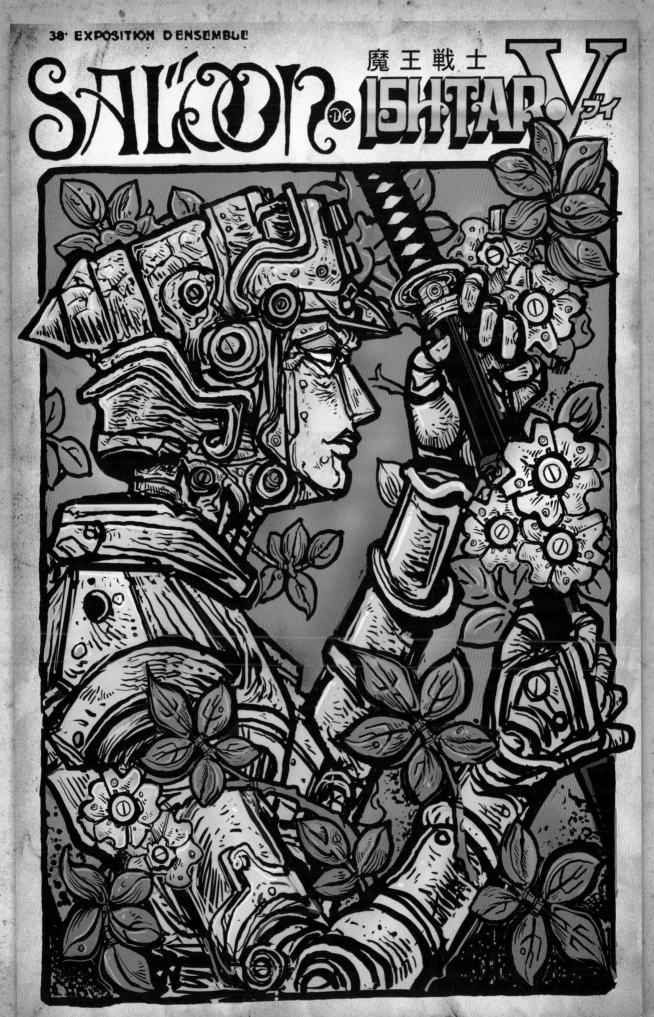

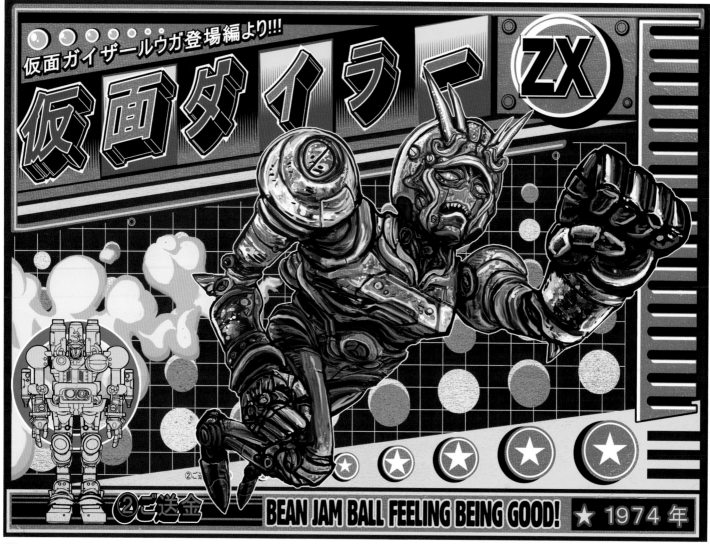

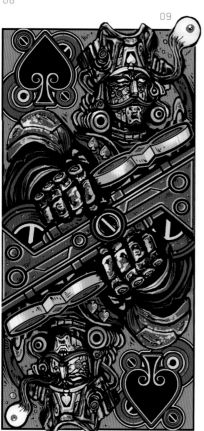

YOUR MANGA COLLECTION:

I can't even begin to count my manga collection, the bulk of which I picked up on trips to Japan. I ended up having to ship large boxes home via cargo ship.

YOUR HOBBIES:

Video games, retro and contemporary. I'm particularly fond of 2-D fighting games like Street Fighter II. Also, I have a large collection of toy robots from the late 1970s up until today that I still add to regularly. I also like bar hopping/billiards, creating/sampling music, singing/free styling, and plastic model kits (robots, of course).

GUNDAMS OR EVAS?

I am a robophile so I couldn't really explain my answer without going into a long dissertation. I certainly enjoy both series.

08. BEAN JAM BALL · 09. JACK OF SPADES

NEXT PAGE: 10. TSUNAMI TATTOO · 11-12. MUSIC PROMO POSTERS

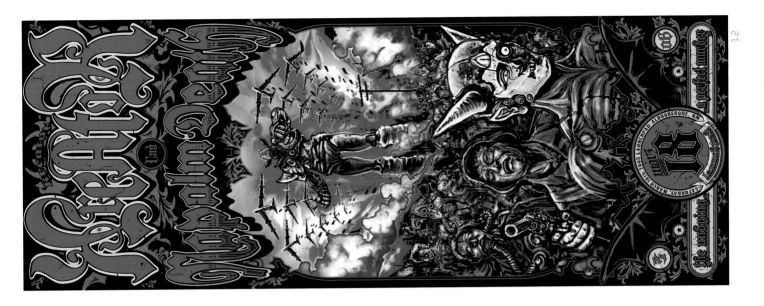

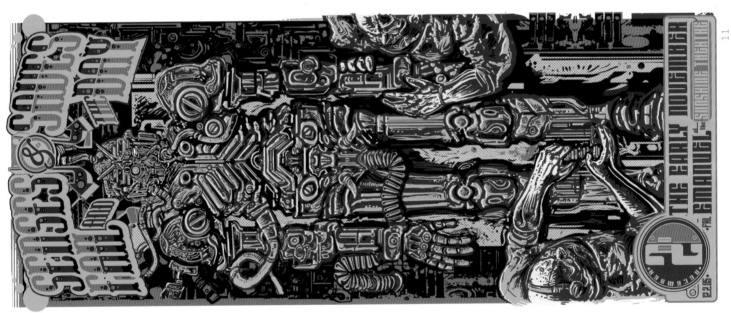

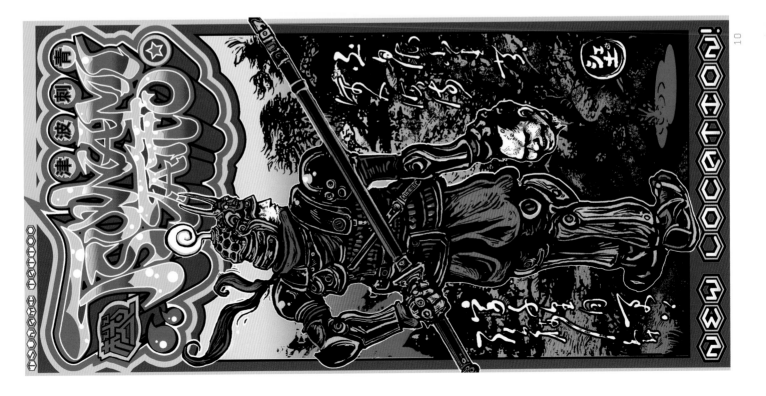

MECH DESIGN
TUTORIAL

BY JESSE PHILIPS

For this tutorial I will demonstrate some of the processes I use to draw and design robots. Through showing a few steps I use and some simple tips I hope to offer some insight into how to create your own original robot designs. An enormous array of science fiction robot designs have been produced over the last 100 years. One could compare the design cycle of robots to that of the automobile. Each decade sees certain stylistic trends that impact a wide variety of design types. Once you decide what type of robot will fit your project best, you should be ready to begin.

Once I have a loose image or theme in my head I sit down and draw some small quick thumbnail sketches. **(01)** Here I am trying to get the basic shapes down and show a variety of sizes and types while maintaining a somewhat consistent style.

01

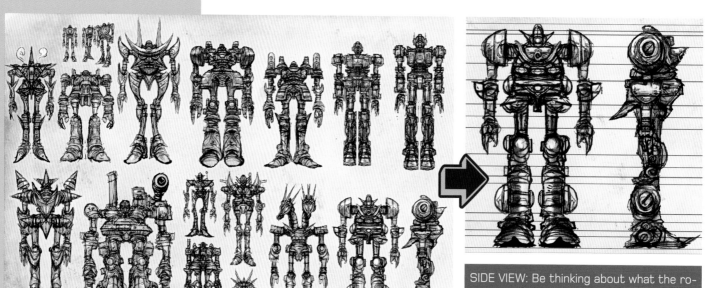

SIDE VIEW: Be thinking about what the robot looks like from every angle. Drawing horizontal guidelines helps build the side and back view from the frontal sketch.

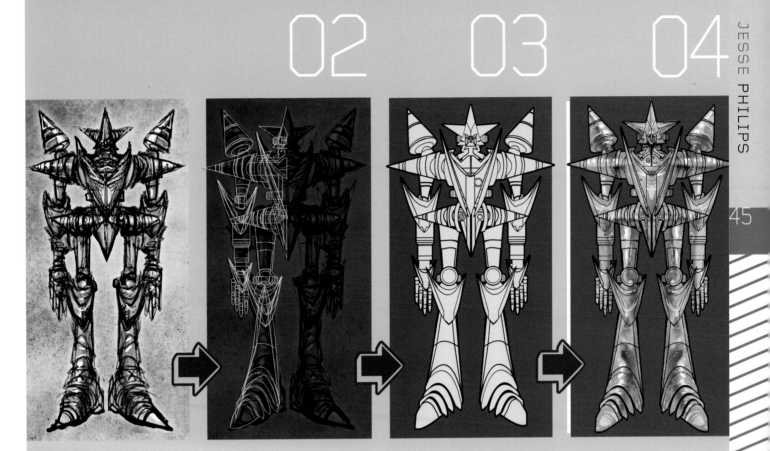

When creating parts getting inspiration from existing industrial equipment can give your designs a more realistic feel. Actual machinery like construction equipment, factory assembly lines, or even train yards can be great references for parts, color, texture, and movement when designing mechs. Once I have a few designs that I am happy with, I scan the sketches into the computer and clean them up a bit. I start by erasing stray lines, swapping parts, and making the designs symmetrical. It is important to try and make all the parts on the robot flow together and work as a cohesive design. Once I am happy with the rough, I take it into Illustrator to convert it into a vector object. **(02)** Using Basic Shapes and the pen tool I trace the left side of the design, mirror it, and join some common parts together. **(03)** Then I import the vector file back into Photoshop for a little touch-up and to apply some shading. **(04)** The design is now ready to be colored, but more on that later

05

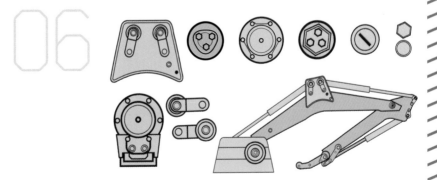

06

JINDAN-6

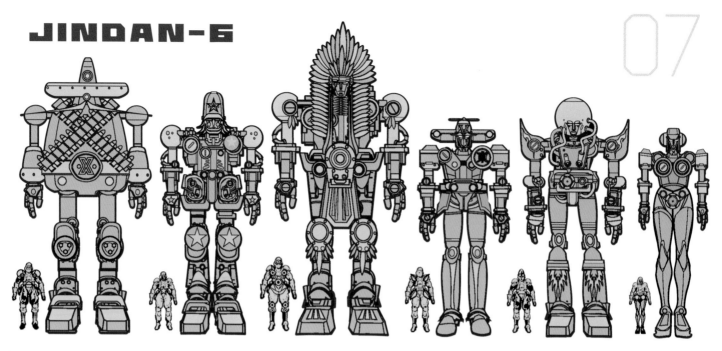

(05) I traced some sections of the photos to make some basic parts. **(06)** I incorporated some of the parts into the following ro-bots. **(07)** One advantage to creating the designs as vector objects is the ability to mix and match parts. The separate parts allow me to easily create variations, as well as groups that share common parts.

COLOR

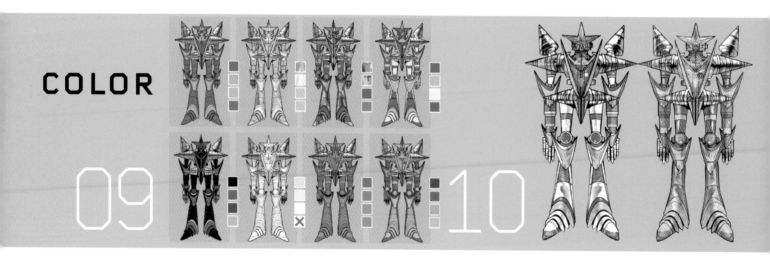

When it comes time to place the robot in a fully realized scene, having a completed schematic will be a great help. **(11)** The foundation for this illustration was created by manipulating the existing color template in Photoshop.

Finally, no robot can be complete without a stylized logo. The classic robot anime logo usually consists of a prefix describing attributes, features, or powers specific to the series. This is followed by the main logo type, often the robot's name, rendered with illustrative flair and dramatically angled text. So there is a simple overview of some of the things to consider when designing a robot. Designing even fictional robots can be very complicated; entire books are dedicated to the subject. While robot books can be inspirational and informative, the most important thing to have when designing a robot is a solid knowledge of tradi-tional art and design.

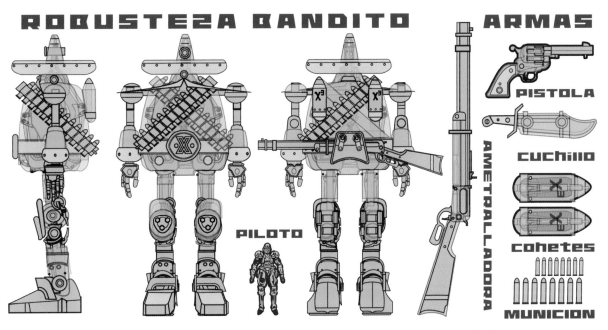

ROBUSTEZA BANDITO

ARMAS

PISTOLA

CUCHILLO

PILOTO

AMETRALLADORA

COHETES

MUNICION

Once you have a design finalized you can build a more detailed schematic for production. **(08)** Again, guidelines and copying parts help to expedite the process.

Color is an integral part of robot design and can greatly impact how a robot is perceived. I duplicated the vectorized robot and applied various color patterns to the images. **(09)** Each affects the robot differently. The color scheme is often used to designate what role the robot plays in a series. For instance heroic, protagonist robots are traditionally colored with bright primary colors and plenty of white, while villain robots are often colored dark blues, purples, greens, and blacks. The more realistic combat mechs tend to have earth-toned or camouflage paint jobs. When deciding on a color scheme it is important to have a color balance spread throughout the parts of the robot. A basic palette could include one or two main colors for large areas, coupled with two or three detail colors. I find it best to do the initial coloring in Illustrator because it is easier to select color. Once a color scheme has been finalized I drop the flat Illustrator colors into the monochrome .psd file I made earlier **(04)** for some quick shading **(10)**.

魔王戦士 ISHTAR-V

MAOH SENSHI ISHTAR-V

RE:
CREATOR OF
PLAY
AND
NEXT EXIT

CHRISTY LIJEW

CHRISTY LIJEWSKI, born January 13, 1981, resides in Baltimore, MD, with Totchi, a very spoiled Norwegian Forest cat. She received a BFA in sequential art from the Savannah College of Art & Design and went on to create *Zombie King*, an original series that was part of the *AmeriManga Anthology* from I.C. Entertainment. She was also a finalist in TOKYOPOP's *Rising Stars of Manga™*, volume three, with her entry, "Doors."

Currently, Christy is the writer and artist of the ongoing comic series for Slave Labor Graphics' *Next Exit*. She is also working on *RE:Play*, a graphic novel series published by TOKYOPOP. In addition to her regular comics work, Christy also works on the English script adaptation for various Mihara Mitsukaz works and is the head of a *doujinshi* circle, Circle Marchen, a collective of artists from North America, Europe, and Asia. More of her work can be seen at http://nyanko-chan.deviantart.com.

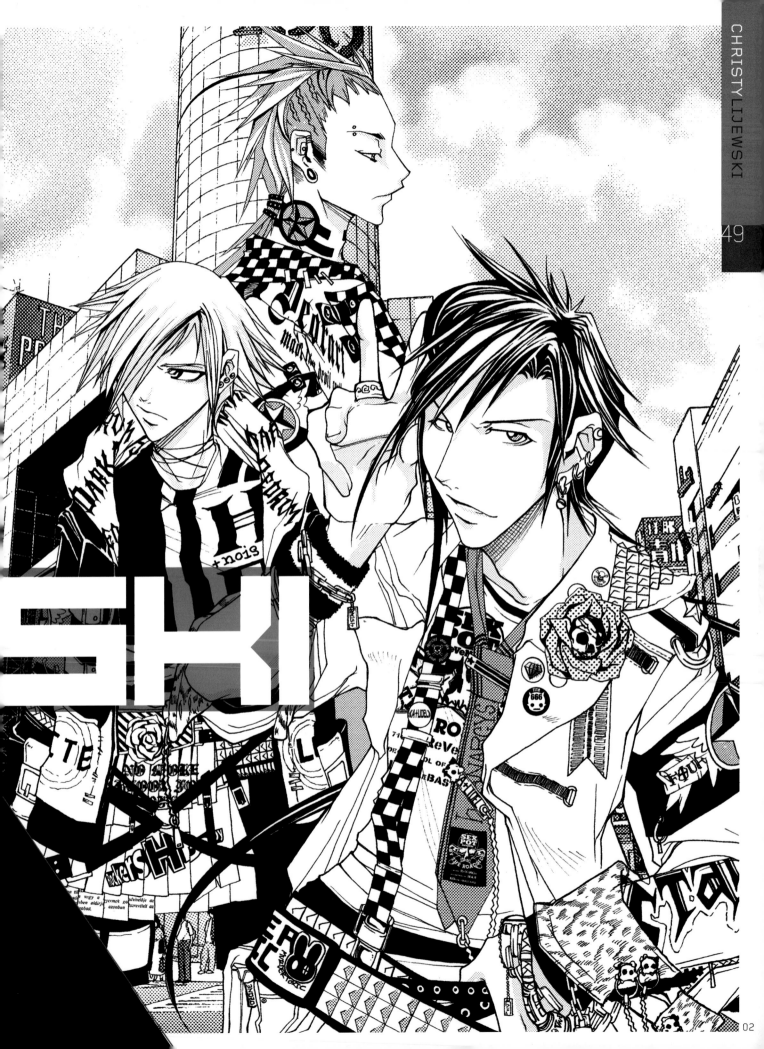

記憶の世界へ…

空海水泳

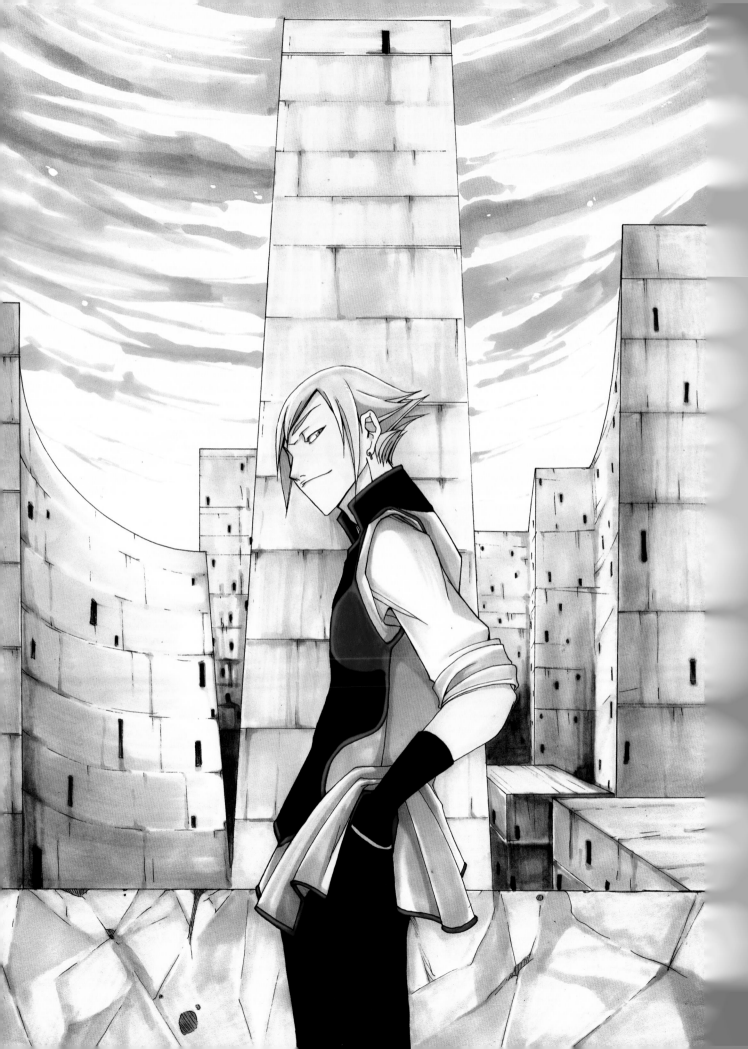

Q + A WITH CHRISTY

YOUR ART STYLE:

More than any one style or genre, my art is a mix of manga and American comics, as well as *shounen* and *shoujo*. I like clean lines and solid spot blacks in my black and white work, and very vivid and lively colors in my color work. If I have a choice I'll stick to analog media before digital, but I hesitate to consider myself a "traditional" artist as I'm just as comfortable working on the computer for colors as I am by hand.

ARTISTIC DUTIES:

I write, pencil, and ink my own work. For past works I've been responsible for doing my own screen tones as well, but right now I have a tone assistant who does the tones for me on my two main comics.

YOUR WORK SCHEDULE:

When I'm working on a deadline I'm pretty much nocturnal. I work better at night so I tend to try to work through the night and crash the next morning. I'm just more productive when the only thing to distract me is infomercials for miracle creams and reruns of old dramas on TV. I don't have a set number of hours I work in a day but I try to make sure I get at least two completed pages done a day, so I average about 14 or so a week.

YOUR MANGA COLLECTION:

Oh good Lord. I'm a bibliophile of the comics sort so bad. Rough guesstimate would be somewhere near 600 manga in my collection!

SUGGEST A MANGA TO A NEWCOMER:

Bleach by Kubo Tite. No one I know who's read it has disliked it.

YOUR HOBBIES:

I'm a clotheshorse: I love making them, designing them, and studying my favorite designers. I'm also a hopeless video game addict and whenever I get a little time off from work I try to sit down with a new game, mainly RPGs. I love music and, sadly, my bibliophile tendencies are actually exceeded by my music-lover tendencies. I seriously don't go anywhere without my iPod.

I also love traveling, when time permits, and concert-going, so those are my two big-ticket hobbies. I try to take one big trip per year. Usually it seems I end up back in Tokyo as I adore that city!

GUNDAMS OR EVAS?

Pssht, neither! Gears! I can't be the only Xenogears fan out there—can I?

YOUR FUEL:

Teas! Many, many kinds of teas! I'm constantly drinking tea, though I try to avoid caffeinated teas as too much caffeine will make my hands shaky. One of my characters is actually named after a tea, heh. And music. As long as I have music to (badly) sing along to, I can keep on working.

KILLER MECHS OR CHIBIS?

Killer mechs all the way. There's no contest there.

DESCRIBE A CON EXPERIENCE:

Let me preface this by saying, yes, I cosplay, I'm a geek, I know it, and now let us move on. During Anime Expo 2002, I was standing in the elevator in a costume (Lulu from *Final Fantasy X*) when Watsuki Nobuhiro and his translator walked in. Watsuki-sensei is the manga creator of *Rurouni Kenshin* and is one of my biggest inspirations ever, so I just froze and tried not to start gushing about how much I adored his work.

A few seconds into the ride I noticed that he kept looking over at me and I panicked, thinking: "Here I am with one of my biggest artistic idols and I'm dressed like a freakin' video game character." During my inner lament he turns to his translator and makes a comment about my eyes, as I had red contacts in. He must have assumed I didn't speak Japanese because when I answered him, and assured him that they were in fact contacts and that I didn't have some weird eye disease, he just started apologizing profusely. Of course it was obvious that we were now best friends for life (in my head). So I started talking to him and told him I was a comic artist and that I was a huge fan of his work. And while the conversation was awesome, and I'm still grateful I got to speak with him, the best part of the conversation was between his translator and himself regarding American comic artists:

Translator: "American comic artists are much bolder than Japanese artists, don't you think?"

Watsuki-sensei: "Aah . . . yeah."

Are we really?

CONTINUED ON PAGE 56

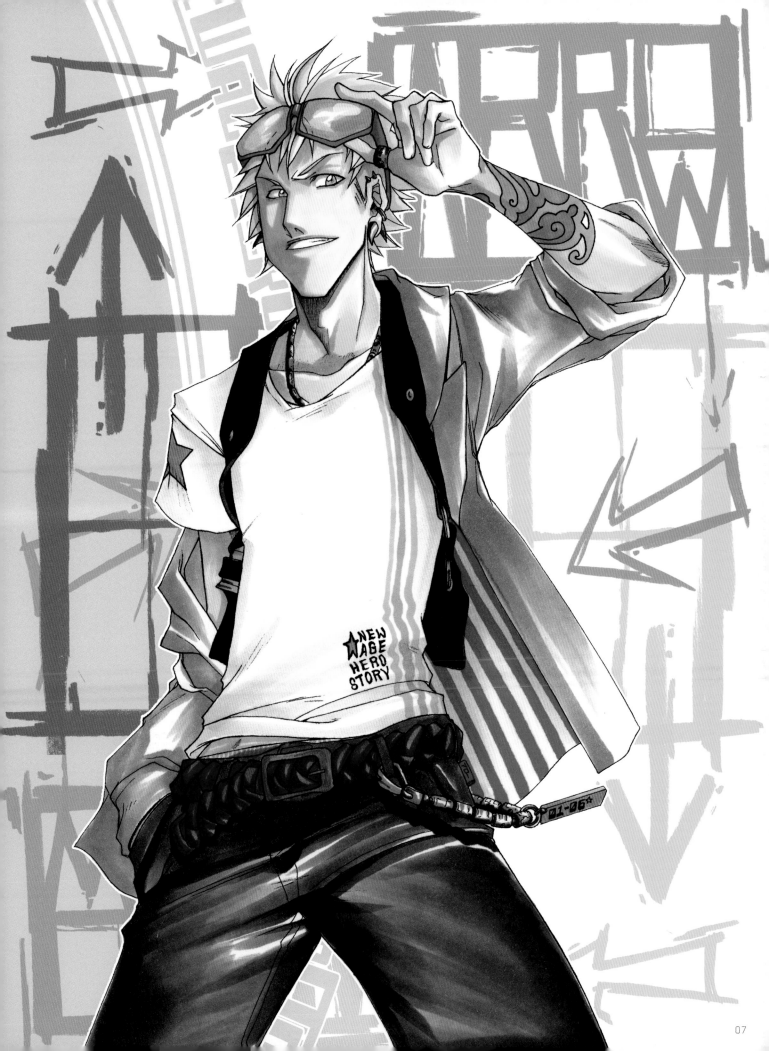

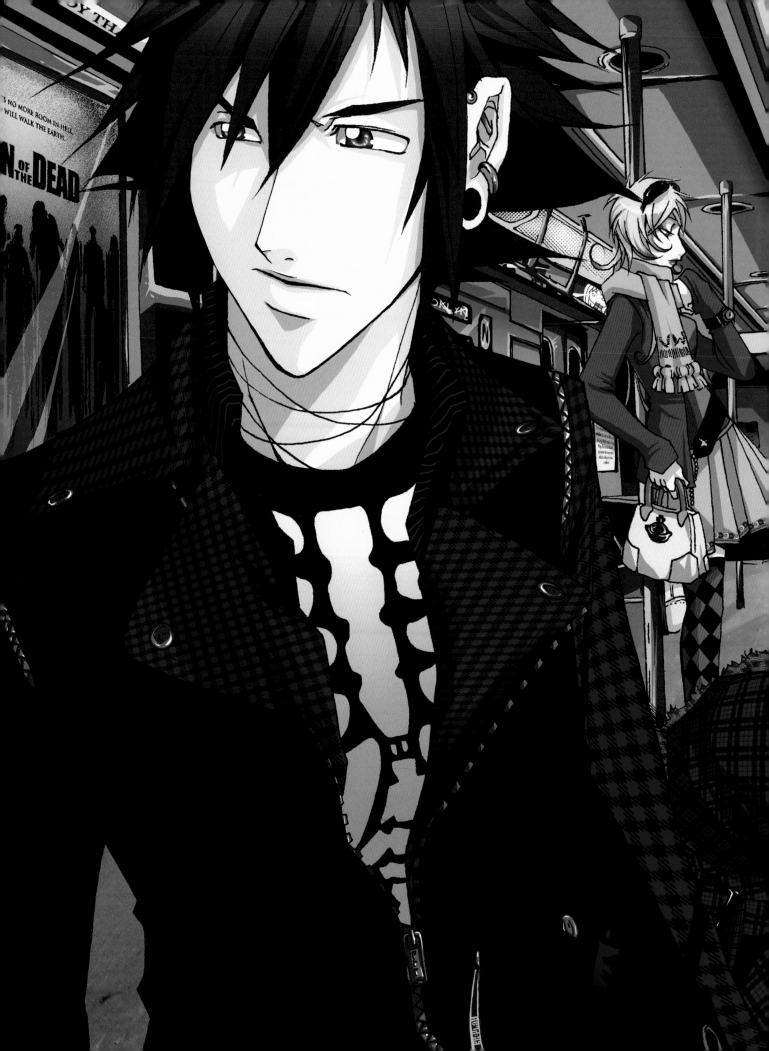

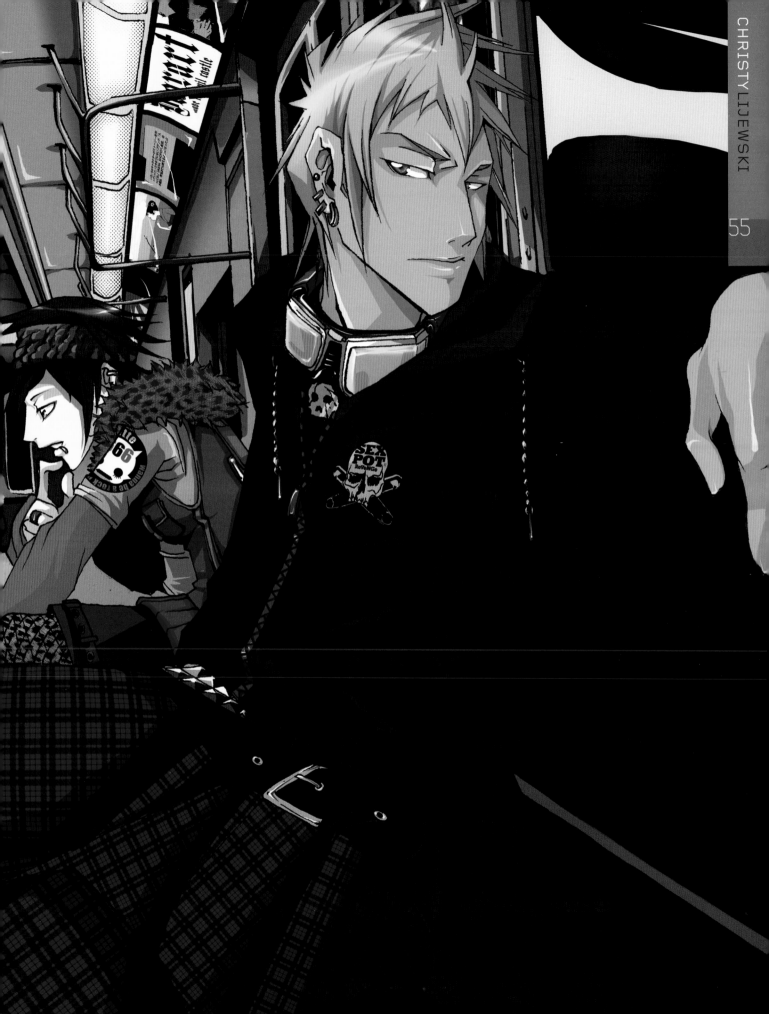

YOUR HAIKU:

No one can ever

Say my last name correctly

It is Lee-S-Key

YOU + DESERT ISLAND + 3 THINGS:

Superman, Batman, and MacGyver. Between those three we'd be off that island before you knew it.

GOAL FOR THE FUTURE:

To produce the most successful comic I can! And to marry a rich cowboy who likes punk music and Chinese food, but that's always been my primary goal!

EXTRA:

I love quiche—like, to an unhealthy degree—so I shall now share my favorite local super-easy quiche recipe:

CHESAPEAKE BAY CRAB QUICHE

Combine and spread in 9-inch unbaked pie shell:

1/2 cup mayonnaise

3 beaten eggs

1 2/3 cups crabmeat

1/3 cup sliced red onion

2 tablespoons flour

8 ounces grated Swiss cheese

1/2 teaspoon fresh thyme leaves

Bake in 350-degree oven for 40-45 minutes. Garnish each slice with fresh sprig of thyme.

Enjoy!

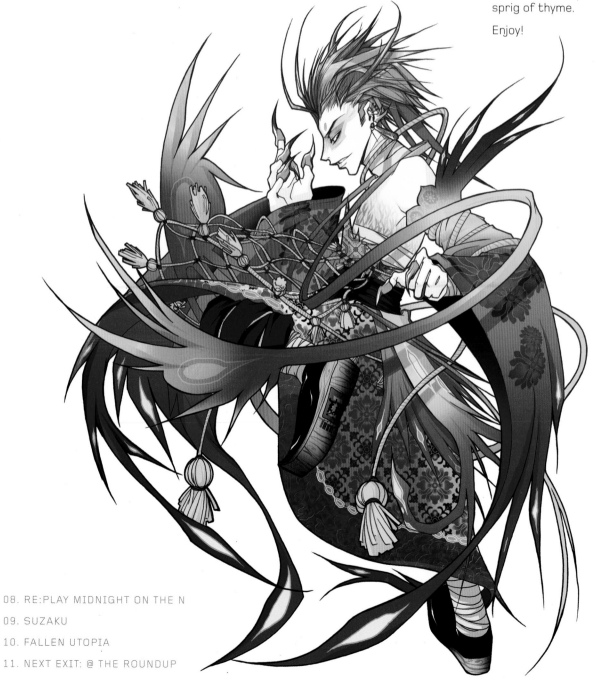

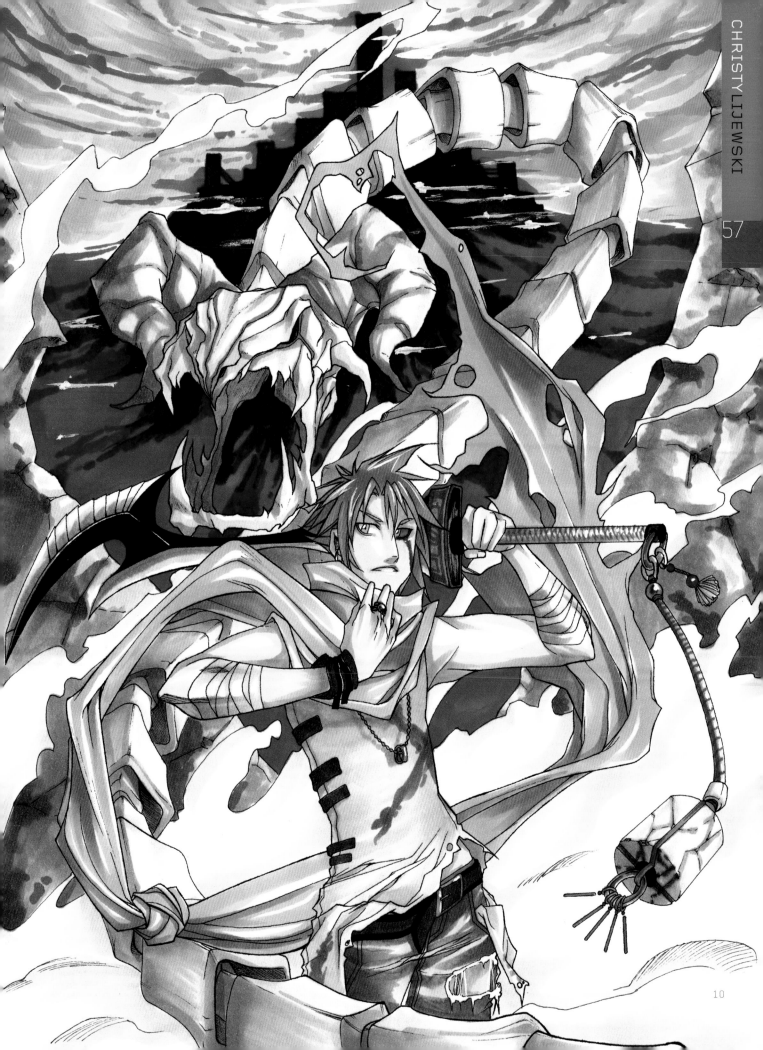

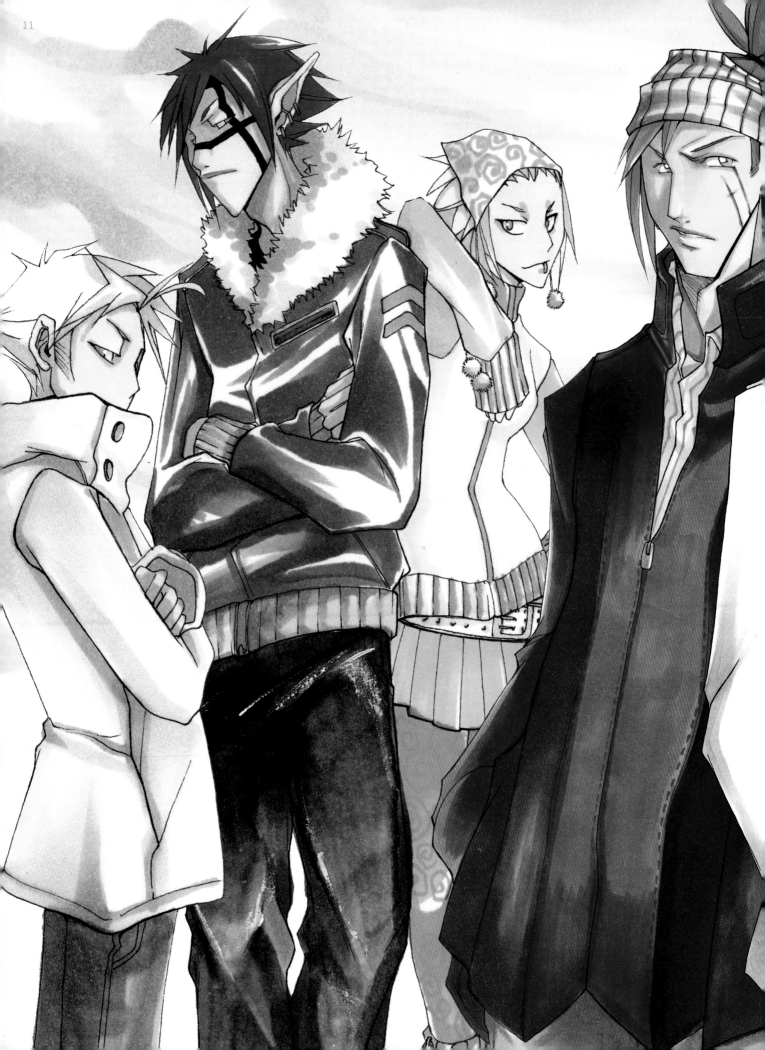

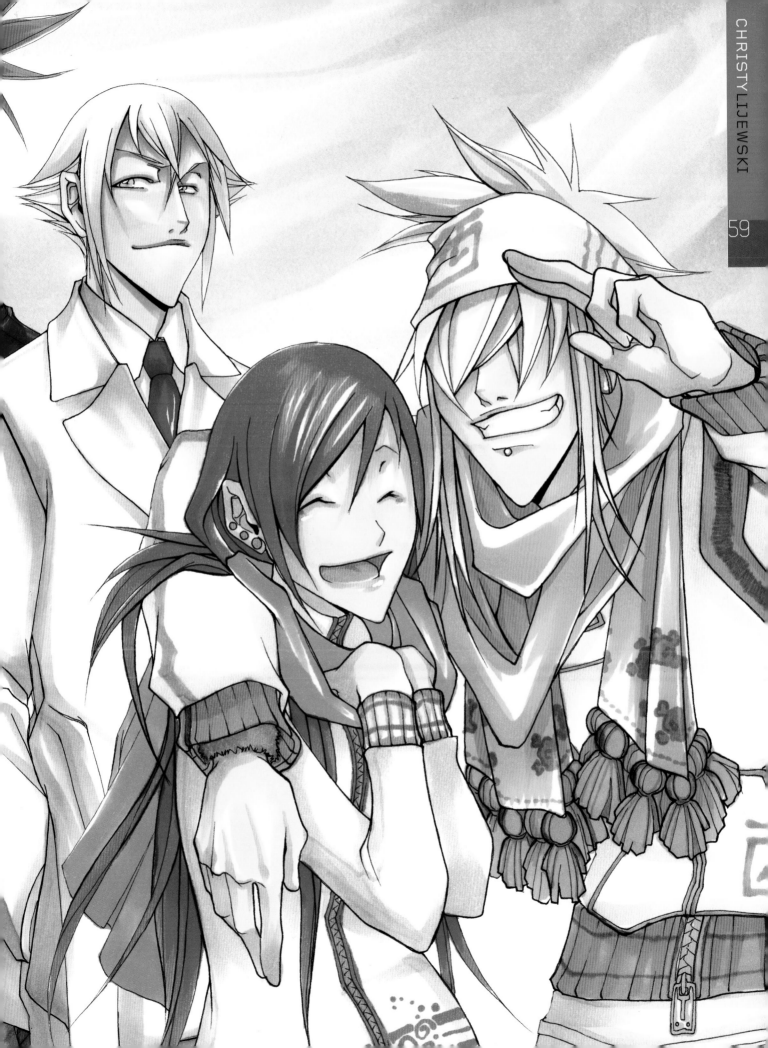

CHARACTER DESIGN
TUTORIAL

BY CHRISTY LIJEWSKI

You get on the subway. The train's packed and you've been on your feet all day so standing isn't looking too pleasant to you. Lucky for you there are two seats open:

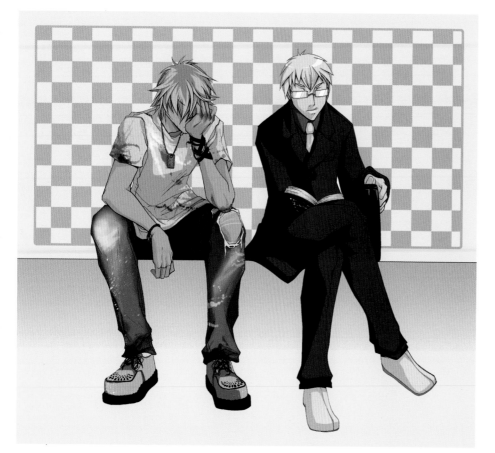

Your first choice is to the left of a rather disheveled young man. He sits slumped forward in his seat, his head resting on his hand, his face covered by tangled, dirty-blond hair. Both his jeans and his ratty T-shirt have seen better days and seem to be covered in paint, dust, and other assorted stains. You notice his knuckles seem to be bruised. He pays no attention to the people around him.

Your second choice is to the right of a well-dressed young businessman. He sits with his eyes down, reading a book on his lap, but his firm grip on the brief-case next to him tells you his mind isn't totally absorbed in his book. His well-trimmed, blond hair and cleanly tailored suit seem to point him out as the kind of man who cares as much about his appearance as he does about his job. The lights from the car glint off the sliver-framed glasses he wears, hiding his eyes from your sight.

Time for you to pick a seat . . . which would you choose?

OK, so by now you might be asking, what does this little story have to do with character designing? EVERYTHING.

01 Every day we make judgments about people based simply on their appearance. We define their personalities from the visual clues they give us and attribute a personality to them without their ever having spoken a word. The fact that we do that, that we define people by what we see, is the key element to successful character design.

Think back now: which man did you choose to sit next to? Now ask yourself, why?

Did you not feel comfortable beside Man A because his clothing was tattered and dirty? Or maybe you didn't like the fact that he didn't make eye contact with people?

What about Man B? Did you feel more comfortable next to him because he was dressed well? Or maybe his alert manner put you at ease?

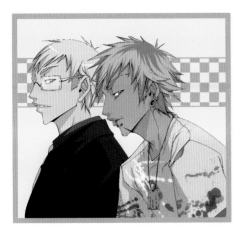

Whatever the reason, you took what you saw and made a judgment call on the person's character based upon it. We do the same thing with fictional characters in an illustrative setting as we do with real people in real life.

The train comes to a halt and the two men get off together. It's then that you notice something odd. They kinda look similar. . . Wait a second . . . twins?! Why didn't you notice before? Their face shape's the same, their eyes, their nose, their lips . . .yep, all the same . . . so why did they look so different?

Simple . . . personality!

When you're designing a character for a comic or manga you have to keep in mind that it's about more than just making a really awesome-looking character. It's about expressing the personality of that character through your design. What they say and what they do go hand in hand with how they look—working toward a unified character representation.

OK, so let's take a look at our two twins and break them down into some of the very basic defining visual factors of their character.

And just what does that all mean? Well, let's see how the design of these two characters relates to the basics of character designing!

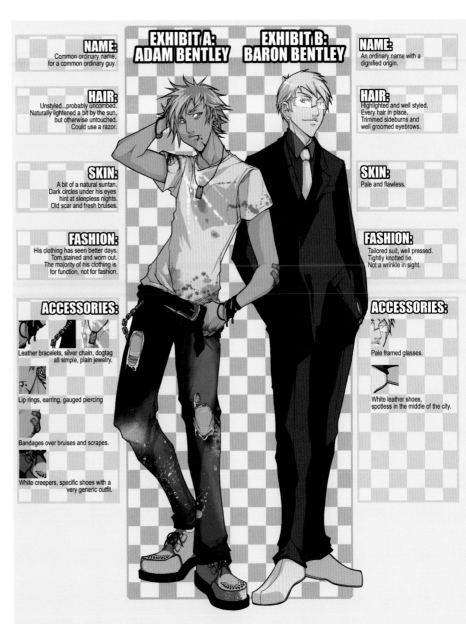

EXHIBIT A: ADAM BENTLEY

EXHIBIT B: BARON BENTLEY

NAME:
Common ordinary name, for a common ordinary guy.

HAIR:
Unstyled...probably uncombed. Naturally lightened a bit by the sun, but otherwise untouched. Could use a razor.

SKIN:
A bit of a natural suntan. Dark circles under his eyes hint at sleepless nights. Old scar and fresh bruises.

FASHION:
His clothing has seen better days. Torn, stained and worn out. The majority of his clothing is for function, not for fashion.

ACCESSORIES:
Leather bracelets, silver chain, dogtag all simple, plain jewelry.

Lip rings, earring, gauged piercing

Bandages over bruises and scrapes.

White creepers, specific shoes with a very generic outfit.

NAME:
An ordinary name with a dignified origin.

HAIR:
Highlighted and well styled. Every hair in place. Trimmed sideburns and well groomed eyebrows.

SKIN:
Pale and flawless.

FASHION:
Tailored suit, well pressed. Tightly knotted tie. Not a wrinkle in sight.

ACCESSORIES:
Pale framed glasses.

White leather shoes, spotless in the middle of the city.

03

NAME:

What's in a name?
A lot more than people think.

While the way each person is going to react to a name is going to be different, a name will always trigger some sort of connotation with the reader. It might give a hint toward the character's ethnic background, or maybe it'll give away his or her gender if it's in question. A regal name placed on a low-class character or a foreign name placed on a native character might give a hint to a duality in their nature we don't get from just looking at them.

Then, again, placing an unfitting name on a character can work as a red herring and mislead the reader as well. It all depends upon your specific goal in naming a character.

HINT: If you're stuck for a name a great way to get those creative juices flowing is to take a gander through baby name books and Web sites. While you might not find the name you're looking for specifically, it can help to get you thinking, and taking a look at the meanings behind names can sometimes put you on the right track.

IN THE CASE OF THE TWINS:
Their family is old-money, so I wanted a last name that was simple and plain, but also had the connotation of expense. For their first names, again they needed to be simple, but they also had to include the opposing natures of the two boys. Adam is about as common an American name as you can get. Baron, while not exotic or odd by any means, traces its meaning back to a royal origin.

04

HAIR:

Hair is probably one of the most versatile facets of a person's anatomy. You can dye it, cut it, braid it, curl it, shave it, style it—anything you want. You can change a character's appearance entirely just by changing their hairstyle or hair color.

If your character is a fastidious princess, then you're probably not going to draw them with their hair in knots sticking out at odd angles as a big tangled mess. But let's say your character is a wild woman living in the forests; then maybe that style wouldn't be so unfitting after all.

Hairstyles can cause a person to see a character in a different light. For instance long hair can lead a person to see a character as more feminine, and short hair can lead a person to see them as more masculine. It can also affect the physical way one sees a character; stark black hair can cause a pale character to look even paler, and light hair can make a tan character look even darker.

Hair is something about the character that the character themselves has a choice over, so it's important to remember that how they choose to wear it says something about their personality as well.

HINT: If you want to create a certain feeling to a character's hairstyle, it can be helpful to research hairstyles of the time period closest to the time in which you've set your story. If it's modern-day, fashion magazines and hairstyle magazines abound. Don't be afraid to look to see what's in style at the moment.

IN THE CASE OF THE TWINS:
Adam has a tendency to sleep in well past when he should, so getting to work in the morning usually becomes a race against the clock. Because of this he rarely has time, or motivation, to do more than run his fingers through his hair and bolt out the door. His work often requires him to spend his days outdoors, so his hair has been bleached out over time by the sun. Baron has a job that puts him in the public eye and requires a certain level of presentability. Perhaps he takes his appearance a little more seriously than he should, but he wants to know he'll look good on TV, should a camera catch him unaware. He claims those are "highlights," but if you ask his hairdresser she'll tell you none of it's natural.

05

SKIN:

Skin is something that a character can't change too easily, so it's an excellent way to quickly define a character. If you have all dark-skinned characters, a pale character will stand out immediately; the reverse is true as well. People are all

different shades and tones, and keeping that in mind when you're designing your characters brings a much broader feeling to your story than if everyone looked exactly the same.

Scars, freckles, tattoos, and wounds— any added marking to the skin—can help to define a character. People are rarely flawless, and if they are it's usually because they work at it.

Tattoos and scars can be intriguing on a character because they usually have a story behind them.

Did that knight get all those scars because he's survived a hundred battles over the years, or did he get them because he's really not very good at sword fighting at all, and has gotten his butt handed to him time and time again?

Does that tattoo mean its bearer has gang connections? Or maybe it means he got drunk on his last birthday and his friends dragged him to a tattoo parlor, where he picked something randomly off the wall.

Simple little details like that can tell a whole chapter of a character's life.

HINT: Before you put a tattoo or symbol on a character, it's wise to research it a bit. Nothing is worse than intending a symbol to carry one meaning, only to find out it means the total opposite. Be careful; symbols can work for you or against you.

IN THE CASE OF THE TWINS:
Being out in the sun a lot, Adam tends to be naturally more tan than his brother, who spends his entire day indoors. A skateboarding accident when he was 12 caused the scar on his chin, but he likes to tell girls it was something more interesting and dangerous. They never believe him.

Adam is up late most nights, even when he's not working a double shift, and always seems to look sleep-deprived and have circles under his eyes.

Baron cares as much for his skin as he does for his hair and his wardrobe, and everything else.

06

FASHION:

Probably the most essential element of a character design is what they wear. Clothing is a form of expression and is usually chosen by the character themselves.

Fashion changes with culture, time period, gender, age, occupation, income, social standing—you name it! EVERYTHING affects how a character dresses. What causes someone to pick up a skirt instead of pants? What makes someone choose jeans over hot pants? What makes someone put on that white suit instead of that black one?

It all comes down to the personal preferences of the character and, because of that, it speaks the loudest ABOUT a

character because they do have that total choice over what it is they're wearing.

When designing clothing for a character, ask yourself what you want people to know about this character.

Do they have a lot of money? Do you want that to show?

Where do they live? Do they represent their culture in the way they dress? Or maybe they rebel against it?

What time period are they from? Are they current with others in their time period or maybe they're old-fashioned? Are they super feminine or masculine? Do they dress for their gender or do they oppose it?

What are some of their interests? Can their interests affect their clothing choices?

Do they dress their age or older? Younger?

The list of questions can go on and on. Just decide for yourself what's most important in your character and figure out the best way to exemplify that visually.

In the case of uniforms and traditional garb, where the character doesn't have a say over what they wear, the simple fact that they don't have a choice steps in and defines their character in a whole different manner.

Even in the case of uniforms, however, you can usually see a little hint of the character's personality. An untucked

school uniform shirt, a shortened or lengthened skirt. A military uniform with the addition of a certain item of jewelry, a knight's armor with a unique helmet, the custom gun on a storm trooper—this all leads into the use of accessories.

HINT: When you're setting out to design your character's clothing, don't be afraid to look at the world around you for reference. Doing a little research and adding a little detail can make all the difference between drawing a "pants-type thing" and drawing an actual pair of pants.

IN THE CASE OF THE TWINS:
Once again style wins out over all else with Baron, as his tailored and well-pressed suit shows. When he found out Court TV would be covering a trial he'd been assigned, he had it specially made since he thought the fabric would really stand out well on-screen.

Adam doesn't have a huge wardrobe, so whenever he gets a painting job he tries to wear the same clothes in order to keep something in his closet paint-free. Because of this he's been mistaken for a homeless man more than once on his way home from a project, but he doesn't mind. In fact he likes it when people try to give him money.

07
ACCESSORIES:
Accessories are the little details that add a human touch to a character. Two characters can wear the same exact clothing, but it will be their accessories that will define their differences.

A ring can indicate a married man, while an armband could mark a grieving comrade. A pair of diamond earrings could hint at wealth, or perhaps stand as a cherished memento from a loved one. A locket could contain a photo of a secret lover or a lost child.

Accessories tell stories, mark ranks, set one character apart from another, and express large amounts of personality in tiny little details.

People, as a whole, love to adorn themselves with objects that serve no functional purpose on their own, but instead serve an emotional or aesthetic purpose in the context of the character. Take advantage of that!

Details will both pique the curiosity of your readers and add an individualistic flair to a character—two benefits from one simple addition.

HINT: When you add an accessory to a character's design, think about why you're adding it. It might be purely for aesthetic purposes, and that's all right to do, but just remember odds are someone out there looking at it is going to wonder "What's that for?"

IN THE CASE OF THE TWINS:
Beyond his glasses (of which he has several different frames for various occasions) and his massive tie collection (well over a hundred last he counted), Baron doesn't accessorize much. He likes clean lines to his clothing, and jewelry, he feels, takes away from that. In all honesty, though, Baron's shoe collection is quickly growing to rival his fiancée's, even if he doesn't realize it.

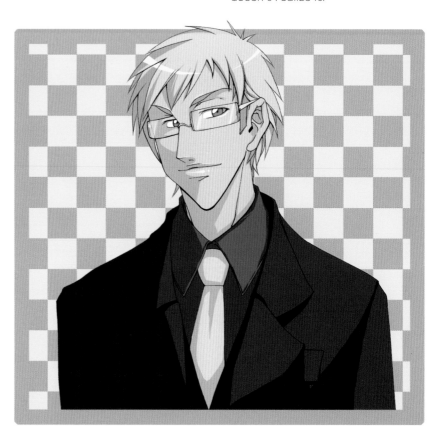

Adam, on the other hand, is hardly ever without at least one piece of jewelry. He likes the weight of bracelets as he's painting, so his left wrist is usually adorned with at least one if not more. His work doesn't require him to be overly presentable, so his piercings never seem to bother his employers (and even if they are bothered, they usually shrug it off as normal artist attire).

Coming back from a friend's gallery opening the night before, Adam noticed a girl being harassed on the street. He stepped between her and the thug, but came out a little bruised, bandaged, and the worse for wear (though still in better condition than the other guy). Adam didn't get her number.

08
BODY LANGUAGE:

People don't all stand the same, and the way people carry themselves is very important to their central emotional state. An extrovert will stand with a more open body position: arms in a relaxed position, eyes ready to make contact with others. An introvert, on the other hand, will stand closed off: arms crossed, eyes down-cast. It comes down to their willingness to interact with others.

Someone who's very proper and well regimented might stand with a stiffer, more upright posture, while someone who's more laid back might stand casually with their hands in their pockets, or on their hips, relaxing their back and slouching a bit.

A nervous person might fidget with their hair or their nails, and an overly confident person might invade others' personal space easily.

A person's body language is dictated by how comfortable they are with both themselves and the world around them. Keep it in mind.

HINT: Study people around you. There's no better way to observe body language than by watching people who are acting naturally.

IN THE CASE OF THE TWINS:
Anything other than proper posture and proper manners just wouldn't do for Baron—at least not in public. Slumped over his desk while scouring through casebooks, however, is another story.

Adam can make himself comfortable pretty much anywhere and around anyone, and takes most opportunities to do so.

OVERALL:
Character designing should be fun. It's creative and enjoyable, so don't make it harder than it has to be. Just get to know your characters and, in turn, other people will be able to get to know them as well. It's all about creating three-dimensional characters that people can connect with. If you can create a character that both looks interesting and IS interesting, you'll be one step closer to creating engaging comics for your readers to enjoy reading as much as you enjoy drawing.

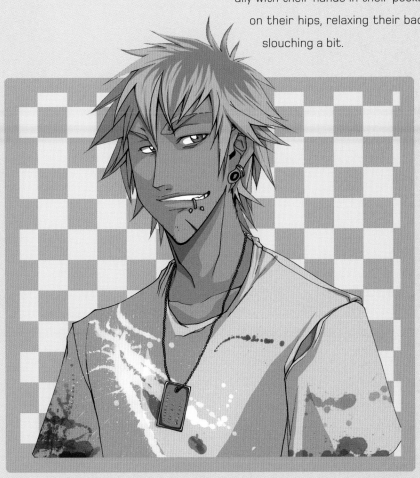

Amy Kim GANTER

CREATOR OF TOKYOPOP'S SORCERERS & SECRETARIES

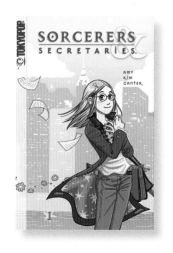

AMY KIM GANTER was born in 1980, she currently lives in Southern California, with her fiancé, Kazu Kibuishi, who also is a comic artist. In 2002 she received a BFA in cartooning from the School of Visual Arts. Her past projects include character design and animation for Gamelab's *Diner Dash*, published by Playfirst; a popular online comic called *Reman Mythology;* and contributions to *Flight* volumes two and four with her stories "A Test for Cenri" and "Food from the Sea." Currently, Amy is hard at work on *Sorcerers & Secretaries*, an original graphic novel series published by TOKYOPOP. You can see more of Amy's work at **www.felaxx.com.**

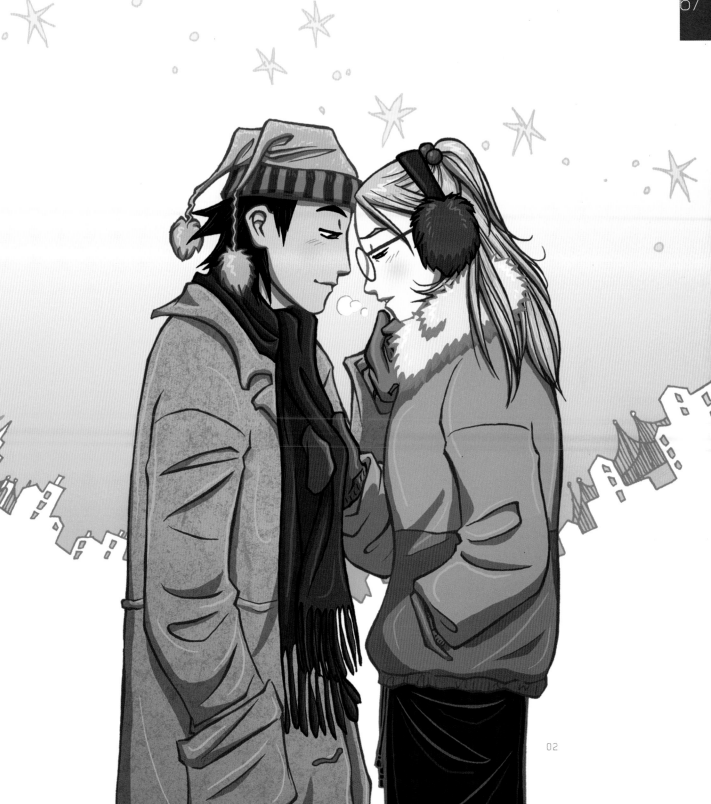

Q + A WITH AMY

YOUR ART STYLE:

Very simple, clear storytelling, friendly, and fresh. Colors tend to be flat shaded with an emphasis on experiencing a moment and appreciating a character.

YOUR INFLUENCES:

Life, my family, my friends, Rumiko Takahashi, Hayao Miyazaki, Jim Henson, Philip Pullman, Carl Sagan, Madeleine L'Engle, J.K. Rowling, Joseph Campbell, Inoue Takehiko, Chun Gye Hyun, music, movies, mythology.

SELF-TAUGHT?

Partly. My comics style was self-made but my drafting skills had tremendous help from art school and art classes taken in high school.

YOUR WORK PROCESS:

After I have a general outline of a story, I write a detailed script. From the script I roughly pencil in thumbnails, two to a sheet of printer paper. I then scan in these thumbnails, expand them to fit into a 9- by 12-inch sheet that's proportional to printing size, and then print them out to be traced with micron pens on a light box. These are my inks. I then scan in the inks and add grayscale shades in Photoshop, converting it to bitmap for the publisher. For color work, I scan in a rough sketch and print out a larger version to ink on a light box. I then scan in the inks and color them on Photoshop using separate layers.

YOUR WORK SCHEDULE:

On average, I do about three to five pages of thumbnails a day, or three to seven pages of inks. For toning, it ranges from five to 10 pages a day. I think this all averages out to a page and a half a day, but I tend to work in chunks for each stage. For color work, it usually takes one day to do one illustration.

YOUR PUBLISHED WORK:

> "OK, GOOD. NOW, I GOTTA DO IT AGAIN AND DO IT BETTER."

When I first held my book my first thought was, "Ok, good. Now, I gotta do it again and do it better." My goal wasn't to have one printed book, but a huge collection of printed books. Even though I was happy I wasn't doing backflips about it. It felt more like a first step in the right direction, and it only inspired me to work harder on more comics. I think Kazu was more excited than I was!

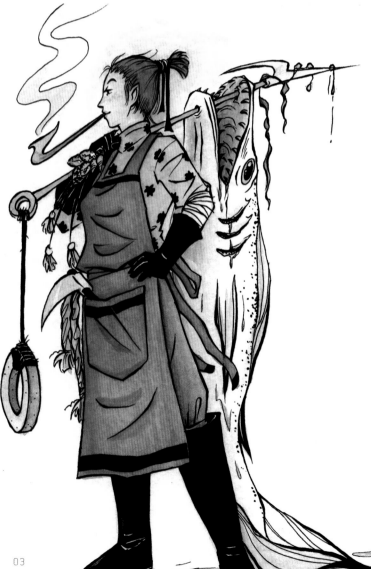

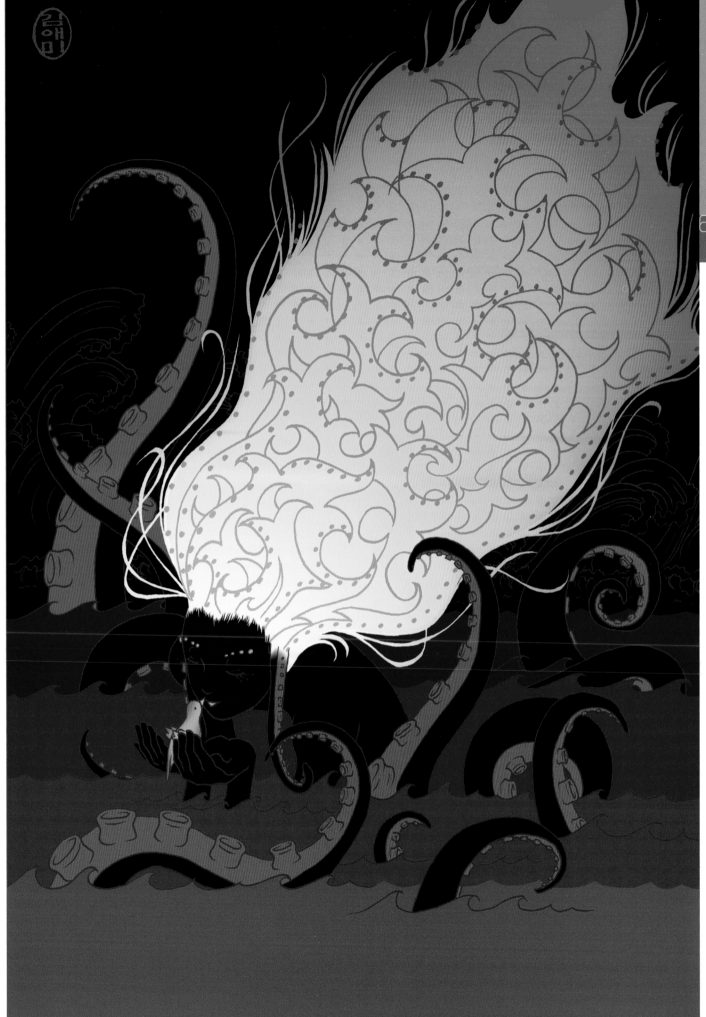

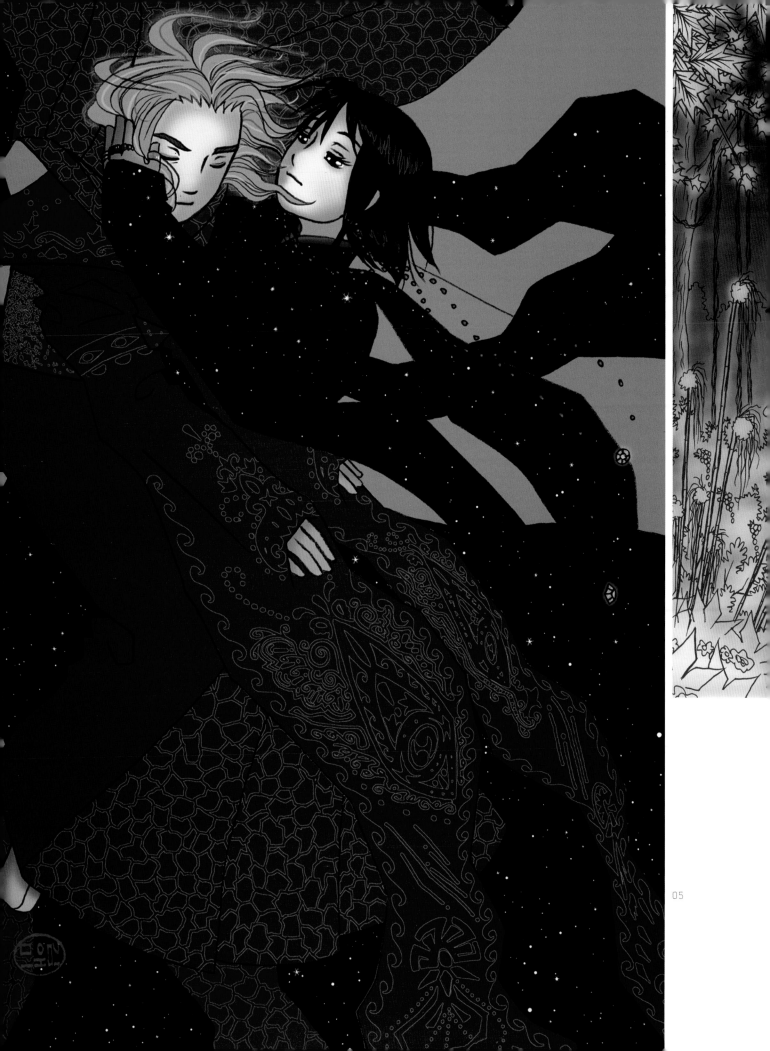

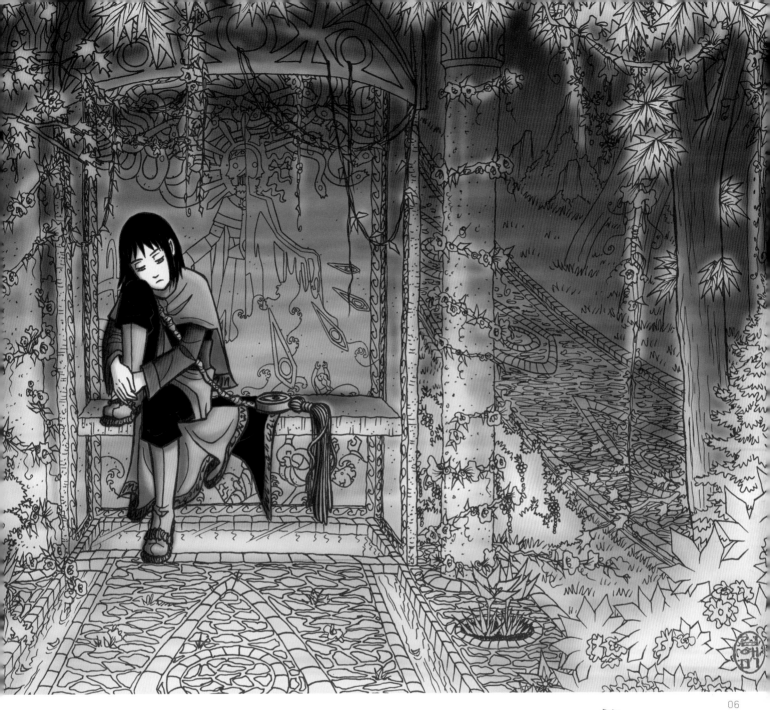

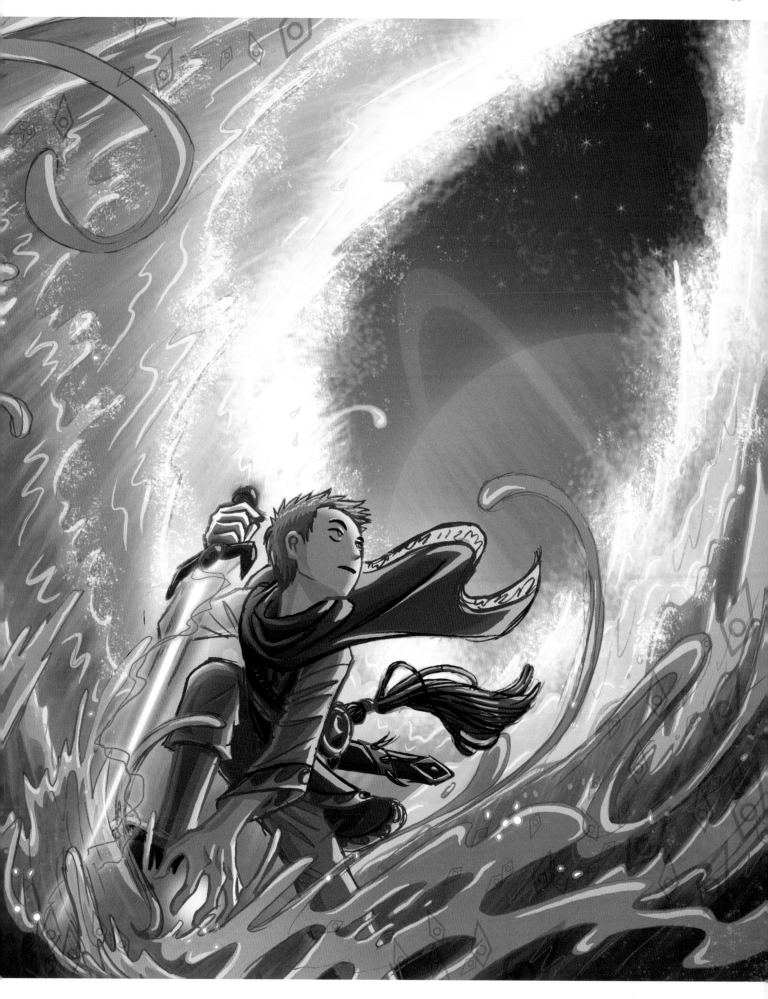

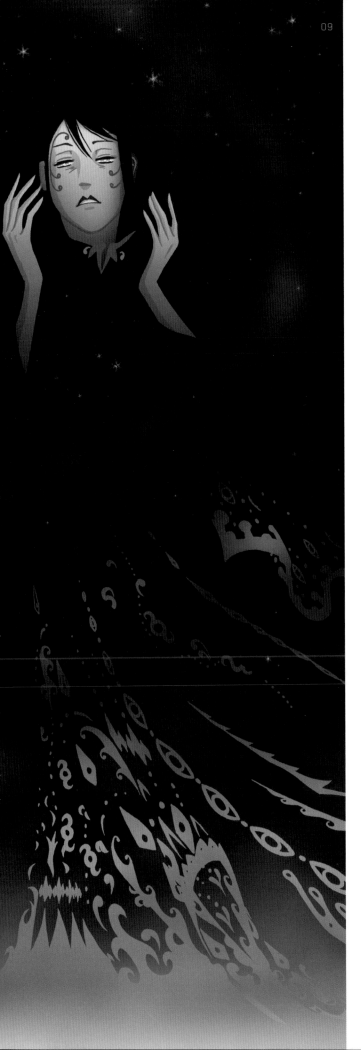

FIRST EXPERIENCE WITH MANGA/ANIME:

My very first was a coloring book my mother sent me from Ko-rea when I was about 10. It featured *shoujo* characters in turn-of-the-century clothing. I didn't understand the visual style, but I was more enchanted by it than by anything else I had at the time. As I grew up I kept seeing that same style pop up in video games and Korean newspapers. I recognized what it was and I think I associated it with fond memories of being with my mother, which is one of the reasons I loved it so much. Later on when I was 14 I went on a trip to Korea to visit relatives where I watched *Miracle Girls* translated into Korean, and bought my first two volumes of *Ranma 1/2*, also in Korean. After read-ing *Ranma 1/2* I found myself drawing epic pencil comics in my school binders on copier paper. Even though I loved American superhero comics and Disney animated films, it was *Ranma 1/2* that really spurred me to get used to drawing long-format black and white comics. I'm eternally grateful to Rumiko Taka-hashi for this.

GUNDAMS OR EVAS?

Uhmmm . . . Voltron?

FAVORITE NON-JAPANESE COMICS:

I don't read any regularly, but some recommended graphic nov-els are *Demo, Scurvy Dogs, Daisy Kutter, Bone, Zed, Same Dif-ference and Other Stories, Owly, Flight* (of course!), *Finder, Calvin and Hobbes, Jimmy Corrigan,* and, of course, manga-influenced comics like *Dramacon, Off-Beat,* and *East Coast Rising.*

YOUR COMIC SHOP:

The Comic's Factory, 1298 E. Colorado Blvd., in Pasadena.

YOUR FUEL: Exercise, green tea, coffee.

EARLY BIRD OR NOCTURNAL?

Nocturnal, but I like it when I wake up early in the morning. It's just hard to do without an office to go to!

GOAL FOR THE FUTURE:

To make a comic so awesome that people forget it's a comic. They just attach themselves to the story.

COLORING WITH TEXTURE
TUTORIAL

BY AMY KIM GANTER

GENERAL LIST OF TOOLS USED:

-HB mechanical pencil, .05 mm lead
-Staedtler plastic eraser
-Staples 8.5- by 11-inch copy paper
-Strathmore Smooth Bristol
 11- by 14-inch paper
-Black Micron pens, sizes 02 and 03
-Epson Perfection 2400
 8.5- by 11-inch scanner
-Canon S9000 printer
-Photoshop CS
-Wacom Intuos 3 graphics tablet
-60G Ipod
-Mint green tea

FOR REFERENCE & INSPIRATION:

-Korean 16th-century art books
-Photos of Monterey Bay
-Blue Planet
-Urutsei Yatsura

This is a piece I've had in my head for a while, and after visiting the Monterey Bay Aquarium, I couldn't hold it in any longer.

I spent about an hour doing pencils on 8.5- by 11-inch printer paper. The amount of fish and pose of the mermaid provided a compositional challenge. As I drew, I kept in mind the motion I wanted the eye to travel in, as drawn below:

Next, I scanned the pencils in at 300 dpi and turned the line work a very faint blue by going to Image > Adjust > Hue/saturation. I increased the size to fit on a sheet of 11- by 14-inch smooth bristol paper and printed it:

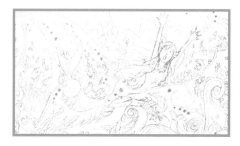

I spent a couple of hours inking the whole thing with size 02 and 03 Sakura Micron pens:

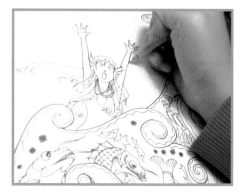

Next, I scanned the whole thing in two pieces at 600 dpi and cut and pasted the pieces together in Photoshop.

Next, I converted the scan to grayscale (Image > Adjust > Grayscale). Then, I adjusted the brightness/contrast until all of the dirtiness of the paper and blue lines were gone, leaving a clean edge. (Image > Adjust > Brightness/contrast):

BEFORE

AFTER

There are different ways to make a transparent line-work layer, but I learned this way so . . .

01 I go to the channels tab and copy the gray channel. With the original gray channel highlighted, I select all and delete the whole canvas. After this, I convert the image to CMYK (Cyan, Magenta, Yellow, and blacK—the four process colors) mode and create a new layer, labeling it "line work." I go back to channels, hold down control, and click the gray channel copy. This should select all of the white areas, so I invert the selection (ctrl+shift+i) to select the black areas. I highlight the CMYK channel, go back to the line-work layer, and fill the selection with black. Now I can paint under the line work without affecting it.

I spent a few hours filling in flat colors using the magic wand tool and adjusting chunks of the colors along the way by going to Image > Adjust > Hue/saturation. I tend to put foreground colors and background colors on different layers so I can play around with them more. In the beginning I'd draw pictures with 20 or so layers, but this image is on eight layers. Someday, I hope to be brave enough to just digicolor on one single layer. As I filled in colors, I kept in mind the original composition drawn in the pencils stage. Even though the colors are kind of wacky and cover the whole rainbow, there is still a focus on the mermaid and the flow of the water. When I'm done with the flat colors it looks like this:

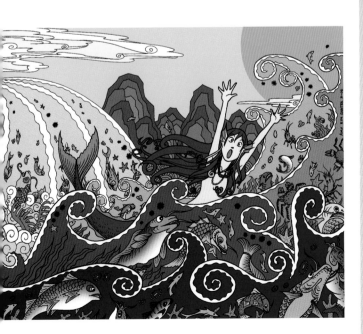

02 Notice how there's enough contrast between the elements so that things don't get so confusing that you can't tell what's happening. Kazu Kibuishi taught me a good way to test the composition of your colors if you get a little unsure about how it's flowing. Convert the image to grayscale and up the contrast to the maximum. You should still be able to understand the basic composition of the image when this is done:

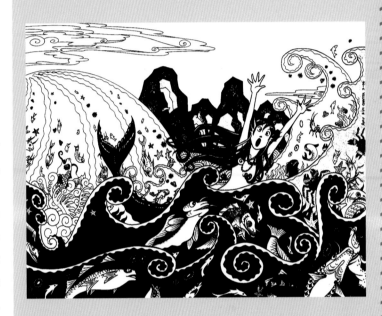

03 Now, it's time to add some subtle texture for variation. I prefer creating my own textures and tones instead of using premade ones in comic-making programs. For this, I scan in a piece of paper that has a lot of grain in it. I do the same treatment to the scanned paper that I did to the line work to make it transparent. You can do this to pretty much any image and use it as a texture or tone. I use this scan a lot, both in my comics and in my illustrations. Here is what the scanned paper looks like:

04 I drag and drop the texture layer onto the flat colors, underneath the line work. Using the magic wand, I select the mermaid's colors and delete her silhouette. I don't want her figure to be affected by the texture, so she'll pop a little more out of the background.

05 I also want the texture in the sky to be a different color from the rest, so I hold control and click on my "sky flats" layer. This selects all of the colors in the sky. With this selection I cut and paste the texture onto a new layer. Now I can choose different effects for different parts of the picture. For the sky, I choose to put the texture layer on "pin light" mode:

BEFORE AFTER

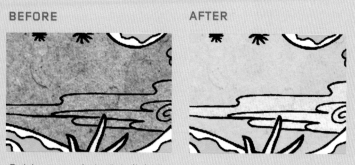

Set layer mode to "pin light," opacity to 47 percent

For the foreground, I set the layer to "linear dodge" mode so the texture looks white instead of brown:

BEFORE AFTER

Set layer property to "linear dodge," opacity to 56 percent

I don't fully understand what all of the layer properties actually do to affect the picture; I just kind of play around with it and see what works. Controlled happy accidents are a big part of my process.

06 Now to add shading and highlights to the mermaid, the star of the picture. This technique is what I use to color almost all of my figures. I guess growing up watching so many cartoons, I got used to seeing drawings colored this way. I used a dark blue for the shadow color this time to unify it more with the ocean. The sun is above her, so I tried to have the shadows generally cast down. Once the shadows were drawn in, I lessened the opacity until they were subtle enough.

BEFORE AFTER

Opacity change to 31 percent

Then, I did the same for highlights, using white to draw in some light reflecting off her hair, jewelry, and tail.

Change highlights layer to 61 percent opacity:

And that's that. Here is what it looks like in the end>>

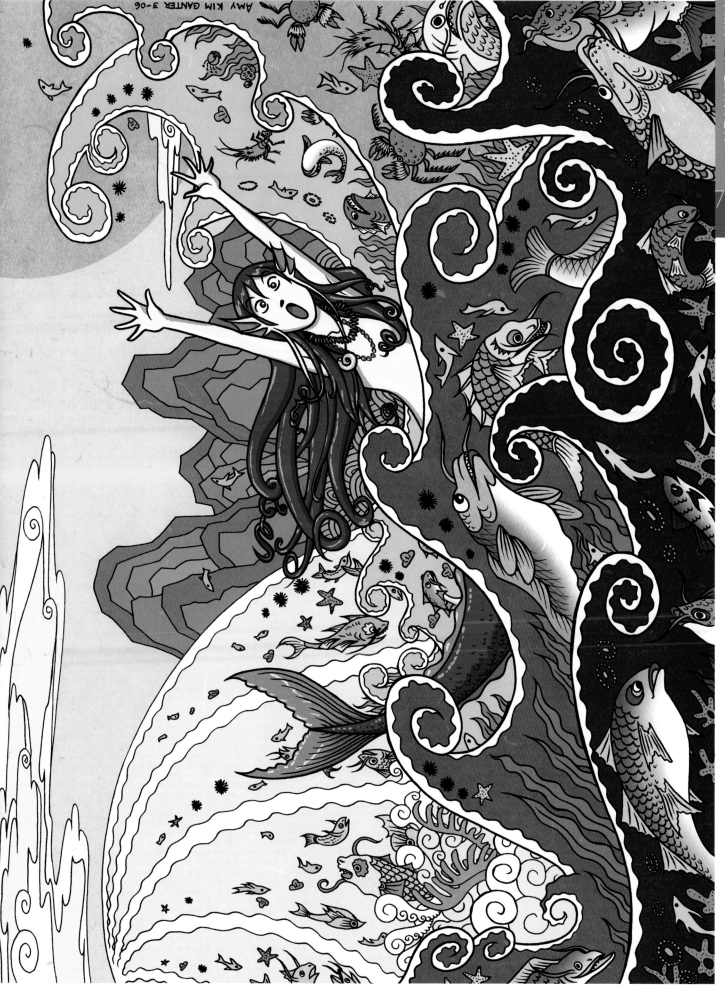

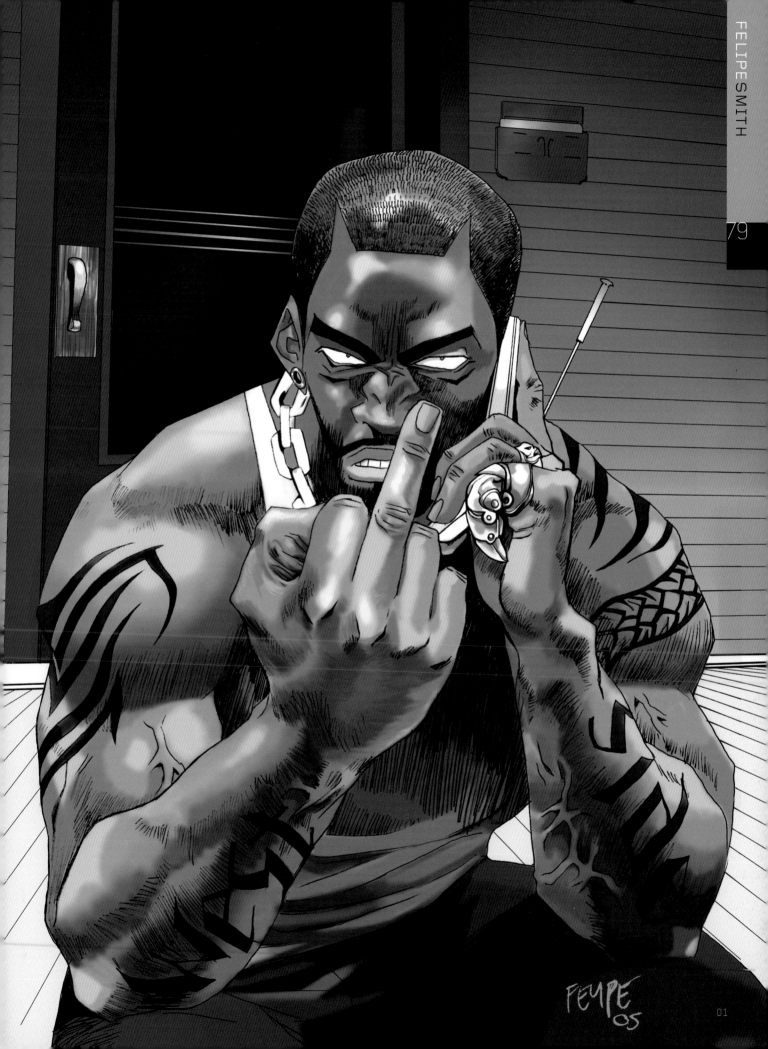

02

03

Felipe Smith was born on June 17, 1978, and currently lives in Los Angeles, CA. He received a BFA from the School of the Art Institute of Chicago and went on to have his story "Manga" selected as a second-place winner in TOKYOPOP's *Rising Stars of Manga™*, volume three. Currently, Felipe is working on an edgy and original graphic novel series, *MBQ*, for TOKYOPOP. *MBQ* volume one was also named one of the best comics of 2005 by *Publishers Weekly*. You can see more of Felipe's work at his Web site, www.felipesmith.com.

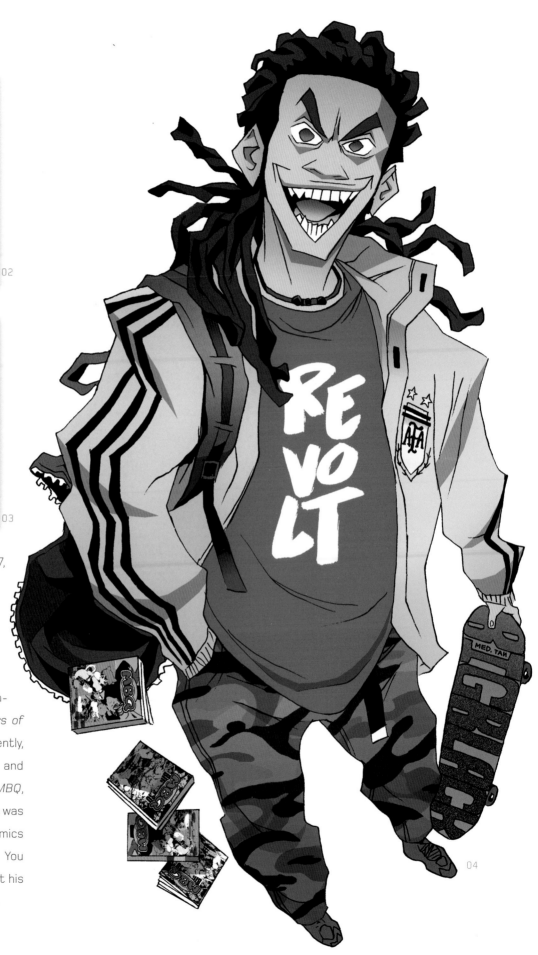

04

05

06

07

Q + A WITH FELIPE

YOUR ART STYLE: 100 percent HEART.

YOUR INFLUENCES:

I'm influenced by manga, American comics, European comics, and the black-and-white comics of Argentina, the place where I was raised.

SELF-TAUGHT?

Yes. I am self-taught. Comics are often frowned upon in schools of fine art. Ironically, most of the elements that help my work stand out from other comics were picked up while learning the meaning of fine art.

YOUR ARTISTIC DUTIES:

Everything. I write and illustrate my own stories. I do my tones and cover painting as well. Due to time constraints I sometimes work with toning assistants; but in the end I always go back to the tones and adjust them myself. I need to be involved with every part of my work 100 percent; anything less than that and I feel the work is no longer mine.

YOUR FAVORITE PART OF THE CREATIVE PROCESS:

My favorite part is when I'm done. That, and seeing people's faces when they read my book, ha-ha. Thank you, readers!!

LEAST FAVORITE PART OF THE CREATIVE PROCESS:

When it's done, and I'm holding my first copy of the finished book. I'm afraid to open it, and my mind is full of things that could have gone wrong with the printing or cropping.

YOUR WORK PROCESS:

I write a script for a 200-plus-page book in about two to three days, depending on how well I've developed the plot in my head. I initially lay out a pretty concise chain of events,

and most of the dialogue for the book is decided during this first stage. Once the outline to my book is laid out, I shoot it to my editor, Luis Reyes.

After fighting with him over what I can and can't do when drawing comics, and how I really need a 38-page fight scene in my book, we come to a mutual agreement, and I'm given the green light to start drawing. I lay out thumbnails for one chapter at a time. These are pretty loose and sketchy, but the layout, action, and even word balloon placement are clear. I'd say Luis can look at one of my chicken scratches and pretty much visualize what the final page will look like.

> "I'M THE MOST FAMOUS COMIC-BOOK-PUBLISHING EX-JAPANESE KARAOKE CLERK/WAITER/POSTAL CENTER WORKER IN WEST LOS ANGELES."

Then, I sit down and draw, ink, scan, resize, and upload the pages to an FTP where an assistant finishes the tones I've started on the page. I usually send one or two panels on the page completely toned, so the assistant has a guide to follow when finishing the page up. Later, I go over every single page and adjust contrast, add highlights, and check for details that may have been overlooked. If the page doesn't look the way I'd planned, I re-tone it myself. After I've quenched my psychotic perfectionist urges, the pages are sent to the publisher for lettering. Sometimes the order of the chapters is rearranged at this point, to create a more dynamic flow in the story. In the case of *MBQ*, I'm telling the story of six main characters, and a few secondary ones, so there's a lot going on story-wise. Each character leads the reader through his own daily life occurrences, sometimes weaving into another character's story line. It's because of this that these stories can sometimes be told in a different order and still make sense. The objective at this point is to find the most entertaining and dynamic arrange-

ment for these scenes. Once the pages are lettered, cover illustration and layout completed, typos corrected, and minor script changes made to assure a natural flow in the dialogue, the book is ready to send to the printer. In about a month or so I'm informed that the book has been printed and that I can check it out. Fear strikes hard.

YOUR WORK SCHEDULE: I wake up whenever, start drawing, eat somewhere in between, fall off my chair exhausted, am no longer able to draw, curl up on the floor and sleep. Repeat for about six or seven months and my book is done.

FAMILY, FRIENDS, AND NOTORIETY:
My family and friends support me and like my art. I'm very lucky. They get what I do, and when they don't, they realize I'm convinced I'm getting somewhere with it, and hell-bent on doing so. So they leave me alone, ha-ha. I'm not an outcast, I'm the most famous comic-book-publishing ex-Japanese karaoke clerk/waiter/postal center worker in West Los Angeles. :D

YOUR FIRST EXPERIENCE WITH MANGA/ANIME:
My first anime was probably *Mazinger Z*, or *The Adventures of Tom Sawyer*, or *Heidi*. Growing up in Argentina, most of our animation was either American or Japanese. The first manga I ever came across had to be *Slam Dunk* or *Dragon Ball Z*, back when I was in junior high. It was in Korean print though, and I couldn't read it. I ignored manga for years, and only started really reading it about four years ago.

YOUR THOUGHTS OF MANGA AT THE TIME:
I thought it was unbelievably clean, and realistic looking (*Slam Dunk*). I thought the characters looked really "cool," like somebody in a music video or something. I thought *Dragon Ball Z* was ridiculous, ha-ha. The characters looked so simple yet solid and extremely dynamic. I was into other stuff and forgot about them rather quickly for some reason. I'm guessing since manga wasn't readily available in Argentina in the early 1990s, it was easy to forget.

09

DESCRIBE MANGA TO A NEWCOMER:
Manga is a comic book. It's usually around 200 pages in length and is printed in black and white. It's read by kids and adults alike because there are enough genres of it to pique ANYBODY'S interest. It's a form of entertainment equal to movies in some parts of the world.

THE FUTURE OF WESTERN MANGA: Me.

FOR THOSE WHO OPPOSE WESTERN MANGA:
Those people exist?

YOUR MANGA COLLECTION:
I own about 330 or so manga books. Many were handed down to me by good friends—thanks guys! Others I bought at discount bookstores. I flip through books in the aisle too, while I knee aisle readers in the back of the head, purely by accident. ;) If I see something I like I'll pick it up and read it at home. Strictly page flipping at the aisle.

GUNDAMS OR EVAS?
Robotech, hands down. (Yes, Macross—for the scrutinizing nerds out there, ha-ha.)

10

KILLER MECHS OR CHIBIS?

You need both.

DESCRIBE A CON EXPERIENCE:

Every convention is in itself an experience. :D Good times all around!

The best one was probably when I was at a PS2 game booth; I approached a group of guys to tell them about my book, and all four of them pulled out copies from their bags and asked me to sign them. I almost lost control of my bladder. Another cool one was one night, while at San Diego for a convention; I stopped by a 7/11, ordered a hot dog, and was eating chili out of the machine like there was no tomorrow. The clerk asked me if I needed an extra box to take the chili with me. I apologized for my behavior and told him about my book and the convention. The next day he showed up at the con, bought my book, and was waiting in line for me to sign it. Pedro, you rock!

YOUR CATCHPHRASE:

I've got too many. You'll probably be able to pick them out if you read this thing carefully. READ *MBQ*! Help me REVOLT!

01. DEE 1
02. MBQ VOLUME 1
03. MBQ VOLUME 2
04. FELIPE
05. SLAP
06. RYDA
07. MERI 1
08. OMARIO 1
09. MERI 2
10. BAR GIRL
11. OMARIO 2
12 OFFICER O'MALLEY
13. DEE 2
14. BRIAN

EXTRA:

A big thanks to everyone who's helped me make it this far. I appreciate the support and I LOVE you! You know this! For those who want to join the ranks, wait no longer: my books are on the shelf! Let's DO this!

EVER BEEN TO JAPAN?

I went to Japan for one week. I won first place in an international manga contest and they flew me out, all expenses paid.

YOUR HAIKU:

Nobody like me.
Get my book and you will see.
Read, help me be me!

**YOU + DESERT ISLAND
+ THREE THINGS:**

Ouch. Drawing utensils and paper, I guess. And two people to hang out with and show my drawings to. Ha-ha.

YOUR GOAL FOR THE FUTURE:

To live exactly the way I want to, 100 percent.

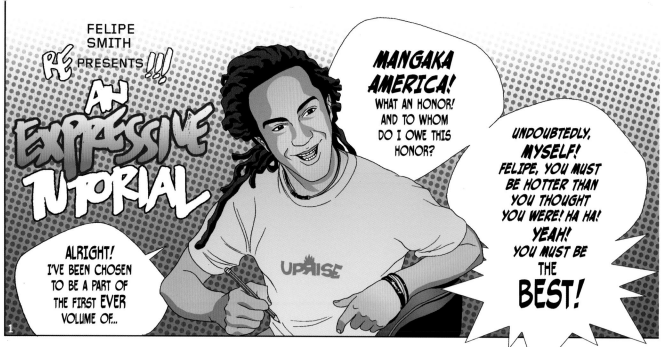
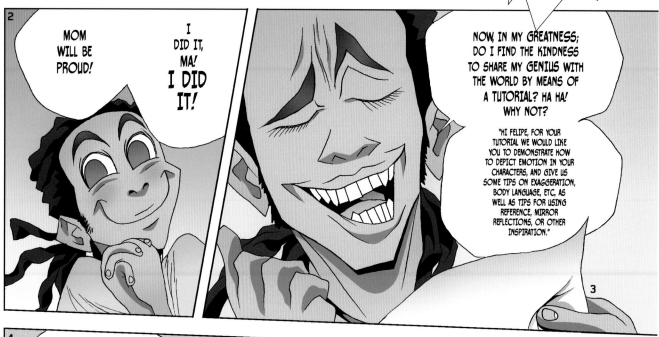
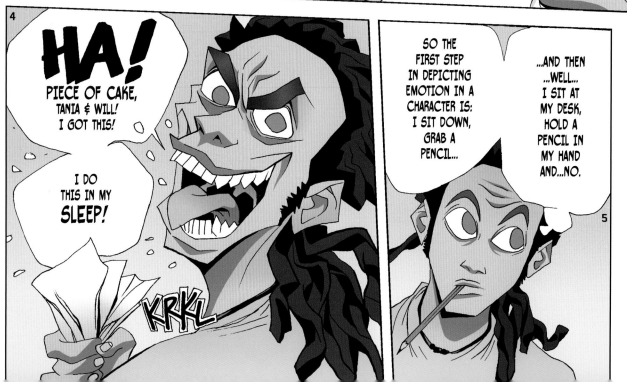

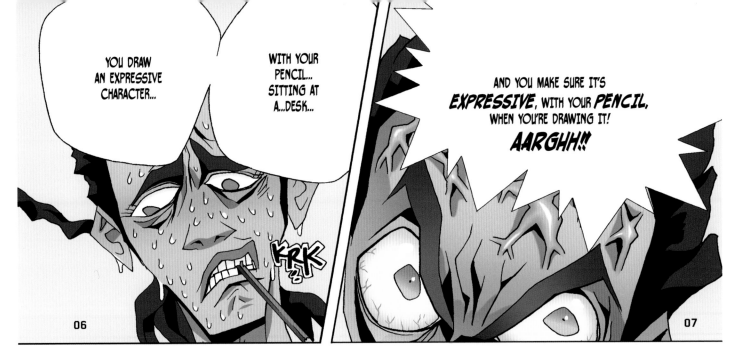

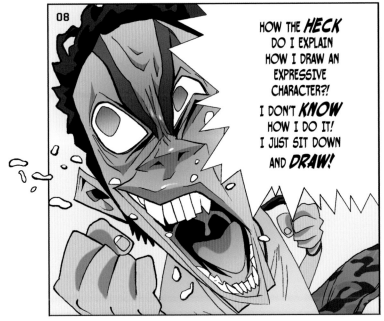

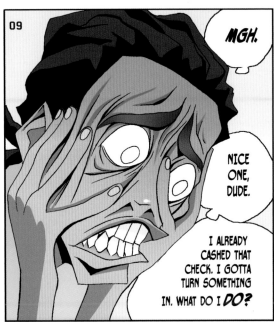

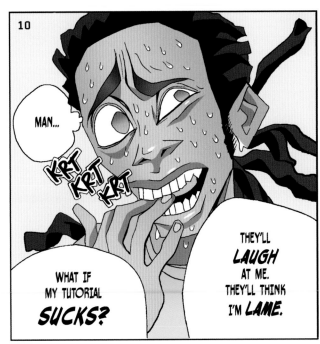

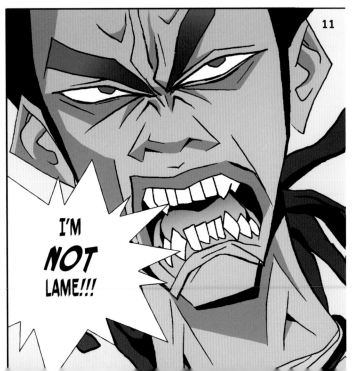

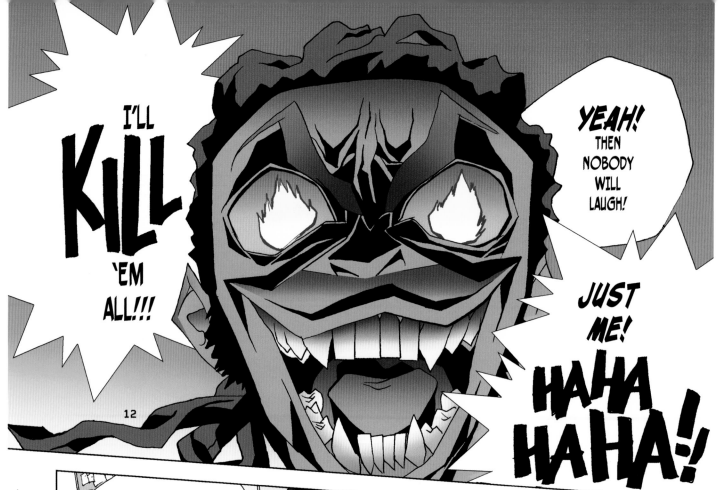

I'LL **KILL** 'EM ALL!!!

YEAH! THEN NOBODY WILL LAUGH!

JUST ME! HA HA HA HA!

12

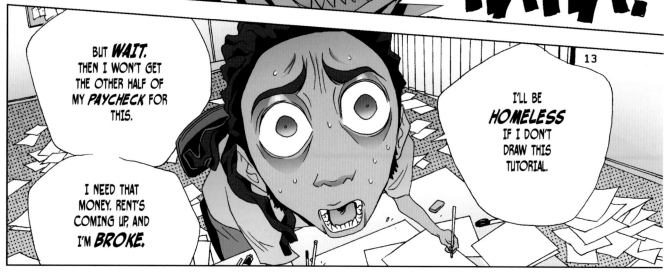

BUT **WAIT.** THEN I WON'T GET THE OTHER HALF OF MY **PAYCHECK** FOR THIS.

I NEED THAT MONEY. RENT'S COMING UP, AND I'M **BROKE.**

I'LL BE **HOMELESS** IF I DON'T DRAW THIS TUTORIAL.

13

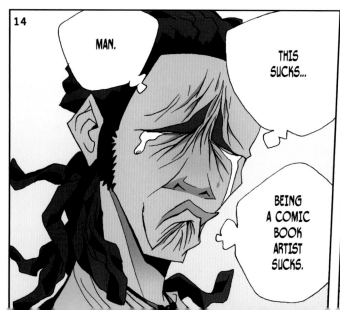

14

MAN.

THIS SUCKS...

BEING A COMIC BOOK ARTIST SUCKS.

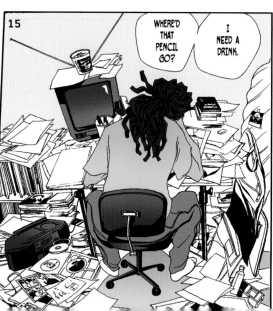

15

WHERE'D THAT PENCIL GO?

I NEED A DRINK.

EXPRESSIONS
TUTORIAL

BY FELIPE SMITH

DETAILED EXPLANATIONS FOR EACH NUMBERED PANEL ARE BELOW:

01 This may look JUST like me, but it's not very expressive at all. (Look at a mirror only for reference; do not attempt to copy exactly what you see.)

02 This looks a LOT LESS like me, but the simplicity and exaggeration of my features make the emotion I'm trying to convey a lot more evident.

03 Simplified shapes and economy of line will bring out the life in your character.

04 Nobody likes a Mr. Braggadocio. Make him ugly and he'll be that much more upsetting and obnoxious.

05 When in thought, let your eyes do the talking.

06 If you're REALLY stressing, you'll break into a SWEAT!

07 Easy on the salt if you've got a tendency for high blood pressure; those veins will start popping when you become irate!

08 Stretch your character's features as much as necessary to express a desired emotion.

09 Bring those hands into the mix. Hands are also expressive.

10 Nail Biting and Anxiety are best friends.

11 Choose your lines wisely when conveying emotion. Curvy shapes are easy on the eye. Angular ones are more aggressive.

12 Dementia is both euphoric happiness and hellish rage! Mix your best smile with your worst scowl and you'll be right on the money.

13 Nothing better than a fish-eye-lens view to make you look small, weak, and helpless. You're alone and doomed.

14 Don't stress it. You'll look like a prune by the time you're 20.

15 Sometimes, the absence of a face can be your most expressive tool.

Lindsay CIBOS
and Jared HODGES

creators of
TOKYOPOP'S
PEACH FUZZ

LINDSAY CIBOS (born November 9, 1981) and **JARED HODGES** (born February 26, 1979) live near Orlando, FL, in Altamonte Springs with their two ferrets, a female named Momoko (Japanese for "peach girl") and a male named Elf. Since 2000, Lindsay and Jared have worked with more than 100 clients on artistic projects involving illustrations, character designs, comics, and more. Some of their past projects include their self-published *Anime CG Tutorial CD*; illustrations in *BESM D20 Anime Role-Player's Handbook*, published by Guardians of Order; and *Digital Manga Workshop*, a tutorial book published by Collins Design/Ilex Press. Currently, they are working on an original graphic novel series for TOKYOPOP, *Peach Fuzz*, which is also being serialized in Sunday newspapers around the country. To see more of their work, visit www.jaredandlindsay.com.

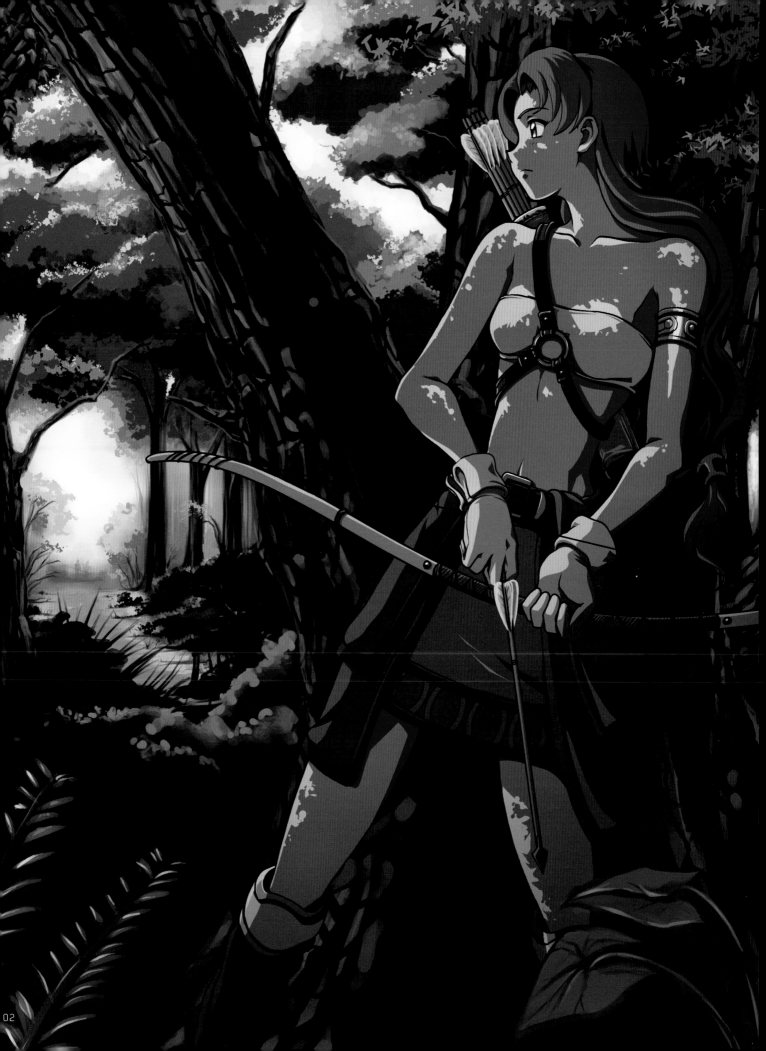

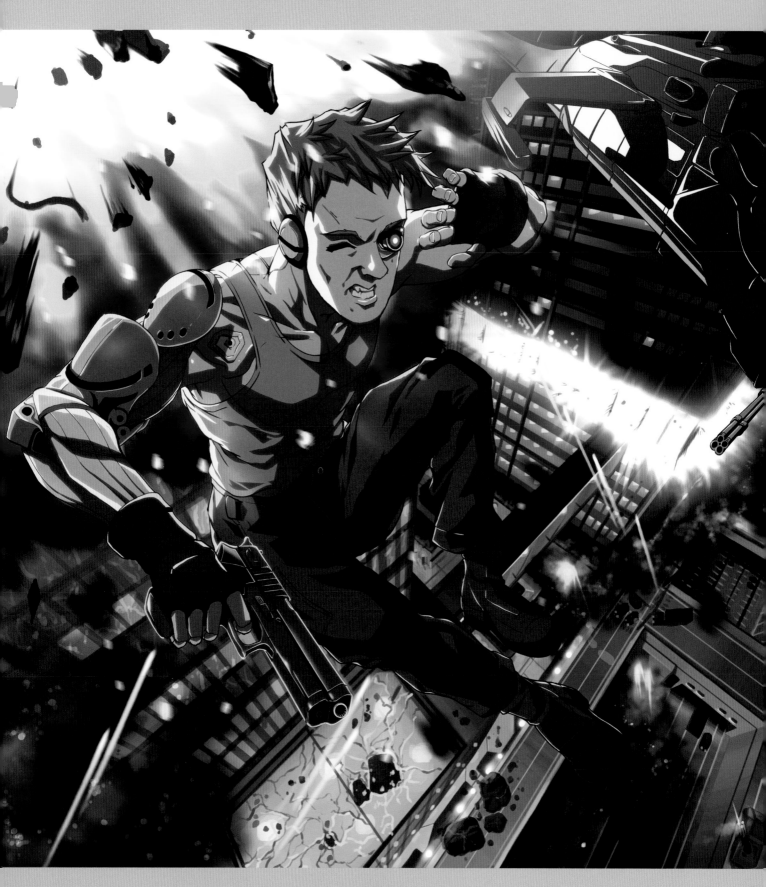

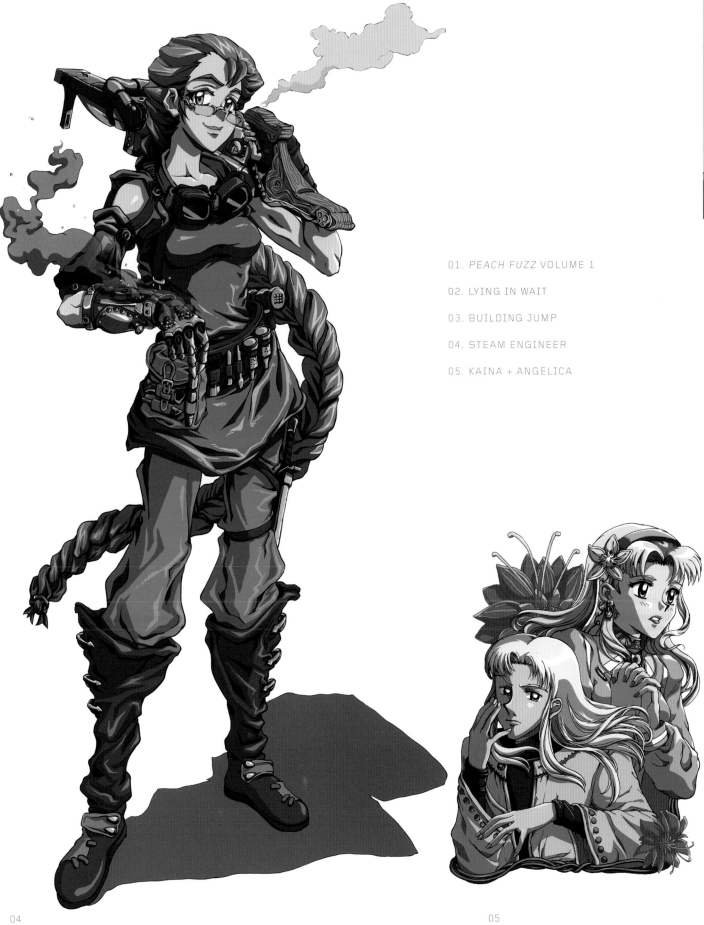

01. *PEACH FUZZ* VOLUME 1

02. LYING IN WAIT

03. BUILDING JUMP

04. STEAM ENGINEER

05. KAINA + ANGELICA

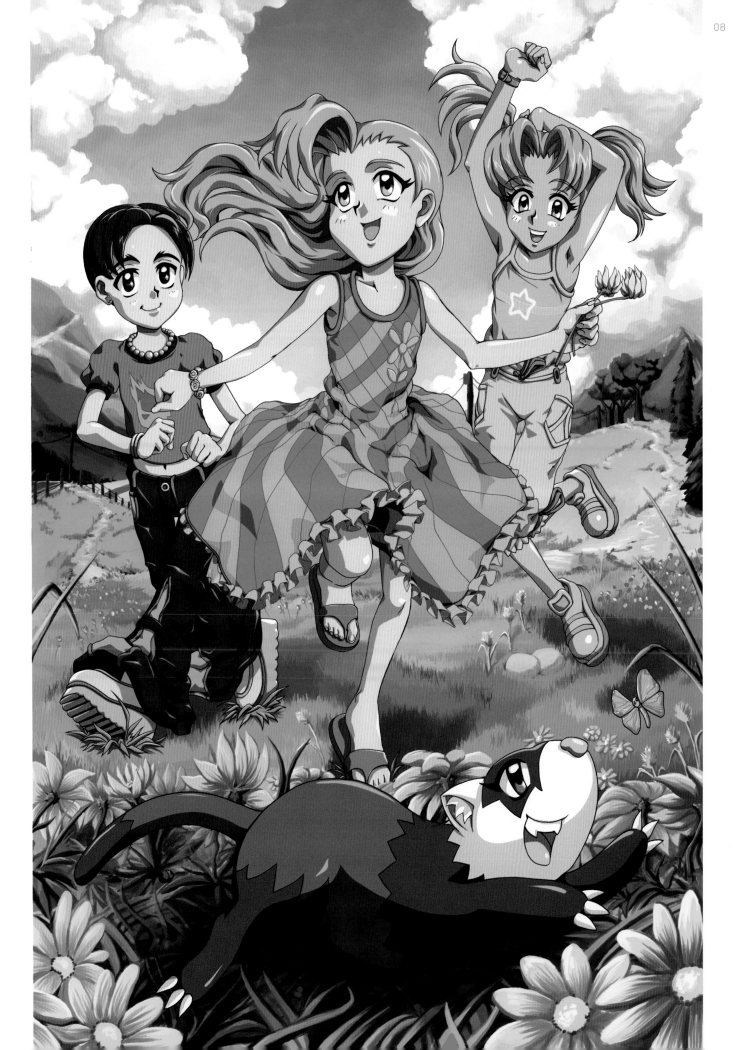

Q + A WITH LINDSAY + JARED

YOUR ART STYLE:

Both: We strive to create works that combine the visual impact and composition of fine art with the look and feel of a still frame of animation. There's a synergy in animation between the realistically rendered background paintings and the bold vitality of simplified, cell-style character art.

YOUR INFLUENCES:

L: Some of my major influences include the masterful story-telling abilities of animation director Hayao Miyazaki; the fluid character animations of Andreas Deja; the decorative works of Alphonse Mucha; the character designs of Atsuko Ishida, Shinya Hasegawa, and Nobuteru Yuuki; and the manga layouts of CLAMP. The character designers in particular heavily influenced my artistic style over the years. I love the level of detail in their work: intricately flowing hair, eyes that shine like jewels, and imaginative costumes and character designs, all elements that are very important to me in my own illustrations.

J: Artistically, I think my style has been most influenced by animation artists like Ikuko Itoh, Yoshiyuki Sadamoto, Toshihiro Kawamoto, and Nobuteru Yuuki, and fantasy artists like Keith Parkinson, Larry Elmore, and Greg and Tim Hildebrandt.

YOUR ARTISTIC DUTIES:

L: In our illustration work, we both handle all artistic duties, from the initial rough sketch to the finished color, although this is oftentimes divided with Jared inking my work, or with my coloring his work, depending on our workload.

J: In the case of *Peach Fuzz*, since it's a collaborative effort between Lindsay and myself, we split up the work evenly to streamline the process and keep the art consistent. We conceptualize the story and write the script together; Lindsay draws the rough layouts and penciled pages, I ink, and then either one of us applies the final touches, such as screen tones and text.

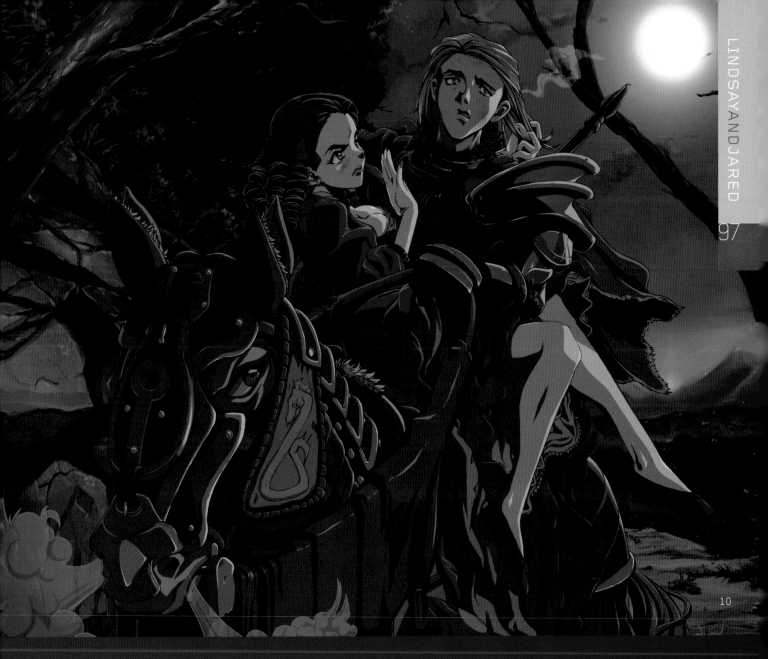

10

FAMILY, FRIENDS, AND NOTORIETY:

L: My family is really proud of me! Growing up, they discouraged me from a career as an artist, but I've managed to turn their opinion around with a couple of books under my belt. I don't know if all of them "get" my manga-influenced art style, but that doesn't stop them from wanting a signed copy of my book.

J: I've been providing for myself as an artist for six years now, and to this day I'm not sure my family understands what I'm doing. The only time I'm a celebrity is when I'm trying to get conventions to cover my travel and lodging expenses; otherwise I'm just a guy who makes a living drawing.

THE FUTURE OF WESTERN MANGA:

L: As time goes on, and more quality manga are produced outside of Japan, I think people will grow to love and support the work of American manga creators. Just as *manhwa* (Korean-made manga) were faced with a similar bias when they first hit the American marketplace, but achieved a general acceptance as more were released over a period of time, I expect the same will happen for American manga.

FOR THOSE WHO OPPOSE WESTERN MANGA:

J: I'm not sure why anyone interested in seeing manga flourish and evolve as an art form would oppose American manga. We're not phonies; we're not drawing this way as a marketing ploy, or because it's "uber cool." We love manga. We've grown up on manga. New blood brings the opportunity for new innovation in manga. New stories, new concepts.

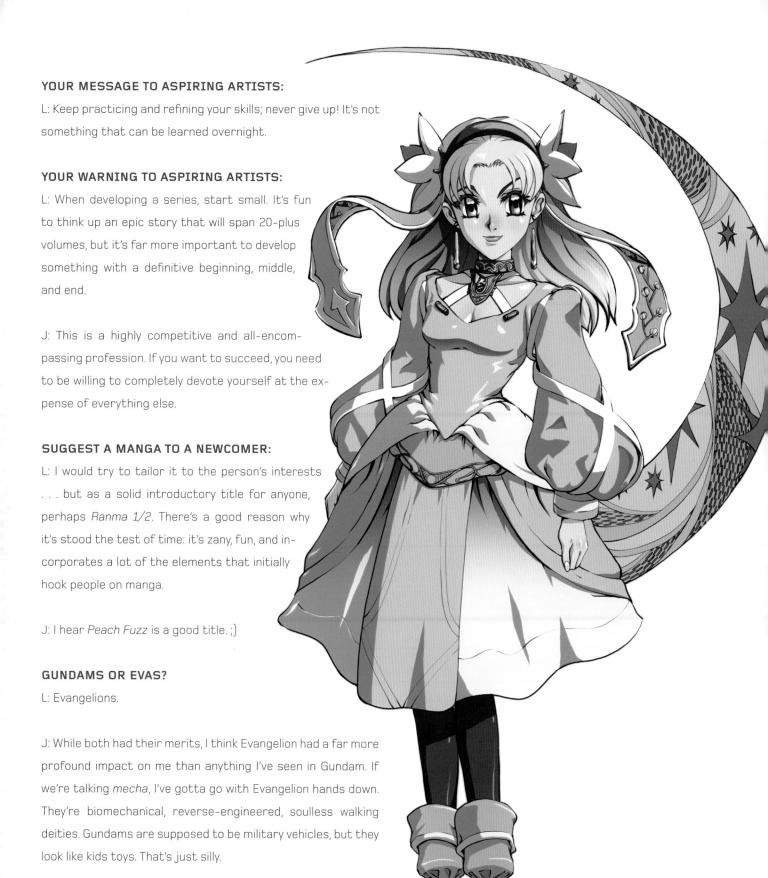

YOUR MESSAGE TO ASPIRING ARTISTS:

L: Keep practicing and refining your skills; never give up! It's not something that can be learned overnight.

YOUR WARNING TO ASPIRING ARTISTS:

L: When developing a series, start small. It's fun to think up an epic story that will span 20-plus volumes, but it's far more important to develop something with a definitive beginning, middle, and end.

J: This is a highly competitive and all-encompassing profession. If you want to succeed, you need to be willing to completely devote yourself at the expense of everything else.

SUGGEST A MANGA TO A NEWCOMER:

L: I would try to tailor it to the person's interests . . . but as a solid introductory title for anyone, perhaps *Ranma 1/2*. There's a good reason why it's stood the test of time: it's zany, fun, and incorporates a lot of the elements that initially hook people on manga.

J: I hear *Peach Fuzz* is a good title. ;)

GUNDAMS OR EVAS?

L: Evangelions.

J: While both had their merits, I think Evangelion had a far more profound impact on me than anything I've seen in Gundam. If we're talking *mecha*, I've gotta go with Evangelion hands down. They're biomechanical, reverse-engineered, soulless walking deities. Gundams are supposed to be military vehicles, but they look like kids toys. That's just silly.

EARLY BIRD OR NOCTURNAL?

L: Definitely nocturnal.

J: Both. As you can imagine, this causes problems.

11

DESCRIBE A CON EXPERIENCE:

L: One time in artist alley I had a person come up to my table, who did not realize that Jared and I were the artists, even though we had our names prominently displayed on the table right next to a stack of *Peach Fuzz* copies. The exchange went something like this: person flipped through the art prints, got to the section of *Peach Fuzz*-related illustrations, and made the comment, "Looks like someone is a big fan . . . ," which was my cue to point out that I'm the creator. Why this person thought I would be selling random manga at my artist table, I'll never know.

GOAL FOR THE FUTURE:

L: To keep improving my skills, and hopefully get an animated series produced for one of my stories someday.

J: Create more stories, create more artwork, help expand the market, create a real honest-ta-gawd studio, and find financial security.

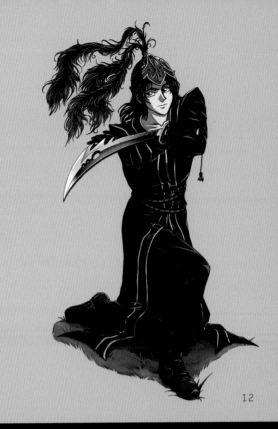

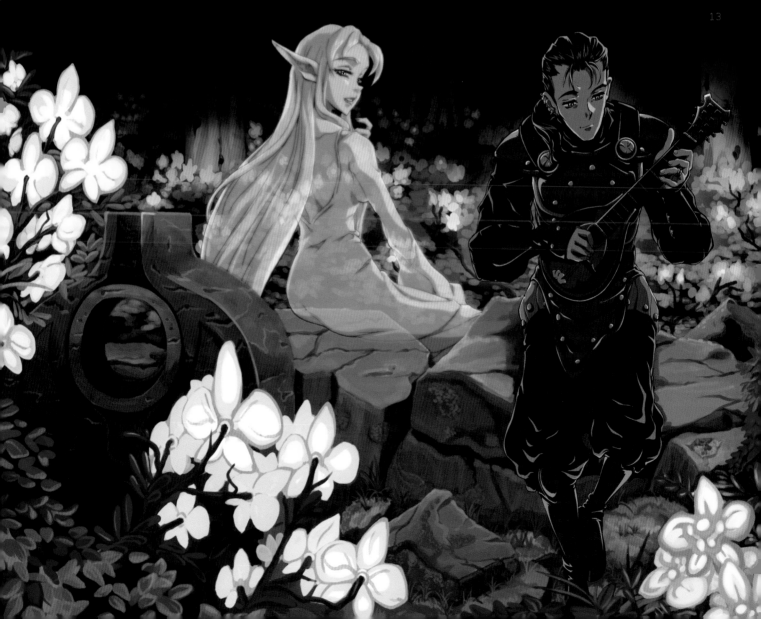

DIGITAL SCREEN-TONE
TUTORIAL

BY LINDSAY + JARED

SCREEN TONING

Screen toning is a powerful technique that allows you to convey light, shadow, form, mood, and texture through the use of small repeating dot patterns. A careful balance of tone can help lead the reader through a comic page and bring attention to important characters and key elements.

Traditionally, the process involves applying clear, adhesive sheets of dot tone to your pages; cutting away the excess; and etching into it to achieve shading and other effects. However, real screen tone can be expensive—a single sheet of tone can run from one to four dollars, and a single comic page can require numerous sheets—and difficult to obtain.

Luckily, it's possible to re-create authentic-looking tone patterns found in manga using Adobe Photoshop.

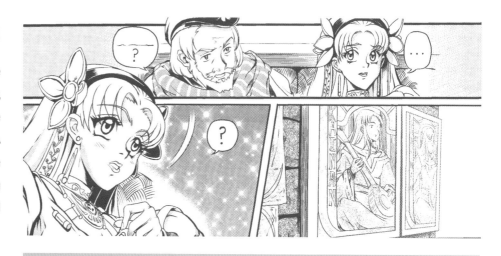

TYPES OF SCREEN TONE

Screen tones come in several primary categories: basic dot tones, gradients, textures, lines, and patterns.

 BASIC DOT TONES consist of flat tonal values. Very versatile and easy to make, these tones can be used to suggest shades of color, or they can be cut to indicate shadows and highlights.

 GRADIENT TONES can be used to create a smooth shift from light to dark, useful for subtle shading, fading out elements, and adding variation to a page.

 TEXTURE, LINE, & PATTERN TONES are excellent for adding additional coarseness, enhancing the tactile quality of objects, and breaking the monotony of standard dot tones. Texture can make the difference between a smooth sidewalk and a bumpy road, a silky blouse and a thick sweater.

01

To make a basic dot tone in Photoshop, first create a new document. Its size should be slightly larger than your comic page's final output size. For tight, profession-looking dot patterns, set the document's resolution to a minimum of 600 dpi. Set the color mode to grayscale, and press OK.

02

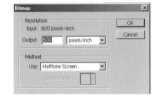

Toning uses luminance as a way of judging the amount of light and dark on a page. For now set the luminance (L) value on the Color Picker to 90. This will make 10 percent gray tone. Click OK and fill the document by choosing Edit > Fill.

03

Finally, change the document's color mode to bitmap by choosing Image > Mode > Bitmap. When prompted, set the document's output to 600 dpi and choose Halftone Screen as the conversion method. On the next prompt, set the frequency to 85 lines/inch, the angle to 45 degrees, and the shape to round.

Voilà, you've made your first screen tone! Save the file for later use, then go back a couple of steps and fill the document with increasingly darker tones of gray (80 for 20 percent, 70 for 30 percent, 60 for 40 percent, and so on), and follow the same bitmap conversion process.

This basic premise can also be applied to creating gradients or any other grayscale design. Simply fill a document with your desired gradient or grayscale pattern. Keep going and soon you'll have the start of your own basic tone library.

For most circumstances, a minimum of five basic tones of varying luminosity, along with a couple of textured tones, is enough to get started. Continue to add to your tone library when possible. The larger it is, the more versatile your options will be when screen toning.

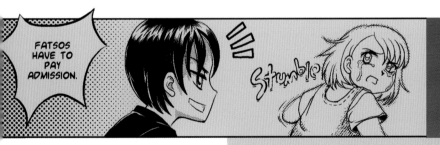

TONES WITH THREE DIFFERENT LPI SETTINGS ARE USED IN THIS PANEL. A 27.5 LPI GRADIENT DRAWS THE EYE TOWARD THE CENTRAL CHARACTER, WHILE AN 85 LPI TONE WORKS AS SHADING. A 50 LPI TONE TRACES THE OUTLINE OF THE CHARACTER ON THE RIGHT—SUBTLE AND EFFECTIVE

ADDITIONAL TONES
CAN BE MADE BY:

ADJUSTING THE LPI SETTING

Lines per inch (lpi) indicate the number of lines vertically or dots horizontally in a square inch. Standard sizes for tones range from 27.5 lpi (dots are very big and spread out) to 85 lpi (dots are small and tightly spaced together). The 85 lpi setting produces tone with a smooth, almost-gray appearance. While it's not recommended to go higher than this (tighter dot patterns cease to look like screen tone, and some printers have difficulty printing them), setting the line frequency lower can create coarser tones for texture and dramatic effects.

CONTINUED >>

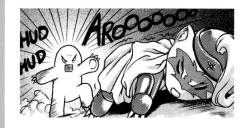

CHANGING THE CONVERSION METHOD

The Diffusion Dither setting creates tight noise patterns useful for texture and design. DIFFUSION'S TIGHT PATTERNS (USED IN THE BACKGROUND HERE) LOOK GRAYSCALE IN PRINT. >>

Also try using Custom Pattern and choosing a tiled pattern from Photoshop's library, or loading your own. Not every pattern produces great results, but sometimes they can result in exciting new texture tones.

THIS GRADATED CUSTOM PATTERN, MADE WITH THE "STRANDS" PATTERN, COULD BE USED AS FUR OR GRASS.

UTILIZING OTHER SOURCES

Real-life textures and patterns can be scanned and converted to bitmap to further build your tone library. Traditional screen tone can also be scanned for use as digital tone, but take care to ensure the sheet of tone is perfectly aligned with the edge of the scanner to minimize problems such as moiré, and scan them at your final page output size and dpi.

THE BOY'S SWEATER TEXTURE WAS MADE FROM A SCAN OF A WASHRAG.

Working digitally, the process of applying tones is slightly different from traditional screen toning. Even so, the aim of digital screen toning is to reproduce the look of a traditionally screen-toned page.

APPLYING TONES IN PHOTOSHOP

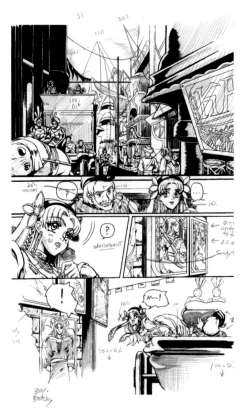

PREPARING YOUR PAGE FOR TONE

01 First, ensure that the page is correctly sized in a template that represents the final output. Then remove any gray values from the page by changing the mode to bitmap. Choose Image > Mode > Bitmap, set the input and output pixels/inch to 600, and the method to 50 percent threshold. Next, since layers can't be used to bitmap mode, change the image back to grayscale. Choose Image > Mode > Grayscale. Finally, create a tone layer set by choosing Layer > New > Layer Set. This will help keep your tones separated from your line art, guides, text, or any other miscellaneous layers.

PLANNING

02 Figuring out which screen tone to use can be daunting at first. Depending on many factors, a single page can have upward of 10 separate layers of tone. It helps to consider the overall desired look of the page before applying any tone. I find the easiest way to do this is by printing out a copy of the page and making notation about which tones to use and where.

SCENES LIKE THE ESTABLISHING SHOT IN THE FIRST PANEL CALL FOR A SCENIC TONE TREATMENT, WHILE PANELS WITHOUT BACKGROUND ELEMENTS OFTEN BENEFIT FROM EMOTIONAL TONE TREATMENTS, SUCH AS THE THIRD PANEL, OR PANELS WITH INTERNALIZED DIALOGUE.

03 PLACING TONES

Using selection tools, select a small area on your page. Then open your pre-saved dot tone file. Copy and paste the tone into the selected area, and set the layer composition method to Multiply. You've now created your first layer mask of tone. Repeat the process to add additional screen tones to your page.

04 WORKING WITH LAYER MASKS

Rather than modifying the actual tone layers, layer masks are used to EXPRESS or HIDE areas of tone on a layer. Since the dot tones are always intact underneath the mask, any cuts and etching can be easily added or subtracted without needing to reapply the tone. For a visual representation of the layer mask, hop over to the channels menu and make your layer mask visible or press shortcut key \.

THE RED IS MASKED, AND THE WHITE REPRESENTS THE UNMASKED AREA WHERE THE TONE SHOWS THROUGH.

TOOLS There are a number of different tools that can be used to express or hide the tone. Selection tools work well for large areas; brushes and erasers are good for small areas; and even lines and shapes are useful at times. In any case, any tool using white on the layer mask reveals tone; using black hides tone.

AVOID THIS. DOTS SHOULD NOT APPEAR FUZZY, SEMI-OPAQUE, OR GRAY.

BLACK AND WHITE. NO GRAY!

The point of tone is to represent shading and texture through the use of one color, black. When working with tones, it's important to work only in black and white. Tools like soft airbrushes and gradients used on the layer mask will create areas of gray, or partial tone expression. This effect may look nice on-screen, but it can have unpredictable results in print. Stick with tools and settings that limit the amount of in-between grays on-screen.

LAYER MASKS AS SELECTIONS: Layer masks can be used as selections (right-click on the layer mask and choose Set Selection to Layer Mask), allowing for more tone to be copied into a precut area. This is helpful when layering several tones in an area, or replacing a tone that doesn't work as well as planned.

MOVING TONES

Tones can be shifted around without changing where they're expressed on the image (make sure you're moving the tone and not the layer mask). This is important if you want to adjust the portion of the tone showing through the mask or when overlaying tones (see advanced techniques on page 104).

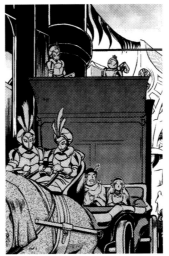 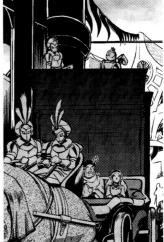

ADVANCED TECHNIQUES

CUTTING AND ETCHING

Traditional screen-tone cutting and etching is generally accomplished using a craft knife. In Photoshop, the brush tool (with a few tweaks to its settings) is a good equivalent.

FLASH ETCHING

Flash or quick stroke etching is easy enough using a pressure sensitive tablet. Try to do your etching with a small tapered line that cuts through the individual black dots of the screen tone at an angle.

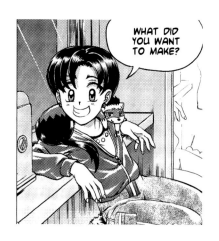

HERE'S HOW TO MAKE A SCREEN-TONE ETCHING BRUSH IN PHOTOSHOP 7.0:
-SET THE DIAMETER BETWEEN 5 AND 10 PIXELS, WITH THE MODE SET TO DISSOLVE
-FOR BRUSH TIP SHAPE, SET HARDNESS TO 100%, AND SPACING TO 25%
-FOR SHAPE DYNAMICS, SET CONTROL TO PEN PRESSURE
-ENABLE DUAL BRUSH; SET MODE TO COLOR BURN, DIAMETER TO 1 PIXEL, AND SPACING TO 25%

PRECISION ETCHING

Etching tones using a ruler in angled parallel strokes, or precision flash etching, is a technique often used in manga. Doing this technique digitally with any finesse is tough.

Unlike paper, tablets don't allow for easy usage of rulers. The following custom brush, while not a perfect substitute for a ruler, helps with precise etching.

STARTING WITH THE ETCHING BRUSH SETTINGS:
- Increase the Diameter into the hundreds of pixels, decrease the Roundness to 1 percent, set the Angle as required (try to avoid cardinal and intercardinal points), and increase the Spacing to 1,000 percent.
-Turn off Shape Dynamics.

It helps to make a selection around the area undergoing precision etching. This keeps the process from affecting finished cuts of tone in the surrounding area. The first pass of strokes is quickly tapped in, one by one, at an angle. An optional second pass of strokes at a slightly offset angle creates a softening effect. Afterwards, clean away stray dots using the normal etching brush.

OVERLAYING TONES

Dots of the same lpi can be overlaid to create extra shadows and effects. Try combining a gradient with a flat tone for gradual shading effect. There are a couple of different ways to do this, all of which yield slightly different results.

PERFECT OVERLAY

Placing one tone directly over another tone covers the smaller of the two tones, revealing only the darker, larger dots.

SEMI OVERLAY

Aligning two tones side by side so they are touching results in a medium combined tone value.

DOUBLE OVERLAY

Positioning one tone between the dots of another tone so that both are fully visible results in a much darker value.

EYE-REPELLING INTERFERENCE PATTERNS FORM BY COMBINING A 50 LPI AND A 65 LPI TONE.

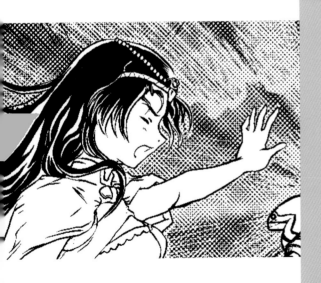

AVOIDING MOIRÉ

Moiré patterns can occur when screen tones are handled incorrectly. While there are rare cases when moiré can be used intentionally to create interesting effects, more often than not moiré is an undesirable optical effect that should be avoided.

TO AVOID MOIRÉ PATTERNS:

- Don't resize your pages or screen tones. One of the reasons why it is important to place tones at your final output size is because resizing changes the spacing between individual dots, which can cause moiré.

-Don't overlay screen tones of different lpi. The dots won't align properly.

-Be careful when rotating tones. If you must rotate a tone, try to stick to 45-degree angles (for example, its safe to flip the gradient tone 90 degrees or 180 degrees). Free transformation can mess up the dots.

COREY
THE REY
LEWIS

Corey Sutherland Lewis was born on June 15, 1982. He currently resides in Seattle, WA, and has two cats, Wipeout and BB. Some of Corey's past projects include *Sharknife*, a graphic novel published by Oni; a one-shot called *PENG*; *Apollonia NO!*, a self-published comic; an online comic, *PINAPL*; *Canon Busters #0*; a comic strip called *Appleton*; and *Street Fighter* and *Darkstalkers* comic strips. Currently, Corey is working on *Sharknife* graphic novels; a comic called *Rival Schools*; *Apollonia NO!*; *Half-Alive Boy*; and a comic called *Kei-Kou-Gyu-Go*. You can see more of Corey's work at his Web site, www.reyyy.com.

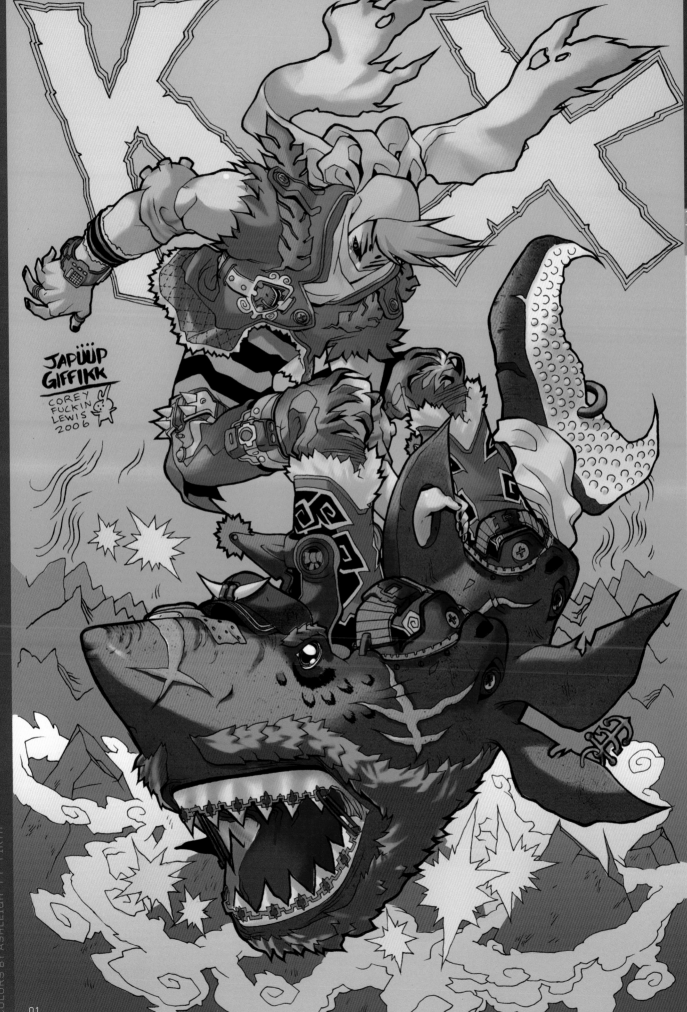

03

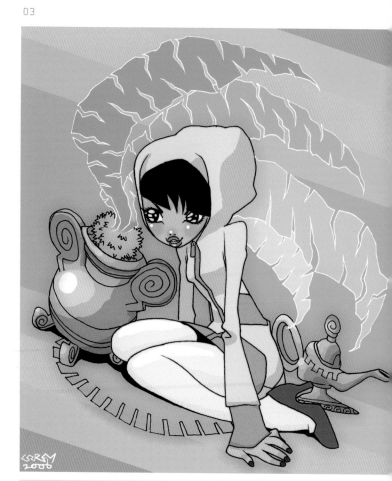

02

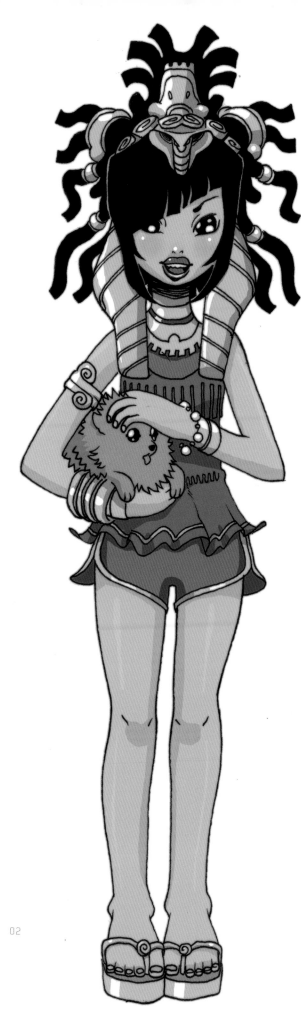

04

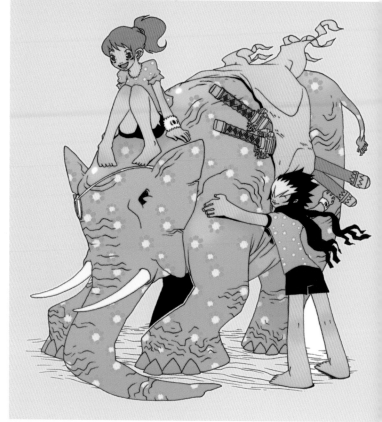

01. JAPUUP · 02. JENI · 03. JENI 2 · 04. ELEPHANT · 05. ANO

06. SHARKNIFE · 07. PENG · 08. REDROX · 09. PENG · 10. PENG II

Q + A WITH COREY LEWIS

YOUR ART STYLE:

I like my work to contain energy and excitement and possibility. My drawing habits are basically dictated by things I really enjoy to draw at any given time . . . right now, I'm working on shapes and patterns and sharp angles and massy weight and stuff. I suppose you could sum up my current style as cartoony yet serious yet rock 'n' roll.

INFLUENCES:

I am a stepchild of *Shonen Jump*. Akira Toriyama's *Dragon Ball Z* was an early influence on me; I love his work in all shapes and forms, really. More recently, Masashi Kishimoto's *Naruto* has me on my knees. I love Naruto from practically every angle, as a comic. Some other classics like *Guyver*, *Vagabond*, *Gundam*, *Ranma 1/2*, *Evangelion*, and *FLCL* have all played major roles in my artistic development over the years. Within my own local scope of comics, I am highly influenced by artistic allies Bryan Lee O'Malley, Becky Cloonan, Brandon Graham, and Paul Pope.

ARTISTIC DUTIES:

For my own books, I do about everything. I will develop an idea, write a script, design characters, draw pages, screentone (or CGI or marker, or whatever finishing method), and design pages (like tables of contents or covers or whatever). For *PENG*, I also formatted the book for printing . . . for comics, I'm working on my entire skill set as a comics illustrator, from the beginning to the end of production. I'm still developing some finer illustration techniques like focus drawing and proper character turnarounds and environment design and all that.

LEAST FAVORITE PART OF THE CREATIVE PROCESS:

Not having "it." There are days when I'm on my path and feeling good about everything I'm creating, and then there are days when I wonder if I'm doing things correctly, or if drawing is really all that serious at all. Sometimes I overreact, but I think it comes with being very passionate about my life's work.

YOUR WORK SCHEDULE:

I'm working on upgrading my life to be a lot more professional about things. I really admire the Japanese comics work ethic, and I want to be more like that really soon in terms of consistency and drawing regularly. Right now, I'm involved in so many projects with so many different styles that my drawing schedule is pretty scattered and makeshift. I draw when it feels good. But if there's a deadline coming up, I crunch harder to get things finished quicker.

FAMILY, FRIENDS, AND NOTORIETY:

My family has always been supportive of my art, as well as my friends. I think they have a good idea of what I am doing, professionally, but maybe not so much about the spirit of my work. Not that they don't understand, but more that they aren't particular fans of my style. I'd say I'm kind of mildly famous in indy comics. I have fans, I have critics, I've got some cred . . . I'm good.

> ## "I REALLY ADMIRE THE JAPANESE COMICS WORK ETHIC . . ."

YOUR PRINTED WORK:

Both of my books have debuted at amazingly epic comic festivals. *Sharknife* dropped at the Alternative Press Expo in San Francisco. We had fortune cookies with *Sharknife* fortunes on the inside, with huge stacks of books. I think we sold 120 books or something. Not bad. *PENG* came out at the Small Press Expo in Baltimore, which was equally fun, spending table time with my mutual homie Bryan O'Malley. There have been fun dinners and parties with toasts and stuff. Classy times.

DESCRIBE MANGA TO A NEWCOMER:

It's just comics, but usually thicker. The stories seem scrutinized more, and the artwork is more concentrated because the creators work in teams with a single vision, unlike changing art teams per story arc or whatever. Also, it's mostly black and white, because when you draw dozens of pages a week, you don't have time to color all of them. Oh, and it's Japanese.

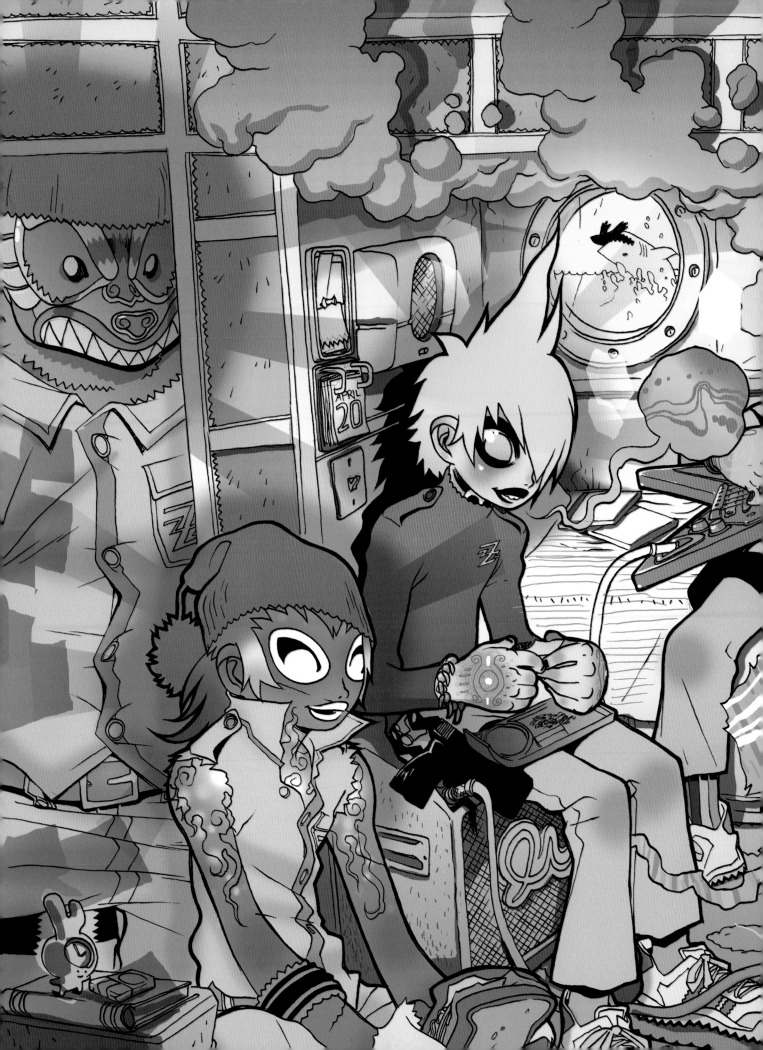

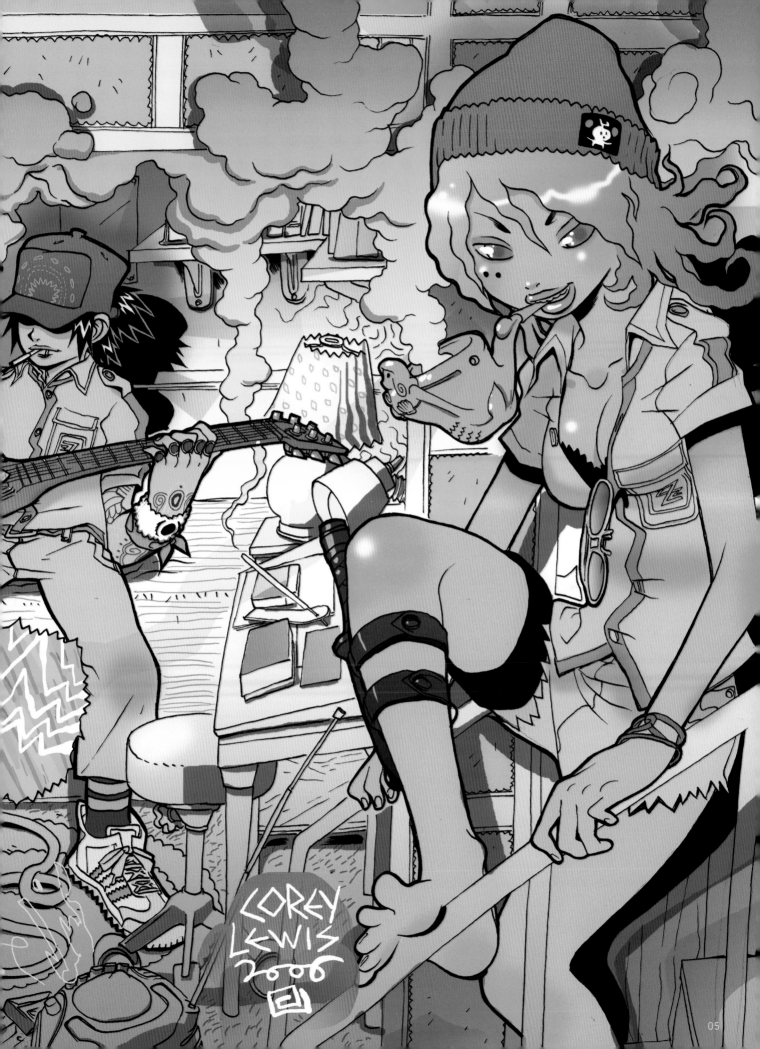

SHOULD WESTERN MANGA BE CALLED "MANGA"?

I think no. Personally, I don't consider my work "manga," because I'm not Japanese. My comics are just comics, regardless of style. I heard the Japanese have a term for American manga called "Nissei Comi," or like "not real manga" or something. I think if that's true, we should consider it a hint and stop trying to front. If you're in America, you pretty much just draw comics. Of course, comics of any region can be any style you want.

YOUR MESSAGE TO ASPIRING ARTISTS:

Draw what you want when you feel inspired. Draw what you have to when you want to get something tangible out of it. If you feel lost, just remember that we are all there with you in this artist lifestyle. Having fun will make you draw better, so try to do that.

YOUR WARNING TO ASPIRING ARTISTS:

Don't let the man boss you around too much. They may have the money, but you got the skills!!!!! Skill is in the blood!!

GUNDAMS OR EVAS?

I love the Evas, but Gundams are timeless. They are the ultimate, definitive robot. Right up there with Optimus Prime.

FAVORITE NON-JAPANESE COMICS:

I read anything Paul Pope puts out. I enjoy his *THB* series a lot. My favorite book by Pope is *Heavy Liquid*. I also cherish Bryan O'Malley's *Scott Pilgrim* series. Those are really the only two artists in the Western Hemisphere that I keep a watchful eye upon (that I don't live with).

YOUR FUEL:

I like getting those Wired B12 energy drinks. The long green ones in the can. I drink coffee sometimes. Also, a quick game of Street Fighter or Final Fantasy or Dance Dance Revolution between drawing sessions can get me quite reinvigorated.

KILLER MECHS OR CHIBIS?

Killer mechs!!!! Actually, the first kind of Gundam that really caught my interest was the SD Gundam—so both!

YOUR CATCHPHRASE: "Dude."

YOUR HAIKU:

I like to draw guys
I like to draw girls as well
I hope I draw well

GOAL FOR THE FUTURE:

To make more books, enough to fill a shelf. Maybe some toys, maybe a cartoon. Meet and befriend the artists I look up to, and ones I have not even met yet. Own original art by those same artists. Live happily and fully with friends and family and be productive, overall.

EXTRA: Seize the day.

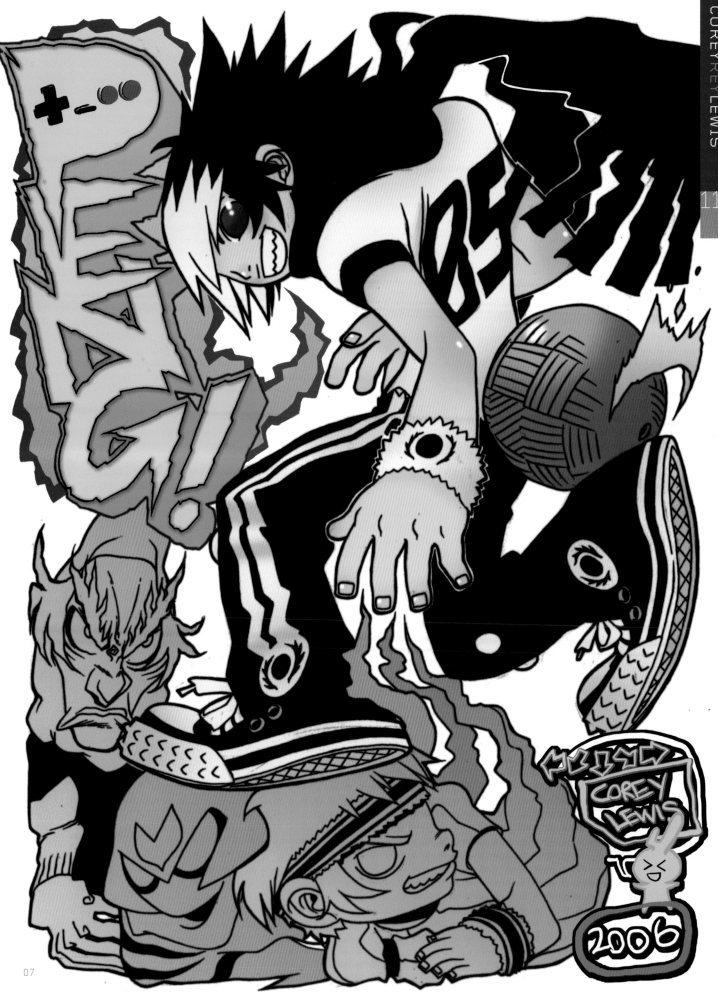

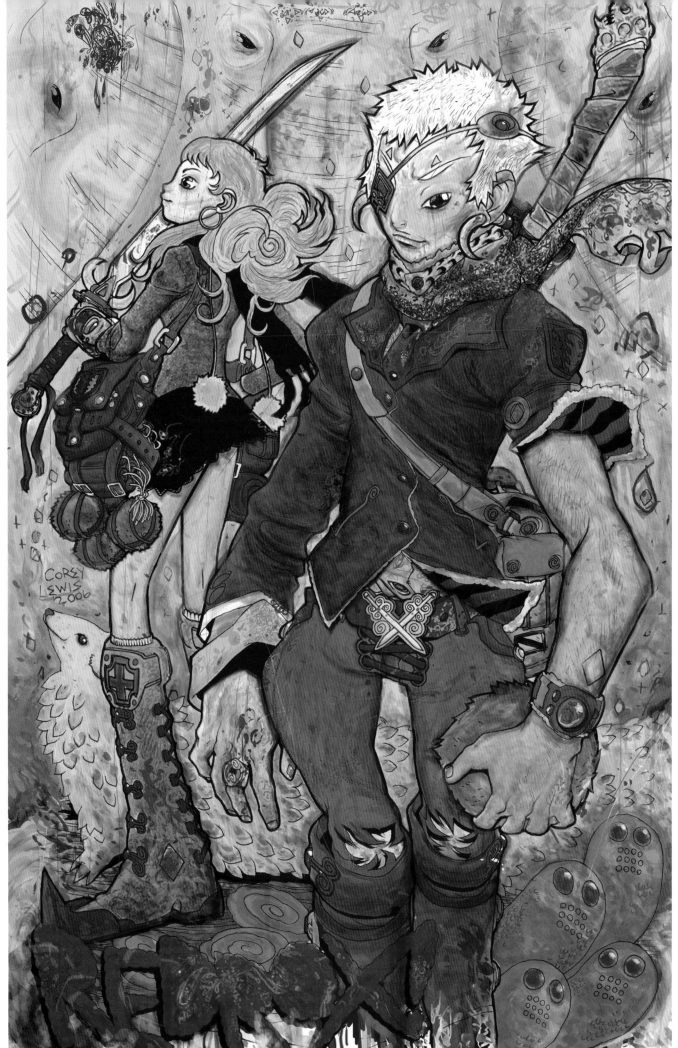

COREY
LEWIS
2006

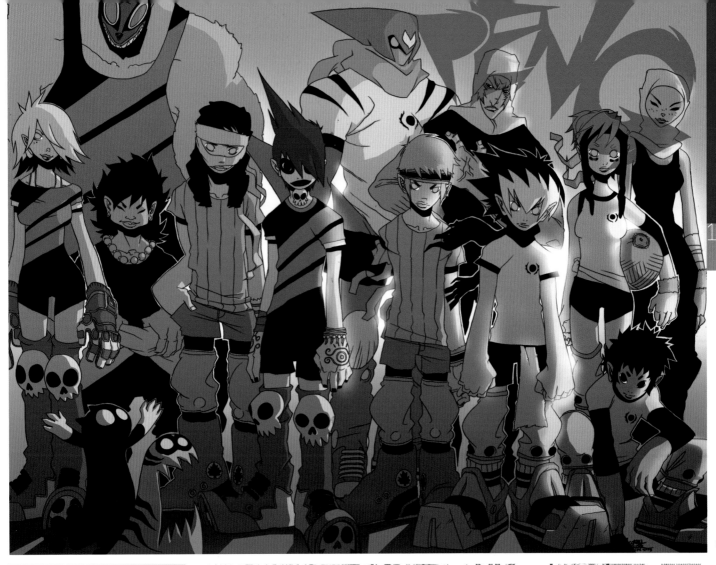

09

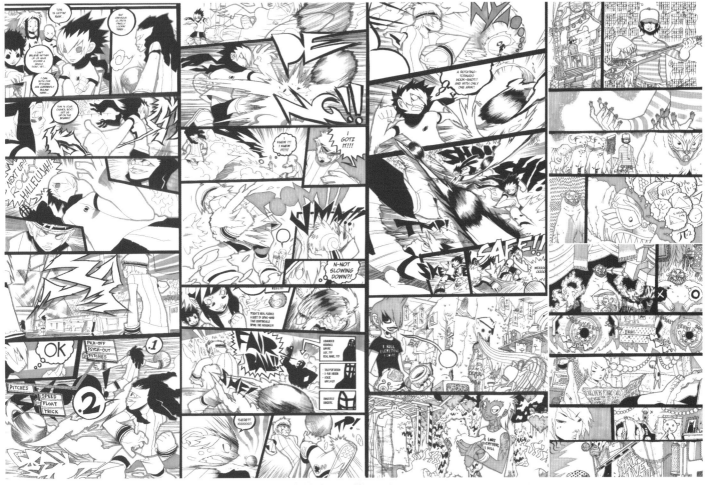

10

ENERGY IN LINE ART
TUTORIAL

BY COREY LEWIS

OK, step one. First of all, my method of drawing is almost totally based on instinct, so I suppose step one is to work up the energy to decide to draw and recognize what kind of direction you want your drawing to go into. This can often be the most difficult step. I suggest watching a film or playing a video game or reading some comics to get the creative stuff flowing.

So once you have the initiative, put the pencil lead end on the paper and start to make lines. Most of the time you will be creating something of a character-type drawing with a central person as the focus. For me, I draw lots of people in complicated action poses, which can be tricky. I start by drawing circles in red pencil to indicate some of the major human features like the head, shoulders, hands, knees, feet, and hips. I sketch these out very broadly and vaguely, mainly kind of "feeling" out what kind of pose my character is in, and trying to make it somehow anatomically feasible, although it is not essential to me to be 100 percent correct on anatomy. To me, the dynamic of the pose and the sleek flow of the character are more important.

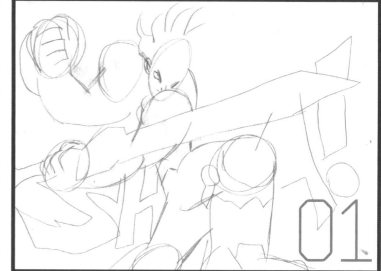

Once I have the circles in the right spots, I start to pencil in tight areas like the facial area. The eyes and nose and mouth are obviously incredibly important (and the chin can completely redefine the feel of a character), and I am also heavy into hair structure, so I'll figure out head shape and hairline. Once the face takes shape, the character begins to talk to me, so I can start drawing how his hands and feet and clothes will look. This process may take lots of trial and error, lots of erasing and disposal of eraser shavings. When feeling out my drawing, I play a lot with mass and shapes. Those are two very important things to me when rendering characters. I try to bring simple things out a little by putting weird amounts of depth and possibly odd angles and shapes into common areas.

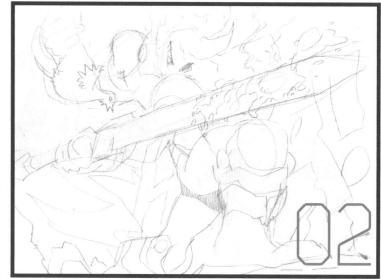

03 Once my red lines are tightened and my hazard spots are penciled, I go into the final stages of penciling and planning for final line art. At this stage I include sound effects. When including sound effects in an action image, it's important to be able to read the sound the effect is making, and the letters should be designed around the character to bring the character out more. Sound effects and characters should enhance each other mutually. I also include funny nuances like frying eggs on the guy's sword, and where does he get the eggs? A chicken in his other hand. This kind of stuff can't be taught. Look within.

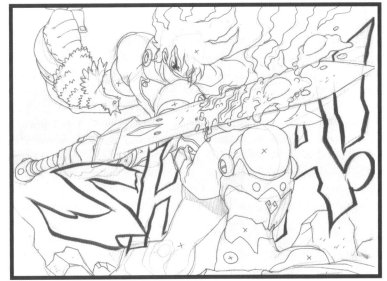

04 Once final pencils are decided, it is time to ink. Inking is incredibly easy because it is essentially tracing. I ink using 01 Sakura Micron pens. I'm still learning the finer aspects of inking, so I'm not a grand master at it yet, though my technique is fleshing out nicely. The main thing I do after the initial inking is to add line thickness—through the character, entirely around the body; in areas that require foreshortening; and in other areas of black—to bring out the drawing. Once the line art is complete, I scan my drawings at no less than 300 dpi .

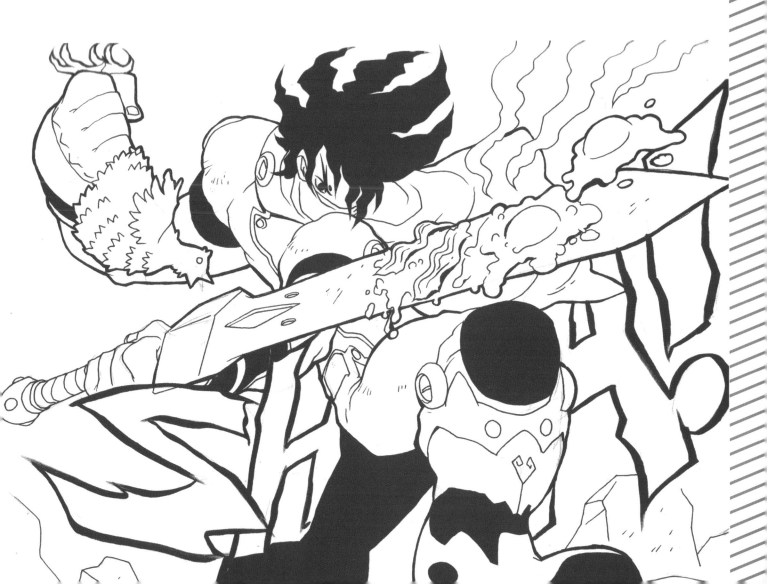

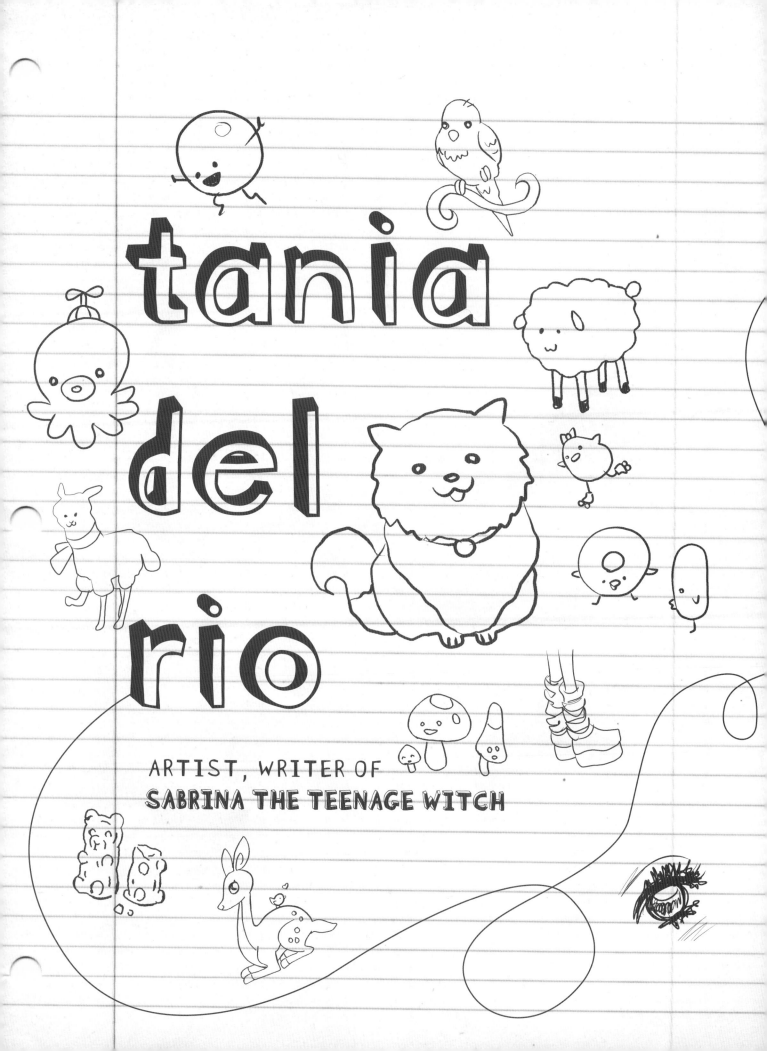

tania
del
rio

ARTIST, WRITER OF
SABRINA THE TEENAGE WITCH

01

TANIA DEL RIO, born November 16, 1979, currently resides in Westchester, NY, with her husband, Will, and her two dogs: Bailey, the corgi, and Oliver, the corgi mix. She received a BFA in animation from the Minneapolis College of Art and Design, where she also studied comics extensively. In 2003, Tania's entry *Lovesketch* was selected to appear in TOKYOPOP's *Rising Stars of Manga™*, volume two. Hearing of her work, Archie Comic Publications hired Tania to give their popular *Sabrina the Teenage Witch*, a manga makeover with a *shoujo* twist. Tania continues to work on *Sabrina* regularly, both writing and drawing each issue. Tania also writes a monthly manga column for popcultureshock.com called *Read This Way* and has a Web comic called *My Poorly Drawn Life,* which she updates weekly. You can see more of Tania's work at: http://witching-hour.deviantart.com and www.mypoorlydrawnlife.com

Q + A WITH TANIA

YOUR ART STYLE:

Light, fun, and full of movement. My previous training as a two-dimensional animator has influenced my work in such a way that I prefer clean, expressive lines, with little hatching or excessive detail. I like a strong silhouette in my art, and my focus is always more on characters and expression than on backgrounds.

INFLUENCES:

My training as an animator has taught me to be versatile, so everything I see and enjoy becomes absorbed into my style. Disney animation, old video games from the 8- and 16-bit era, and Wendy Pini's *Elfquest* are some of my earliest influences. More recently, I am inspired by the work of Hayao Miyazaki, Yayoi Ogawa, Ai Yazawa, and Rumiko Takahashi.

YOUR WORK PROCESS:

For *Sabrina*, I start by sending my editor a page-long synopsis of the story. Once that gets approved, I write the script—which is 20 to 23 pages, depending on advertising. After that, I do a rough layout for each page on an 8- by 11-inch piece of paper. I don't do thumbnails! My layouts are super rough—little more than scribbles and stick figures. Then I jump right into the pencils. I always work in order and I even finish each panel in order, before moving to the next one. I can't jump around because it throws me off.

PREFERRED PENCIL:

Mechanical. The only lead I like is Pentel Super HB 0.5. It's the only lead that doesn't break when I use it, and it doesn't smudge as much as others.

PREFERRED INK:

Digital. I'm hopeless at real inking. I ink in Comicworks or Manga Studio with my digital tablet.

FAMILY, FRIENDS, AND NOTORIETY:

My family has always been entirely supportive of my art, and has helped me out a lot in achieving my goals. But I have to admit that my parents weren't crazy about comics at first. My dad grew up in Mexico where comics are either for young children, a way to communicate to illiterates, or pornographic. My mom also thought that comics were "cheap" and something for the uneducated. Luckily, since my work on Sabrina, they have both changed their opinions and they are very supportive and enthusiastic about my work.

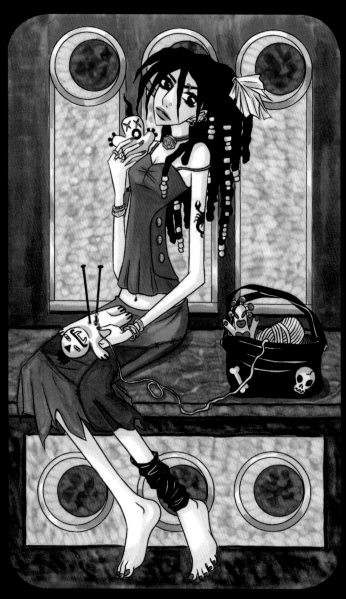

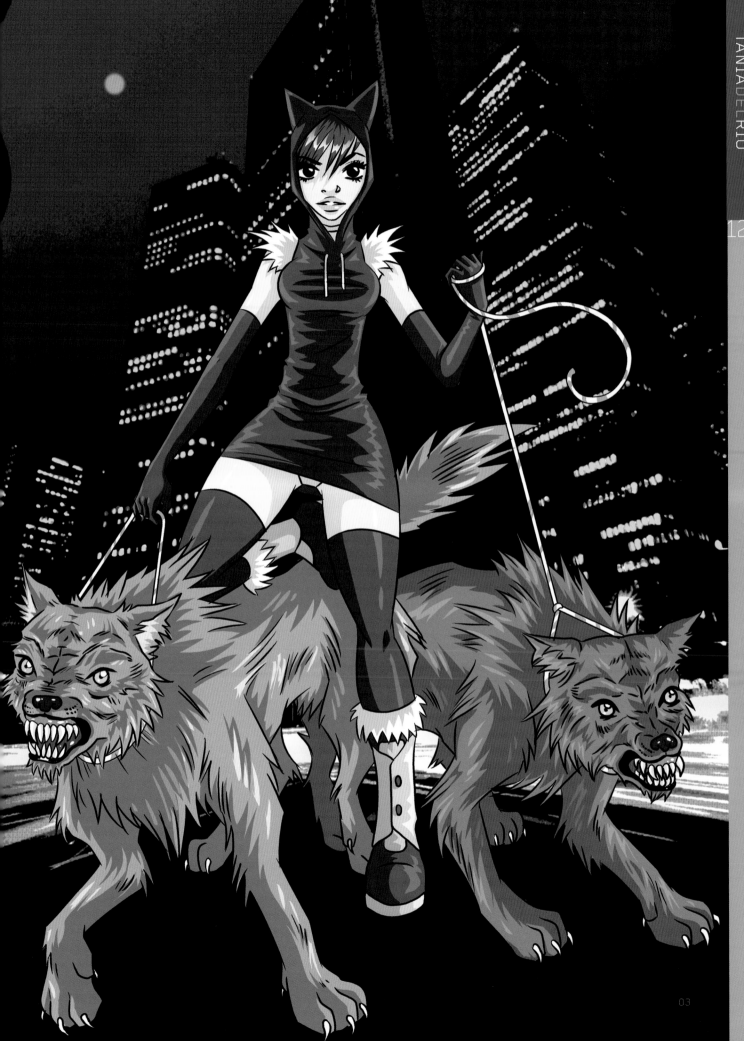

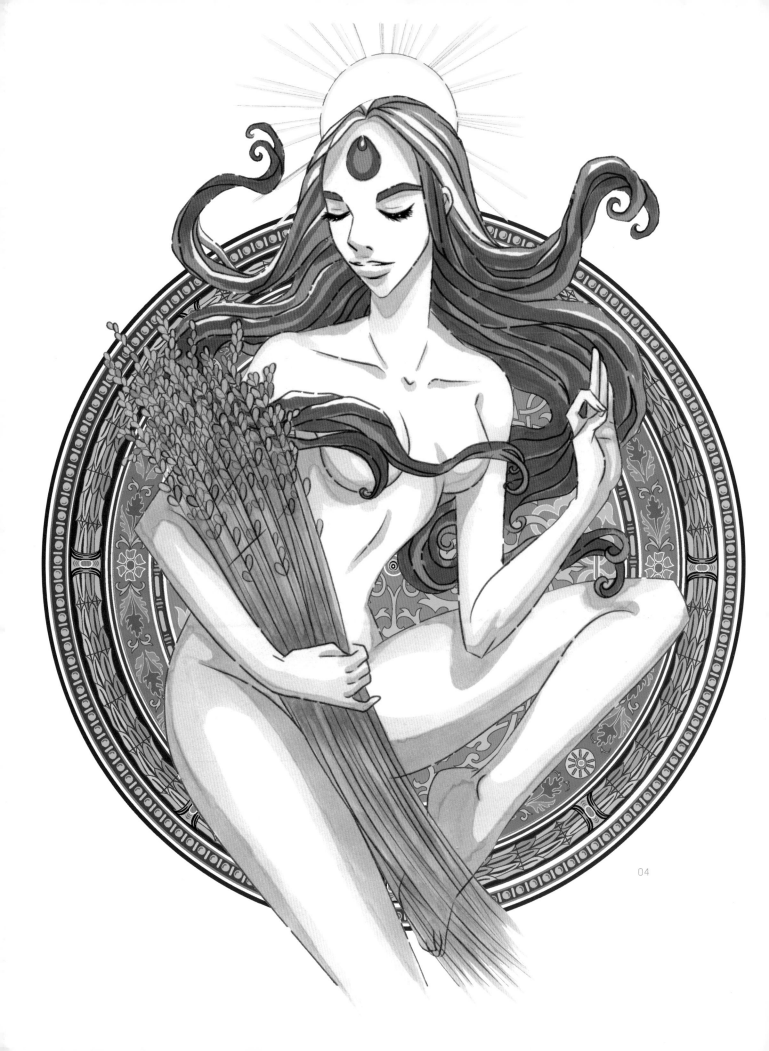
04

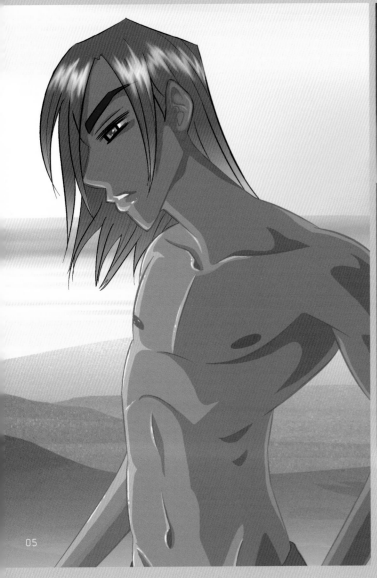

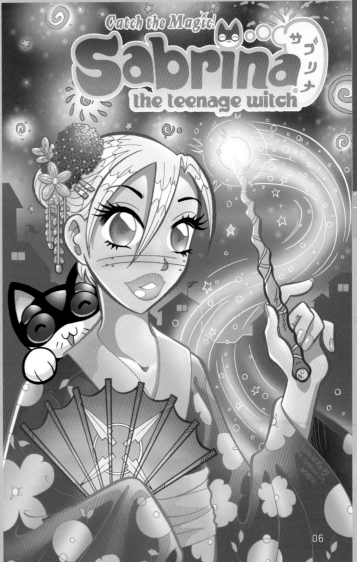

⌃ INKS BY JIM AMASH / COLORS BY JASON JENSEN

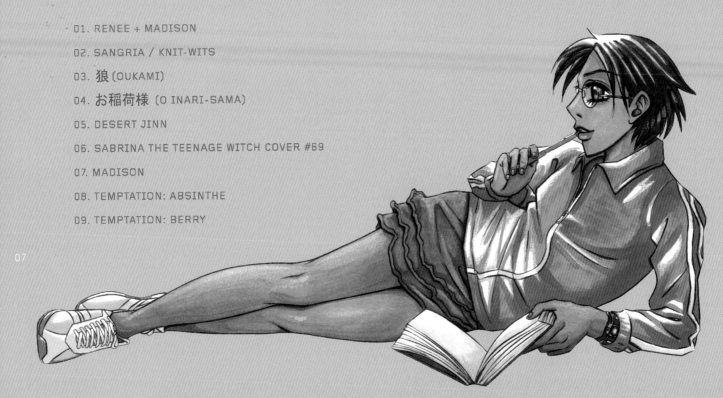

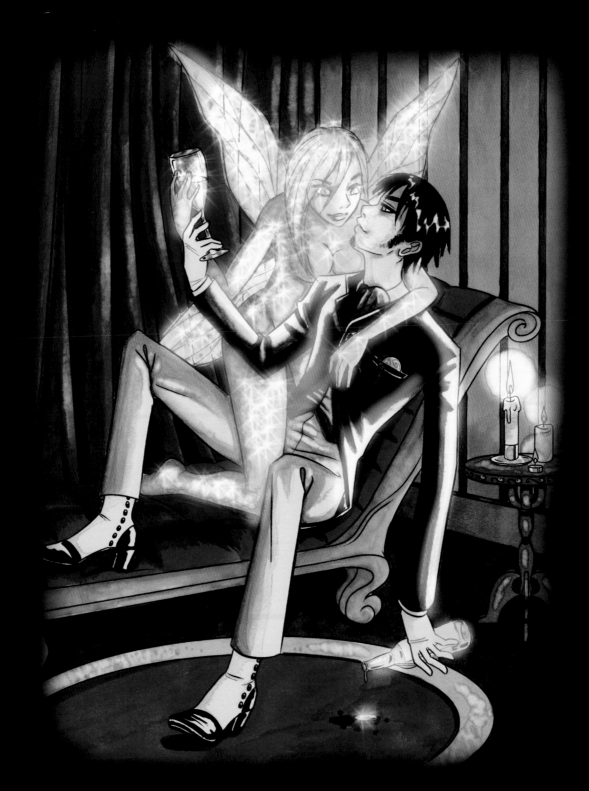

FIRST EXPERIENCE WITH MANGA/ANIME:

My earliest recollection is a French/Japanese anime series from the 1980s called *Mysterious Cities of Gold*. I loved that show! It was unlike anything else I was watching on TV at the time. While American cartoons were light, funny, and basically half-hour commercials for toys, *Mysterious Cities of Gold* had such an involving plot line and interesting, flawed characters. It was funny, but also darker and more serious with an epic story line. That really appealed to me.

YOUR MESSAGE TO ASPIRING YOUNG ARTISTS:

If you want to make comics, draw lots of comic pages—don't just do pinups or character shots. It's important to practice telling a story with pictures. Most of all, know that anything is possible. If you want to do this, think about being an artist every day. Imagine yourself being successful and don't let negative thoughts enter your mind. Accept criticism and use it—don't take it personally. No matter how good you are, there's always room to grow.

YOUR MANGA COLLECTION:

Oh, boy. Way too much. I don't read manga in the bookstore because I feel guilty reading something without paying for it. But I'm also one of those people who likes to own things, so most of my spare money is spent on manga. I have about 350 right now.

YOUR COMIC SHOP:

Alternate Realities
700 Central Park Ave.
Scarsdale, NY 10583

YOUR FAVORITE MANGA:

Tramps Like Us. I love everything about it.

EARLY BIRD OR NOCTURNAL?

Definitely nocturnal. I can barely function before noon, and I don't really hit my stride until around 3 or 4 p.m.

GOAL FOR THE FUTURE:

I want to continue to grow as an artist. I want to be respected as an American-manga-style artist, and my ultimate goal is to have a bookshelf full of graphic novels that I have created. I know it will be a lot of work, but if they can do it in Japan, so can I.

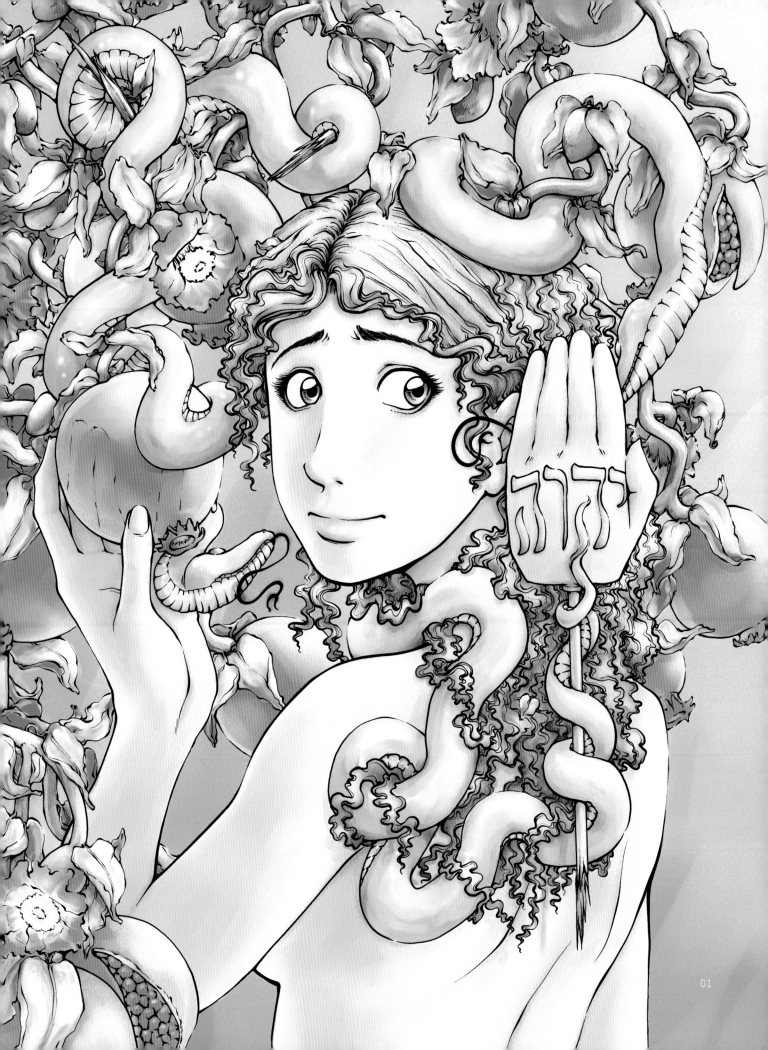

02

rivkah

RIVKAH GREULICH was born on Friday the 13th, in November 1981. She currently lives in Austin, TX, and has one gray-striped cat named Katchoo. Rivkah is the creator of the well-received manga graphic novel series *Steady Beat*, which is published by TOKYOPOP. Previously, Rivkah's short manga story "Pink" received a runner-up award in the international Create Your Own Manga contest held by Manga Academy. You can see more of Rivkah's work at **www.rivkah.com.**

03

Q + A WITH RIVKAH

YOUR ART STYLE:

I've had my artwork described to me as very "liquid." I tend to place an emphasis on line, symmetry, and layout rather than on form and dimension. When I look at a page, I think less of "how will the arm look bent this way?" and more "what is the natural flow of the lines that'll create a true sense of movement in the arm? How's it look in comparison to the overall composition?" I also place a lot of value on line weight. Heavier lines bring one down to earth and weight down the mood of a piece. Lighter, more delicate lines give a picture an ethereal quality, as though daydreaming. So I spend a lot more time inking than I do sketching. As for my overall style, though, it's simple but elegantly detailed, giving it a more graphic or iconic quality. I don't like to overburden a picture with texture or heavy shading. I prefer to give my lines space and room to breathe on a page, balanced by the full weight and dimension of a page.

INFLUENCES:

My first manga ever was *Sailor Moon* in eighth grade. From there followed a variety of *shoujo* manga, which have been the foundation of my leaning in comics and manga. However, after a while, I began to discover other artists and writers: Osamu Tezuka with his expressive backgrounds and cartoonish, emotive faces; Terry Moore's *Strangers in Paradise,* which enchanted me with his more American storytelling and his love of using a brush to ink such expressive characters; and Takeshi Kawabata, of *Hikaru no Go*, whose inking style constantly leaves me in the throes of lust. Some of the things that attract me to the artists I've mentioned is a love of expression in their art. I love artists who use body language and facial expression to the utmost. While there's a lot of very pretty art out there, I like for my characters to tell a story—whether it's a single pinup or a full-length graphic novel.

SELF-TAUGHT?

Absolutely. I never went to college because it was too expensive, and I was busy nurturing my other career (before comics, that is!). I didn't start actually drawing my own manga/comics until August 2003, when I pretty much just woke up one day and said, "This is what I want to do with my life." So, every day for the next several months, I made sure to practice at least four hours after working both a full-time job and managing my private publishing company. I studied tutorials online. I went out and drew everything and everybody around me. I studied my own body in the mirror to get a sense of anatomy and proportion and took a life drawing class. Not even a year later, I had my first book contract with TOKYOPOP, and I haven't stopped since.

ARTISTIC DUTIES:

I do everything. Writing, drawing, layouts, inking, toning, coloring, etc. TOKYOPOP, the publisher of *Steady Beat*, actually offered to find an inker and toner for me, but I declined the offer because, honestly, I'm a control freak. I don't like the thought of my art losing personality in the process of being handed to another person. It may take longer, but I feel the end results are entirely worth it. The only thing I don't do is the ballooning and lettering, but I'm working on changing that because I've yet to be happy with a single person who's lettered my work!

FAVORITE PART OF THE CREATIVE PROCESS:

Everything? Actually, the writing is my favorite, but since this is an art book, I'd have to say that I really enjoy inking. My pencils are generally very rough and sometimes illegible to anybody but myself. But when I go in to ink—adding detail, solidifying lines, enhancing expression, and creating the hint of form through line weight and angle—I get entirely swept away by the process!

> "I LOVE ARTISTS WHO USE BODY LANGUAGE AND FACIAL EXPRESSION TO THE UTMOST."

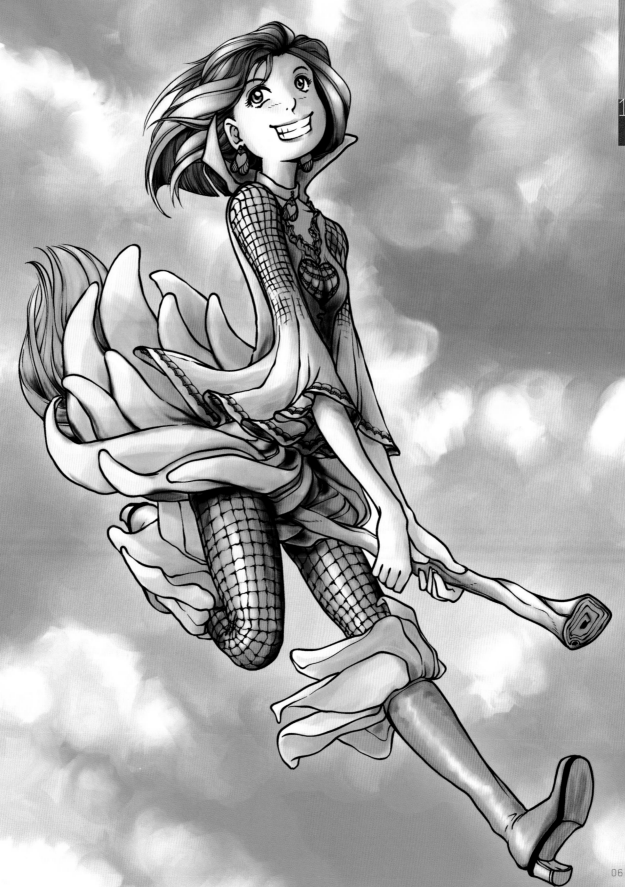

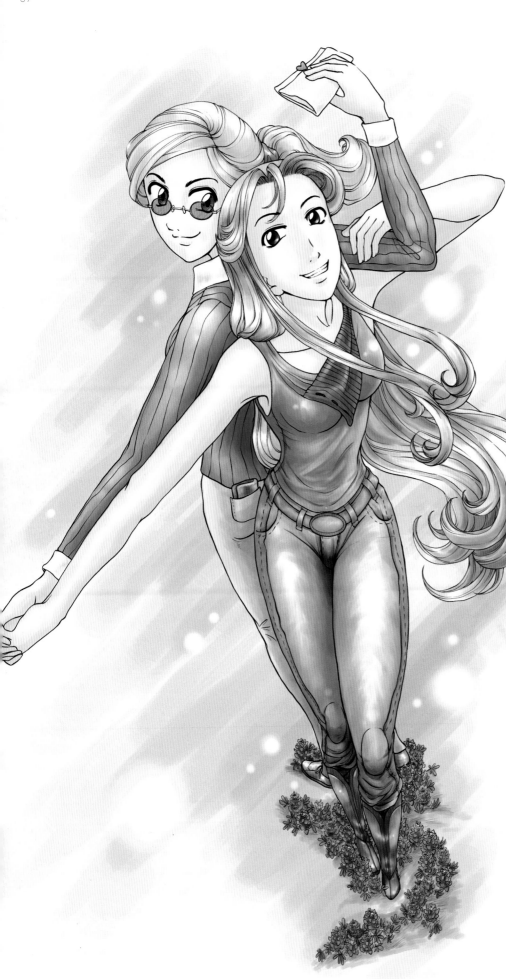

LEAST FAVORITE PART OF THE CREATIVE PROCESS:

It depends! When I'm doing a pinup, it's the backgrounds—they're tedious and sometimes difficult to match up to the foreground art. When it comes to my graphic novels, it's the toning that's a pain. I tend to use tones more to emphasize mood and contrast rather than to show lighting and dimension, and sometimes it gets a little boring cutting and pasting the same tones over and over and over again. I use a lot of circular gradients that look great on the page, but are still a pain to fill and erase over the final inks.

YOUR WORK PROCESS:

For an illustration, I usually start raw. It begins with the right eye, and from there, only fate knows where it goes. I rarely have a preset image in my mind for stand-alone illustrations, while the art for my strips and graphic novels is always thoroughly thought out first—for composition, pose, expression, and clarity.

YOUR WORKSPACE:

It's warm, cozy, often crowded with students, and has the pervasive earthy scent of fresh brewed coffee. When I'm not working on inks, tones, or colors, I'm usually to be found at my favorite local café (free coffee and iced tea refills!) working on my pencils. I find myself incredibly productive when I'm in a busier environment, and the buzz of activity around me keeps me from slipping off into a daydream and losing focus on work. I've also recently started sharing a studio with another artist. He's usually at the computers while I'm at the draft-

ing table, but the company of another creative person, busy at work, really helps to boost production and concentration and ease tedium and stress.

SHOULD WESTERN MANGA BE CALLED "MANGA"?

To each his or her own. The publishers and bookstores consider it manga. My family calls it manga. My fans call it manga. And it's often better than calling it "comics," with all the implied stigmas attached. Personally, I prefer either "manga" or "graphic novels," but certainly not "comics."

FOR THOSE WHO OPPOSE WESTERN MANGA:

The "opposition" is so small it isn't worth making a fuss over. I have been incredibly well accepted as a mangaka at conventions, at libraries, and within the online community. I have yet to run into anybody who outright opposes American manga. They may oppose the styles and techniques of many American mangaka, but few oppose the concept itself.

YOUR WARNING TO ASPIRING ARTISTS:

As Roosevelt used to say, "Speak softly and carry a big stick." Your biggest liability is to brag. Your greatest asset is to follow through on what you'd like to brag about. Don't talk about becoming a great artist. DO it.

RECOMMEND MANGA TO A NEWCOMER:

It really depends on the age and mind-set of the person. However, it seems the one title I find myself recommending more than any other is *Peach Fuzz* by Lindsay Cibos. It's typically parents asking about what to get for their kids, and yet a lot of "all ages" Japanese manga are still considered inappropriate by many adults, whether it's because of nudity, fantasy violence, or content that goes against their religious values. In fact, I find myself recommending a LOT of American titles lately, and not because it's my own!

YOUR HOBBIES:

Drawing, teaching art, fencing, kayaking, reading, restoring old furniture, writing, collecting manga, cooking, baking, vintage cars, politics, religion, Torah, and debate.

GUNDAMS OR EVAS?

Ew. Neither. I'm a *shoujo* fan.

PINK JUST WASN'T MY COLOR.

08

YOUR COMIC SHOP:

I used to buy them at the bookstore, but there's a local comic shop called Austin Books that always gets my favorite titles in early, they have an incredible selection, and there's always a 10 percent discount on all graphic novels.

> "THEY MAY OPPOSE THE STYLES AND TECHNIQUES OF MANY AMERICAN MANGAKA, BUT FEW OPPOSE THE CONCEPT ITSELF."

FAVORITE MANGA: Osamu Tezuka's *Buddha.*

YOUR FUEL:

Coffee, coffee, and more coffee. It's so bad for you. So I alternate with iced tea or juice if it isn't cold out.

YOUR HAIKU:

Outside I'm hidden
Within I'm releasing tears
Spinning past my skin.

GOAL FOR THE FUTURE:

I want to finish *Steady Beat* in however many volumes it takes. I also want to pitch my children's series and finish writing my first Young Adult novel.

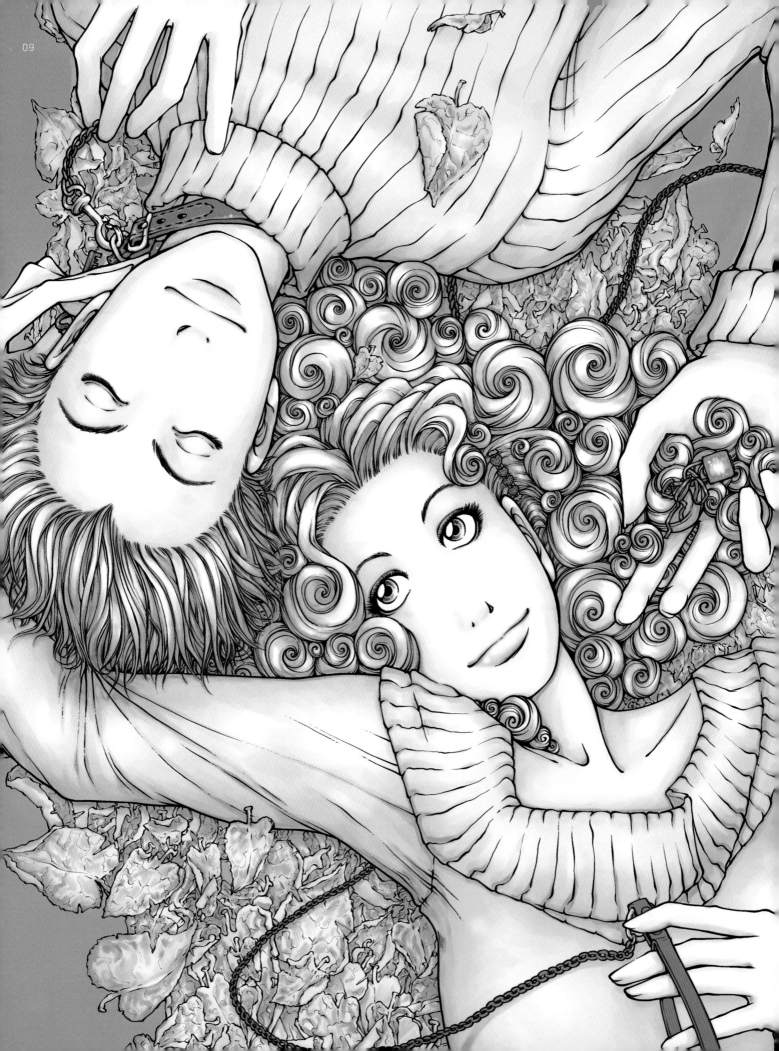

DIGITAL INKING
TUTORIAL

BY RIVKAH

HARDWARE TOOLS: While there are many different tablet brands out there, I use a Wacom 9- by 12-inch Intuos tablet. The general rule of thumb for selecting a tablet is to get one that most closely matches the size of your monitor. The greater the size variation, the less control you're going to have over your lines. And since this is specifically for digital inking, you also want the tablets that offer the greatest sensitivity. Anything less is going to seriously restrict your capabilities. The Wacom Intuos line is my personal favorite.

SOFTWARE TOOLS: There are a variety of programs on the market with which to successfully ink. Larger, more complex programs like Photoshop and Corel Painter can get the job done, but they also tend to be expensive and memory intense, and to create large files.

Two programs that I personally recommend are Deleter Comicworks for PC (available from www.akadotretail.com) and Manga Studio for either PC or Mac (available from www.e-frontier.com). Both are relatively inexpensive, are easy to learn, and best of all, create files sizes below 5 megs and don't hog memory like Photoshop or Painter. I use Comicworks for all of my inking (and also layout and toning), but I've also used Manga Studio and have reviews of both on my Web site at www.rivkah.com/reviews.

For the purpose of this tutorial, I'll be referring to Deleter Comicworks, but all the concepts mentioned herein are easily applied to any of these programs.

TIP! The important rule to remember about digital inking is that it's not WHAT you use, but HOW you use it. Fine digital inking isn't found in fancy filters, vector drawing, or smoothing curve correction. It's found through control of your hand, fingers, and body, and your mind-set—a thorough knowledge of what works, what doesn't, and why.

01

SCANNING IN YOUR ARTWORK: Comicworks and Manga Studio both work entirely in black and white. So if you import an image that you scanned in at 300 dpi into either program, both the scan and your inks are going to come out looking pixilated. There are two ways to get around this. Either scan in your image at a higher resolution (600-1,200 dpi) or, if you have a slow scanner like mine, use this little trick in Photoshop: Scan in your image using Photoshop at 300 dpi, in grayscale mode. Now go to Image > Mode > Bitmap.

Change output to 1,200 pixels/inch and change the Method Use to Diffusion Dither. Select OK.

Voilà. Now you have a non-degraded black-and-white image to ink! Save as a bitmap and open in Comicworks. Now you're ready to get started.

02

PREPPING THE PAGE: With your artwork open in Comicworks, double-click on your sketch layer to rename it. I assign names to every layer I use to keep from getting confused once the image starts becoming more complex. So start naming them early.

Now we're going to lighten the image for easier inking. Select the eraser tool, use the slider to set the diameter (the larger the eraser, the more memory it takes, so don't set it too large!), and turn opacity pressure ON. To save your settings, click the disk icon.

03

Now start erasing lightly over your sketch lines. This is one of the longer and more tedious processes, but it's the best way to get a clear image to ink over. Once this is complete, make sure to save your im-

age in the native file format (in this case, a *.cmx file). At this point, I also go back and make any changes I deem necessary to the picture itself, erasing, redrawing, and lightening. In this case, I added the collar and leash and lock, adjusted the boy's hairline, added a hand and adjusted another, and reworked folds in clothing. Instead of being just a boy and a girl lying in the leaves, now the picture has a theme.

TIP! Always use the eraser on your stylus to erase! Erasing with the nib will very quickly wear it down. A worn nib is less sensitive to pressure and makes inking inconsistent and dull.

04

SETTING THE NIB: Just like traditional inking, you have to figure out what kind of nib works best for you. Some nibs are stiff, creating delicate lines with little variation. Other nibs are flexible and allow you to make thicker lines with greater line variation. Comicworks functions the same way.

Select your pen tool and take a look at the pen options window (window/pen options). You have several different options to play with.

The first slider adjusts pressure sensitivity. The farther left, the more easily your pen will respond to pressure change. The farther right, the more stiff your "nib" and the less sensitive to pressure change. I keep this option always set to zero for optimum sensitivity.

The second slider adjusts to the size of your line. You'll notice when you adjust this that the top of the option box will show the actual weight size of your nib. I keep several pen variations (that's what the tabs are for): one for hair and details; a thicker one for skin, clothing, and expressions; and a last one for simple sketching. The usual sizes of my nibs are 0.32 mm and 0.24 mm.

TIP! If you're new to digital inking, start with a heavier line. Thin lines reveal the unsteady hand, and since this is inked at an extremely high resolution, line jitter stands out like a sore thumb. So start with 0.5 mm and work your way down.

To save your settings, click on the disk to save.

TIP! In digital inking, there is a tool function that can be both dangerous and useful. In the pen setup window, you can turn on stroke revising, a setting that smoothes your lines and prevents jiggle. Avoid using line correcting tools!!! It's a handicap that makes you think your lines are smooth, but it also prevents you from developing a steady hand. It's like paying somebody to do your homework, but failing the final exam because you never learned anything for yourself. Once you've learned how to ink without this function, THEN I'll show you when and how to use it. For now, leave stroke revising unchecked.

05 DRAWING THE FIRST LINE: Just for practice, create a new layer and draw a simple, quick line.

One of the drawbacks to using a tablet is that the smooth surface tends to create a tapered effect at the beginning and end of a line, and thick in the middle. This is the wrong way to ink.

You want HEAVY at the ends, LIGHT in the middle.

Now place your stylus tip down on the tablet, but don't immediately draw your line. Instead, tap down, increase pressure, THEN start to draw your line. Practice with increasing and decreasing pressure as you ink, for this is vital in creating beautiful, natural lines.

Once you've gained a bit of control of your stylus, create your first new ink layer.

06 WHERE TO START: The face is generally where I expend the most time and effort in inking because we're genetically wired to look at expression first, THEN detail. And the first things we look at on the face? Eyes, eyebrows, and mouth.

One of the things manga is most known for—especially *shoujo* manga—is the expressive, detailed eyes. Don't just ink in two lines and a circle. Show detail: the eyelashes, the glare of the light off the eye, the eyelid crease, the pupils, and the texture within the eye.

Detail in eyebrows is often just as important as detail in the eyes. I tend to use quick, short strokes to fill them in. You can make them however you like, but by all means do NOT use a single, heavy black line. It'll stand out against the eyes and look terribly out of place.

Next is the mouth, a sadly overlooked part of expression. It's one thing to show a smile. It's another thing to show she's HAPPY—or, in this case, in a sort of peaceful state of mind. The focus of the mouth is at the corners—the part that changes as our expressions change—not so much the center. So increase pressure as you ink the corners of the mouth and decrease pressure for the main line. Thick lines emphasize. Thin lines de-emphasize.

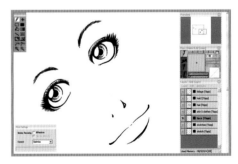

TIP! Thick lines also indicate shadow, while a thin or broken line indicates light source. The lower curve of an arm, the chin, the underside of the nose and ear, etc.—unless your light source is coming from below, these lines are gener-

ally drawn heavier. Keep this in mind at all times while inking. Another useful learning tool: practice drawing and inking inanimate objects with a strong light source.

BACKGROUND TO FOREGROUND: Unlike painting, where you start with the background, inking is the reverse. Start with the foreground and work your way to the background.

CREASES, CORNERS, AND CROSSES: Wrinkles and creases generally start and end with a tapered end. However, where two creases meet, there is a slight shadow cast, so thicken your intersecting line where it meets the other line to indicate that shadow.

To make your creases look more natural, instead of trying to create a perfectly smooth line, vary pressure as you ink. It's best if you don't think too much about how you're varying pressure midline, as this creates a nice, realistic look to your folds.

Another place lines tend to thicken is at corners, such as an arm bending, a fold of cloth crossing over the skin, folds meeting the edge of a pant leg, hair crossing the body, etc. Every object crossing over the body casts a slight shadow, so make certain your line indicates such—just enough to separate one object from the other, but not so much that it pops away from its surroundings.

LONG, SMOOTH LINES: One of the most common questions I receive about digital inking is how I create beautiful, long, smooth lines. Well, it's all in the shoulder and the pinky finger.

When drawing longer lines—mostly for an unbroken surface such as skin or hair—NEVER use your wrist to draw. Lift that wrist up off the tablet surface! And direct your motions with your elbow and shoulder. As a stabilizer, I'll often rest my pinky finger on the surface. This helps prevent jitter by directing the unconscious vibrations of your arm down into the tablet surface rather than into the stylus.

TIP! If you're having difficulty keeping your wrist off the surface, try putting a Kleenex tissue under your hand and letting your wrist slide across the surface. I do this when I need a particularly controlled heavy line, such as the underside of a leg or arm.

Another thing you can do is practice drawing lines with an Ace bandage around your wrist. Not exactly practical for inking a picture, but it's excellent for showing what it should at least feel like.

LINE CORRECTION: The reason I discourage line correction is because, while it may smooth lines, it also takes

away your control over the final image. A lot of the personality found in one's style of inking is due to slight shifts and changes in hand movement. Line correction overrules these little quirks and takes a great deal of the originality out of inking. However, now that you've learned how you're supposed to hold the pen and how to use that line, I'm going to show you the few places where it's appropriate to use line correction:

HAIR: Hair is a beautiful thing. It can be just as expressive as a facial expression and body language. I tend to use very thin, delicate lines for hair. It's free flowing and light, and the line should reflect that. However, it's also wild and doesn't take well to being controlled.

I often turn on line correction to ink hair.

Not only does it make the lines smoother, but also it gives a certain unpredictability to my line that fits perfectly with how hair naturally falls and flows. Too much perfection and control in the hair, and it ends up looking stiff and lifeless. This is your chance to let fate take its course!

For longer, flowing hair—such as in my dancing ballerina picture—I often ink separate strands of hair on different layers so that the natural curve is continuous. I'll then go back and erase the underlapping lines. However, for things like curls or short strands of hair—such as in this tutorial—I ink each individual's hair all on the same layer.

LONG FOLDS AND SKIN: Another place it's appropriate to turn on line correction is when you need an extremely smooth, unbroken line, such as for skin or long, stretched folds. First, in order to create the smoothest line possible, I rotate the canvas so that my strokes will angle downward, curving in. This is the most natural motion for your arm, and attempting to ink a horizontal line gives you less control.

DETAIL IN LIGHT AND SHADE: In hair and clothing, the more shadow, the more detail; the more light, the less de-

tail (this applies to everything, actually). Don't try inking every strand of hair or fold of cloth. Instead ink in "chunks" first, then fill in detail. With hair, I typically draw a single, heavier line for each chunk of hair, then draw thinner lines on either side. This creates a feathered look that makes hair look more free flowing and natural. With clothing, I draw the major folds first, then use thinner, wispy strokes for minor folds.

Places in the hair that generally have more detail are the brow, the part, sudden bends or curves, around the ears, and at the tips.

DETAILS GIVE LIFE: Details, though seemingly insignificant, really give a scene life. However, since they aren't the focus of a piece, it's best to ink details with a thinner nib. That way, they accent but don't overpower the more important aspects of your picture.

FOLIAGE: Leaves, branches, trees, and flowers are some of my favorite things to ink because it's where you're the least restricted by line weight. Whereas digital

inking tends to require a higher level of concentration than regular inking (thanks to that incredibly smooth surface that accents every little motion), natural lines are where you can stop thinking and just let your hand naturally move across the page. The best kind of line to use for inking foliage is one that constantly varies in width as you draw. Don't think about light and shade so much. Just let your fingers increase and decrease pressure randomly across the page.

SAVING YOUR WORK: Now that you're done inking, congratulations! It's time to save and export this image for coloring or toning.

I always save as a bitmap (*.bmp) file, but if you think you're going to need layers, save as a Photoshop (*.psd) file. But first, make certain to turn off your sketch layer before saving. Now you're done and ready to move on!

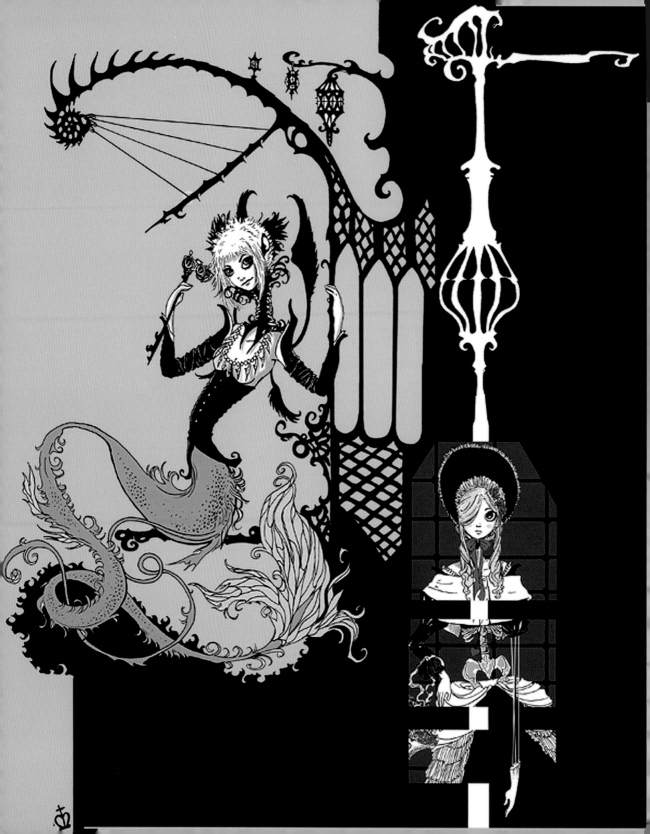

creator of TOKYOPOP'S
Bizenghast

02

M Alice LeGrow was born on October 13, 1981 and currently lives in New England with two mice named King of Prussia and Frankie Zan. She received a BFA in sequential art from the Savannah College of Art and Design and went on to have her story "Nikolai" selected to be printed in TOKYOPOP's *Rising Stars of Manga™* anthology, volume two. Currently, M. Alice is working on *Bizenghast*, an original manga graphic novel series published by TOKYOPOP, and another series, which has yet to be announced! You can see more of M. Alice's work at www.bizenghast.com.

M Alice LeGrow

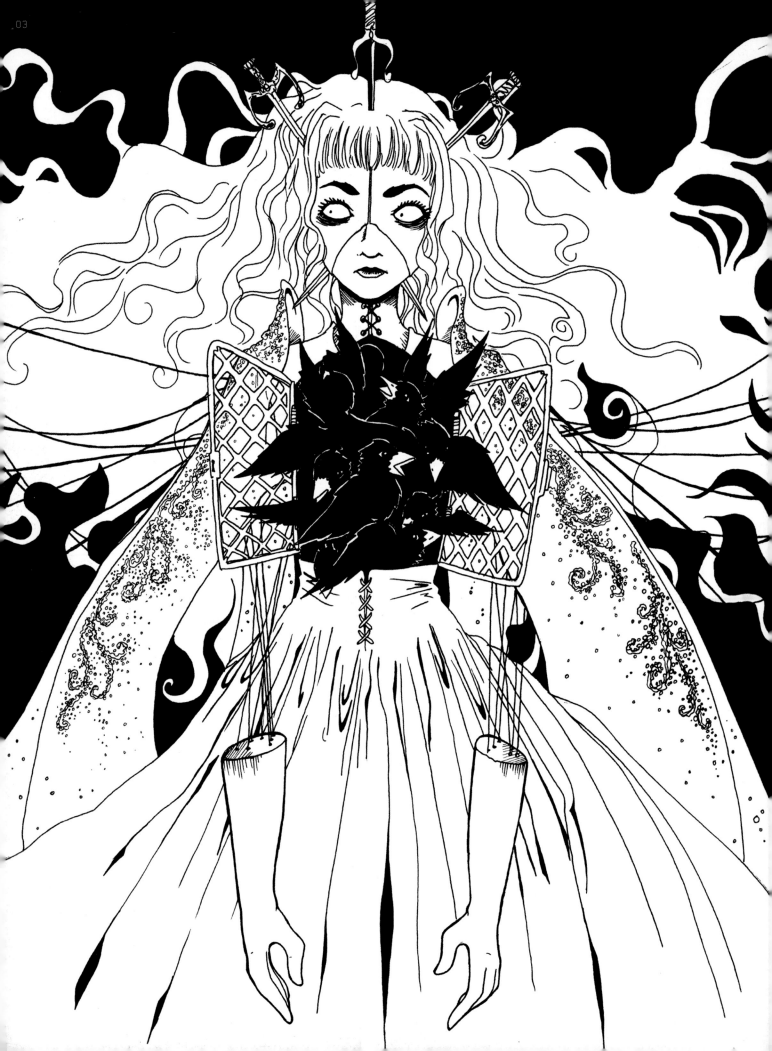

Q + A WITH M.ALICE

YOUR ART STYLE:

It's kind of an amalgamation of different artists I admire and is influenced by patterns and shapes that occur in nature.

INFLUENCES:

Kenji Tsuruta, Gustave Doré, Aubrey Beardsley.

ARTISTIC DUTIES:

I do all of my own writing and art, but I have a separate letterer.

FAVORITE PART OF THE PROCESS:

Designing and drawing backgrounds and buildings.

YOUR PUBLISHED WORK:

I started a party the day after getting my contract that's basically been going since then and will probably continue for several years. We're running dangerously low on chips and beer, so someone's going to have to go to the store eventually.

DESCRIBE MANGA TO A NEWCOMER:

There are lots of explosions and school uniforms and guys with mysterious pasts and cat women. Also sometimes pirates. It's a bit like Andrew Lloyd Webber.

YOUR MESSAGE TO ASPIRING ARTISTS: Rock on.

YOUR WARNING TO ASPIRING ARTISTS:

Go to art school and don't defend everything you do wrong as your "style." Listen to comments during critiques and learn.

SUGGEST A MANGA TO A NEWCOMER:

Spirit of Wonder by Kenji Tsuruta.

YOUR HOBBIES:

I design and create costumes and props, read a lot of books (mostly on business and philosophy), and generally enjoy learning. I also embroider.

GUNDAMS OR EVAS?

Gigantor.

FAVORITE NON-JAPANESE COMICS:

I don't really read a lot of comics right now, but I really like Mark Oakley's *Thieves and Kings*, which is a comic series from Canada. I like to bug Mark online a lot about it.

YOUR COMIC SHOP:

The Paperback Trader IV on the UConn campus in Storrs, Connecticut. They rock and I've been going there for more than a decade now.

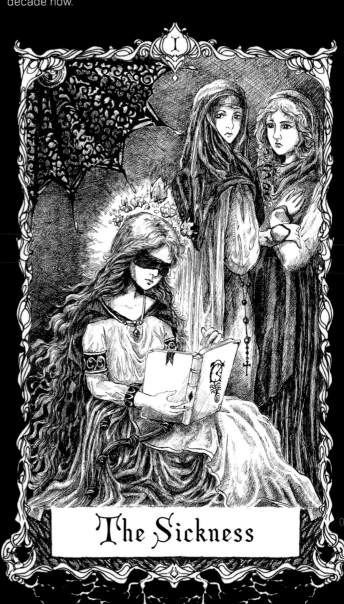

The Sickness

04

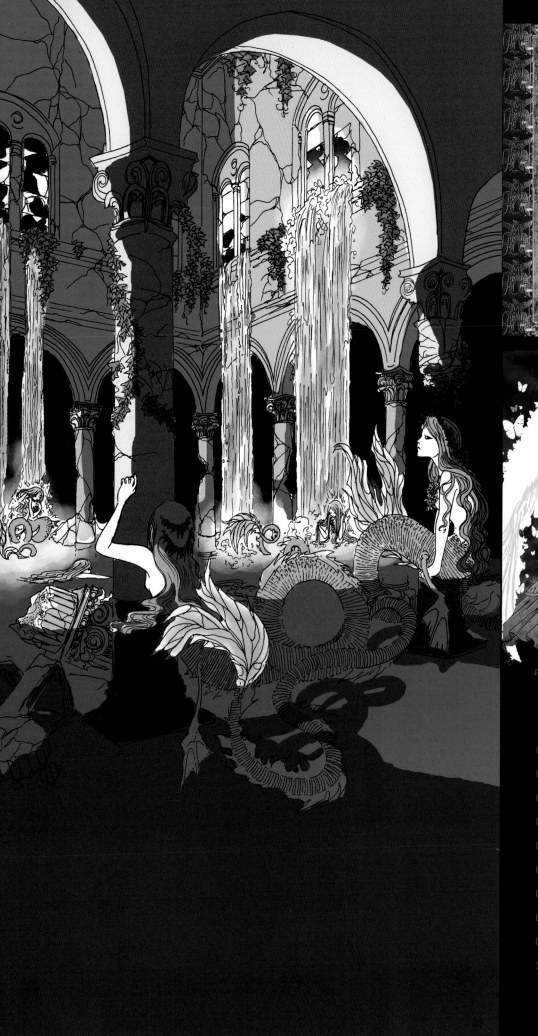

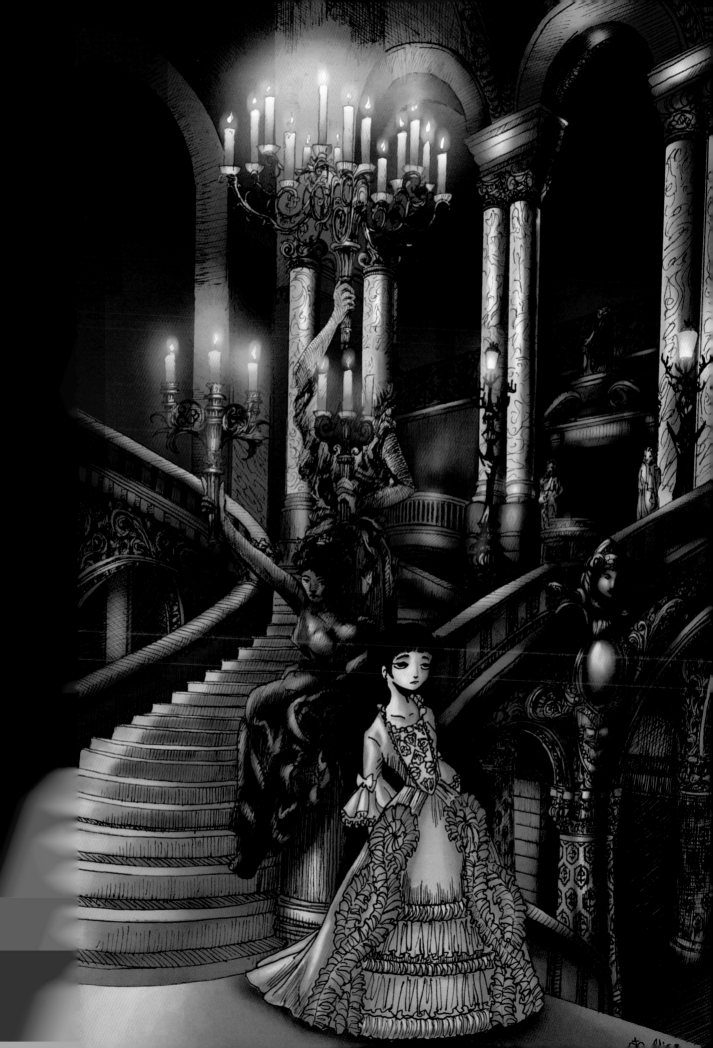

FAVORITE MANGA:

Uzumaki.

FAVORITE NOVEL:

The Complete Compendium of Sherlock Holmes.

FAVORITE MOVIE:

The Slipper and the Rose, 1976, starring Richard Chamberlain.

YOUR FUEL:

About a case of Diet Pepsi. Daily.

EARLY BIRD OR NOCTURNAL?

I don't have a normal sleep schedule. I kind of wake up at all hours of the day and night and work until I'm sleepy again. I usually work a 13-hour day.

DESCRIBE A CON EXPERIENCE:

They're all kind of interesting, I guess. I went to 13 cons this last year alone, so I kinda rack up the interesting con stories after awhile. There was this one time I was in a skit with my